The Art of
Drawing People

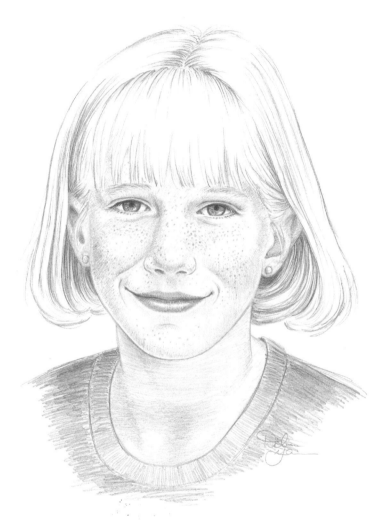

Quarto is the authority on a wide range of topics.
Quarto educates, entertains, and enriches the lives of our readers—
enthusiasts and lovers of hands-on living.
www.quartoknows.com

6 Orchard Road, Suite 100
Lake Forest, CA 92630
quartoknows.com
Visit our blogs at quartoknows.com

Printed in China

20 19 18 17 16

The Art of
Drawing People

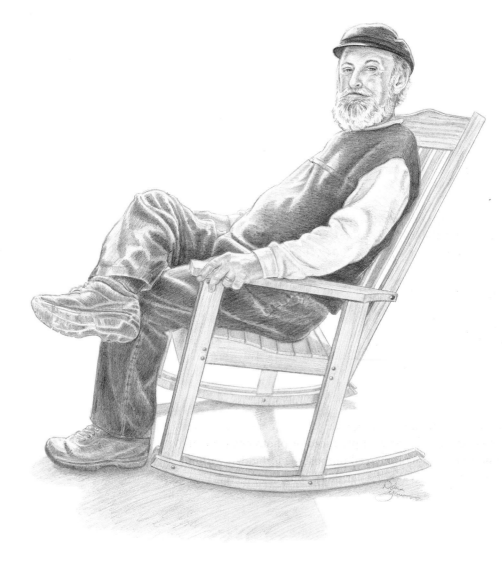

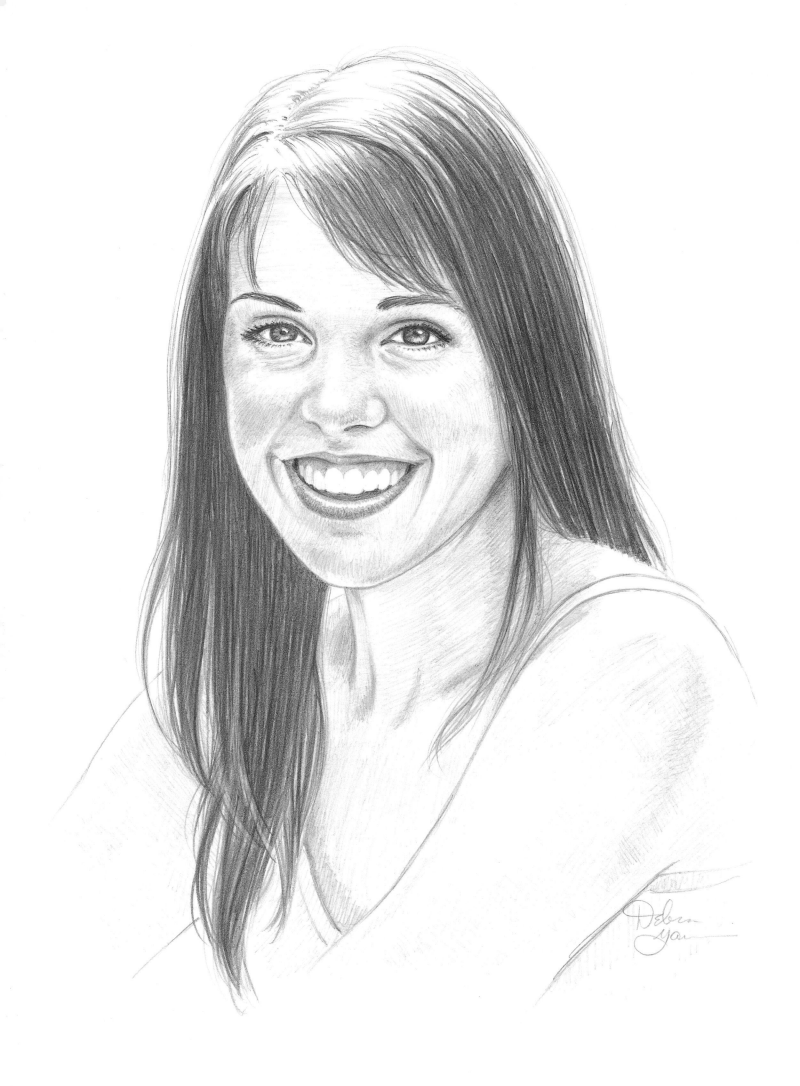

CONTENTS

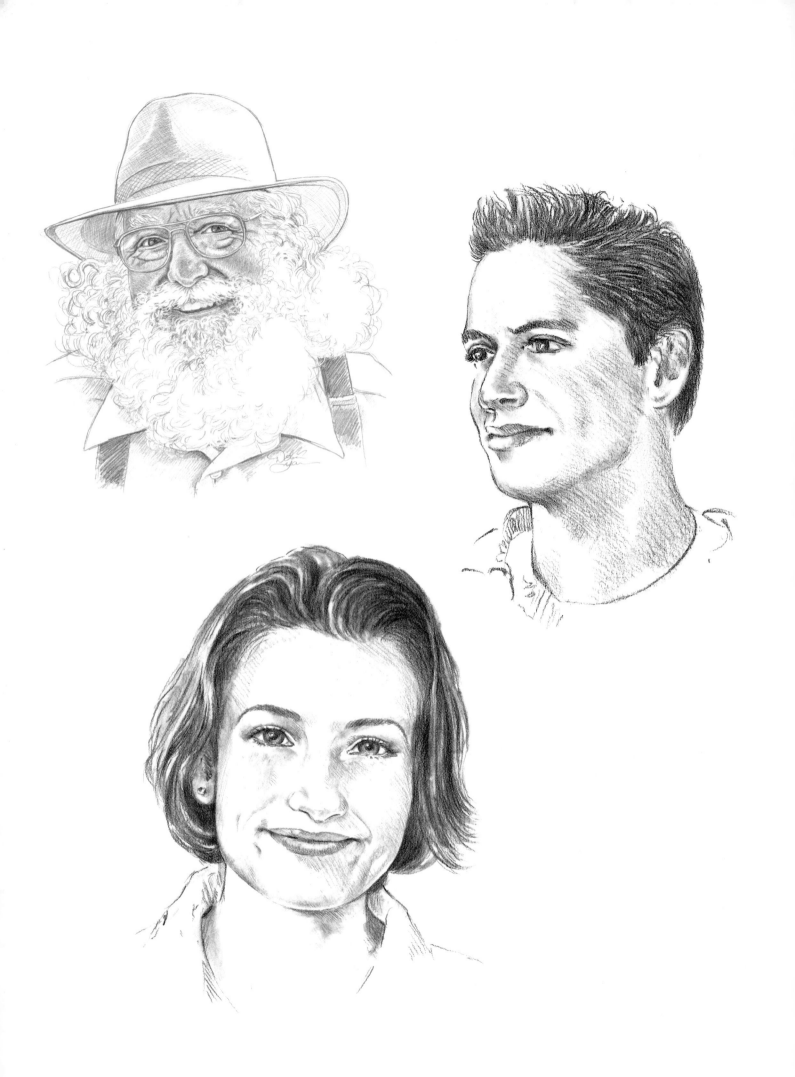

INTRODUCTION TO DRAWING PEOPLE

People are such interesting and varied subjects to draw. With this compilation of projects from some of the most popular titles in our How to Draw and Paint series, you'll find in-depth information on every aspect of drawing people. Featuring instruction from four accomplished artists, this book is filled with step-by-step demonstrations that show you how to re-create a range of people of differing ages and ethnicities. You'll find plenty of helpful tips on tools and materials, shading, and other fundamental drawing techniques, as well as important information about the influences of bone structure and musculature. And detailed examples of facial features, hands, and feet will help guide you through the most challenging aspects of drawing people. With practice, you'll soon be able to capture amazing likenesses of family and friends in your pencil drawings!

TOOLS & MATERIALS

Drawing is not only fun, it also is an important art form in itself. Even when you write or print your name, you are actually drawing! If you organize the lines, you can make shapes; and when you carry that a bit further and add dark and light shading, your drawings begin to take on a three-dimensional form and look more realistic. One of the great things about drawing is that you can do it anywhere, and the materials are very inexpensive. You do get what you pay for, though, so purchase the best you can afford at the time, and upgrade your supplies whenever possible. Although anything that will make a mark can be used for some type of drawing, you'll want to make certain your magnificent efforts will last and not fade over time. Here are some materials that will get you off to a good start.

Sketch Pads Conveniently bound drawing pads come in a wide variety of sizes, textures, weights, and bindings. They are particularly handy for making quick sketches and when drawing outdoors. You can use a large sketchbook in the studio for laying out a painting, or take a small one with you for recording quick impressions when you travel. Smooth- to medium-grain paper texture (which is called the "tooth") often is an ideal choice.

Work Station It is a good idea to set up a work area that has good lighting and enough room for you to work and lay out your tools. Of course, an entire room with track lighting, easel, and drawing table is ideal. But all you really need is a place by a window for natural lighting. When drawing at night, you can use a soft white light bulb and a cool white fluorescent light so that you have both warm (yellowish) and cool (bluish) light.

Drawing Papers
For finished works of art, using single sheets of drawing paper is best. They are available in a range of surface textures: smooth grain (plate and hot pressed), medium grain (cold pressed), and rough to very rough. The cold-pressed surface is the most versatile. It is of medium texture but it's not totally smooth, so it makes a good surface for a variety of different drawing techniques.

Artist's Erasers
A kneaded eraser is a must. It can be formed into small wedges and points to remove marks in very tiny areas. Vinyl erasers are good for larger areas; they remove pencil marks completely. Neither eraser will damage the paper surface unless scrubbed too hard.

Charcoal Papers Charcoal paper and tablets also are available in a variety of textures. Some of the surface finishes are quite pronounced, and you can use them to enhance the texture in your drawings. These papers also come in a variety of colors, which can add depth and visual interest to your drawings.

Tortillons These paper "stumps" can be used to blend and soften small areas where your finger or a cloth is too large. You also can use the sides to quickly blend large areas. Once the tortillons become dirty, simply rub them on a cloth, and they're ready to go again.

Utility Knives Utility knives (also called "craft" knives) are great for cleanly cutting drawing papers and mat board. You also can use them for sharpening pencils. (See the box on page 9.) Blades come in a variety of shapes and sizes and are easily interchanged. But be careful; the blades are as sharp as scalpels!

GATHERING THE BASICS

You don't need a lot of supplies to start; you can begin enjoying drawing with just a #2 or an HB pencil, a sharpener, a vinyl eraser, and any piece of paper. You always can add more pencils, charcoal, tortillons, and such later. When shopping for pencils, notice that they are labeled with letters and numbers; these indicate the degree of lead softness. Pencils with B leads are softer than those with H leads, and so they make darker strokes. An HB is in between, which makes it very versatile and a good beginner's tool. The chart at right shows a variety of drawing tools and the kinds of strokes that are achieved with each one. As you expand your pencil supply, practice shaping different points and creating different effects with each by varying the pressure you put on the pencil. The more comfortable you are with your tools, the better your drawings will be!

ADDING ON

Unless you already have a drawing table, you may want to purchase a drawing board. It doesn't have to be expensive; just get one large enough to accommodate individual sheets of drawing paper. Consider getting one with a cut-out handle, especially if you want to draw outdoors, so you easily can carry it with you.

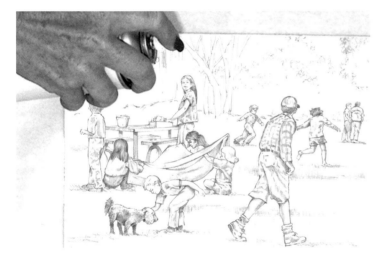

Spray Fix A fixative "sets" a drawing and protects it from smearing. Some artists avoid using fixative on pencil drawings because it tends to deepen the light shadings and eliminate some delicate values. However, fixative works well for charcoal drawings. Fixative is available in spray cans or in bottles, but you need a mouth atomizer to use bottled fixative. Spray cans are more convenient, and they give a finer spray and more even coverage.

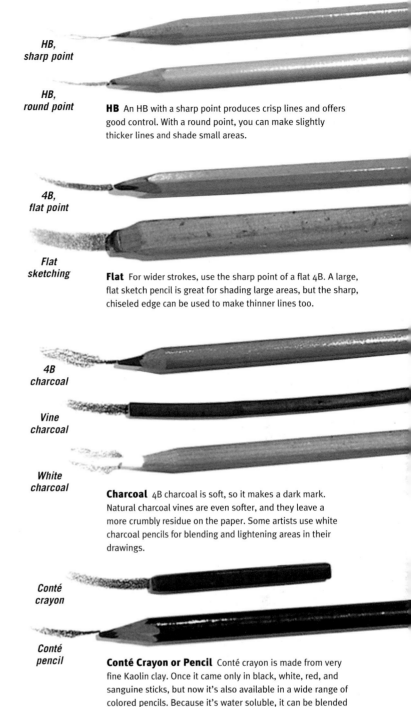

HB, sharp point

HB, round point

HB An HB with a sharp point produces crisp lines and offers good control. With a round point, you can make slightly thicker lines and shade small areas.

4B, flat point

Flat sketching

Flat For wider strokes, use the sharp point of a flat 4B. A large, flat sketch pencil is great for shading large areas, but the sharp, chiseled edge can be used to make thinner lines too.

4B charcoal

Vine charcoal

White charcoal

Charcoal 4B charcoal is soft, so it makes a dark mark. Natural charcoal vines are even softer, and they leave a more crumbly residue on the paper. Some artists use white charcoal pencils for blending and lightening areas in their drawings.

Conté crayon

Conté pencil

Conté Crayon or Pencil Conté crayon is made from very fine Kaolin clay. Once it came only in black, white, red, and sanguine sticks, but now it's also available in a wide range of colored pencils. Because it's water soluble, it can be blended with a wet brush or cloth.

SHARPENING YOUR DRAWING IMPLEMENTS

A Utility Knife can be used to form different points (chiseled, blunt, or flat) than are possible with an ordinary pencil sharpener. Hold the knife at a slight angle to the pencil shaft, and always sharpen away from you, taking off only a little wood and graphite at a time.

A Sandpaper Block will quickly hone the lead into any shape you wish. It also will sand down some of the wood. The finer the grit of the paper, the more controllable the resulting point. Roll the pencil in your fingers when sharpening to keep the shape even.

Rough Paper is wonderful for smoothing the pencil point after tapering it with sandpaper. This also is a great way to create a very fine point for small details. Again, it is important to gently roll the pencil while honing to sharpen the lead evenly.

THE ELEMENTS OF DRAWING

Drawing consists of three elements: line, shape, and form. The shape of an object can be described with simple one-dimensional line. The three-dimensional version of the shape is known as the object's "form." In pencil drawing, variations in *value* (the relative lightness or darkness of black or a color) describe form, giving an object the illusion of depth. In pencil drawing, values range from black (the darkest value) through different shades of gray to white (the lightest value). To make a two-dimensional object appear three-dimensional, you must pay attention to the values of the highlights and shadows. When shading a subject, you must always consider the light source, as this is what determines where your highlights and shadows will be.

MOVING FROM SHAPE TO FORM

The first step in creating an object is establishing a line drawing or outline to delineate the flat area that the object takes up. This is known as the "shape" of the object. The four basic shapes—the rectangle, circle, triangle, and square—can appear to be three-dimensional by adding a few carefully placed lines that suggest additional planes. By adding ellipses to the rectangle, circle, and triangle, you've given the shapes dimension and have begun to produce a form within space. Now the shapes are a cylinder, sphere, and cone. Add a second square above and to the side of the first square, connect them with parallel lines, and you have a cube.

ADDING VALUE TO CREATE FORM

A shape can be further defined by showing how light hits the object to create highlights and shadows. First note from which direction the source of light is coming. (In these examples, the light source is beaming from the upper right.) Then add the shadows accordingly, as shown in the examples below. The *core shadow* is the darkest area on the object and is opposite the light source. The *cast shadow* is what is thrown onto a nearby surface by the object. The *highlight* is the lightest area on the object, where the reflection of light is strongest. *Reflected light,* often overlooked by beginners, is surrounding light reflected into the shadowed area of an object.

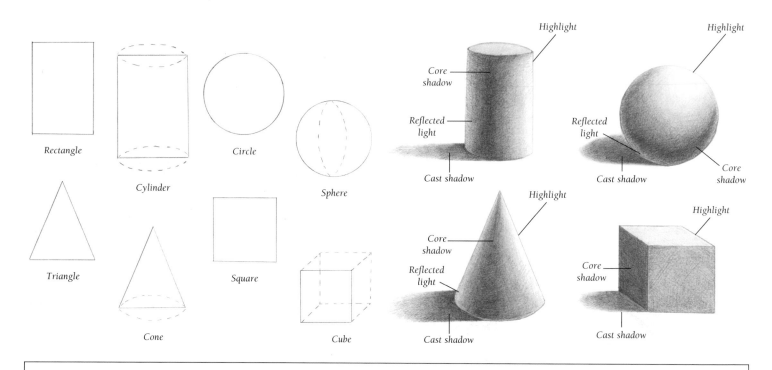

Rectangle

Cylinder

Circle

Sphere

Triangle

Cone

Square

Cube

Highlight

Core shadow

Reflected light

Cast shadow

Highlight

Reflected light

Cast shadow

Core shadow

Highlight

Core shadow

Reflected light

Cast shadow

Highlight

Core shadow

Cast shadow

CREATING VALUE SCALES

Just as a musician uses a musical scale to measure a range of notes, an artist uses a value scale to measure changes in value. You can refer to the value scale so you'll always know how dark to make your dark values and how light to make your highlights. The scale also serves as a guide for transitioning from lighter to darker shades. Making your own value scale will help familiarize you with the different variations in value. Work from light to dark, adding more and more tone for successively darker values (as shown at upper right). Then create a blended value scale (shown at lower right). Use a tortillon to smudge and blend each value into its neighboring value from light to dark to create a gradation.

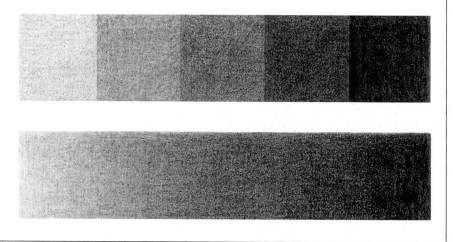

BASIC PENCIL TECHNIQUES

You can create an incredible variety of effects with a pencil. By using various hand positions and shading techniques, you can produce a world of different lines and strokes. If you vary the way you hold the pencil, the mark the pencil makes changes. It's just as important to notice your pencil point. The point is every bit as essential as the type of lead in the pencil. Experiment with different hand positions and techniques to see what your pencil can do!

GRIPPING THE PENCIL

Many artists use two main hand positions for drawing. The writing position is good for very detailed work that requires fine hand control. The underhand position allows for a freer stroke with more arm movement—the motion is almost like painting. (See the captions below for more information on using both hand positions.)

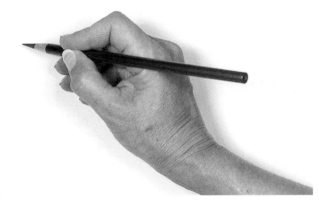

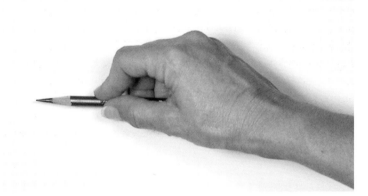

Using the Writing Position This familiar position provides the most control. The accurate, precise lines that result are perfect for rendering fine details and accents. When your hand is in this position, place a clean sheet of paper under your hand to prevent smudging.

Using the Underhand Position Pick up the pencil with your hand over it, holding the pencil between the thumb and index finger; the remaining fingers can rest alongside the pencil. You can create beautiful shading effects from this position.

PRACTICING BASIC TECHNIQUES

By studying the basic pencil techniques below, you can learn to render everything from a smooth complexion and straight hair to shadowed features and simple backgrounds. Whatever techniques you use, though, remember to shade evenly. Shading in a mechanical, side-to-side direction, with each stroke ending below the last, can create unwanted bands of tone throughout the shaded area. Instead try shading evenly, in a back-and-forth motion over the same area, varying the spot where the pencil point changes direction.

Hatching This basic method of shading involves filling an area with a series of parallel strokes. The closer the strokes, the darker the tone will be.

Crosshatching For darker shading, place layers of parallel strokes on top of one another at varying angles. Again, make darker values by placing the strokes closer together.

Gradating To create graduated values (from dark to light), apply heavy pressure with the side of your pencil, gradually lightening the pressure as you stroke.

Shading Darkly By applying heavy pressure to the pencil, you can create dark, linear areas of shading.

Shading with Texture For a mottled texture, use the side of the pencil tip to apply small, uneven strokes.

Blending To smooth out the transitions between strokes, gently rub the lines with a tortillon or tissue.

OTHER WAYS TO SHADE

PRACTICING LINES

When drawing lines, it is not necessary to always use a sharp point. In fact, sometimes a blunt point may create a more desirable effect. When using larger lead diameters, the effect of a blunt point is even more evident. Play around with your pencils to familiarize yourself with the different types of lines they can create. Make every kind of stroke you can think of, using both a sharp point and a blunt point. Practice the strokes below to help you loosen up.

As you experiment, you will find that some of your doodles will bring to mind certain imagery or textures. For example, little Vs can be reminiscent of birds flying, whereas wavy lines can indicate water.

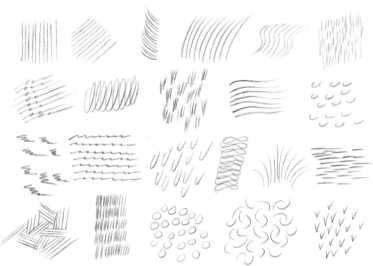

Drawing with a Sharp Point First draw a series of parallel lines. Try them vertically; then angle them. Make some of them curved, trying both short and long strokes. Then try some wavy lines at an angle and some with short, vertical strokes. Try making a spiral and then grouping short, curved lines together. Then practice varying the weight of the line as you draw. Os, Vs, and Us are some of the most common alphabet shapes used in drawing.

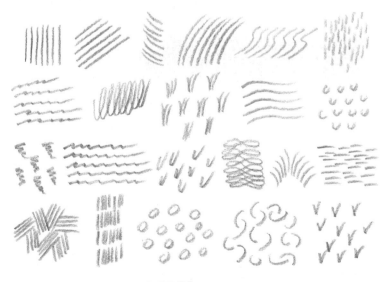

Drawing with a Blunt Point It is good to take the same exercises and try them with a blunt point. Even if you use the same hand positions and strokes, the results will be different when you switch pencils. Take a look at these examples. The same shapes were drawn with both pencils, but the blunt pencil produced different images. You can create a blunt point by rubbing the tip of the pencil on a sandpaper block or on a rough piece of paper.

"PAINTING" WITH PENCIL

When you use painterly strokes, your drawing will take on a new dimension. Think of your pencil as a brush and allow yourself to put more of your arm into the stroke. To create this effect, try using the underhand position, holding your pencil between your thumb and forefinger and using the side of the pencil. (See page 11.) If you rotate the pencil in your hand every few strokes, you will not have to sharpen it as frequently. The larger the lead, the wider the stroke will be. The softer the lead, the more painterly an effect you will have. These examples were all made on smooth paper with a 6B pencil, but you can experiment with rough papers for more broken effects.

Starting Simply First experiment with vertical, horizontal, and curved strokes. Keep the strokes close together and begin with heavy pressure. Then lighten the pressure with each stroke.

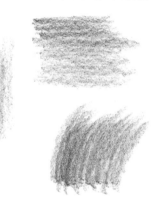

Varying the Pressure Randomly cover the area with tone, varying the pressure at different points. Continue to keep your strokes loose.

Using Smaller Strokes Make small circles for the first example. This is reminiscent of leathery animal skin. For the second example (at far right), use short, alternating strokes of heavy and light pressure to create a pattern that is similar to stone or brick.

Loosening Up Use long vertical strokes, varying the pressure for each stroke until you start to see long grass (at right). Then use somewhat looser movements that could be used for water (at far right). First create short spiral movements with your arm (above). Then use a wavy movement, varying the pressure (below).

Finding Your Style

Many great artists of the past can now be identified by their unique experiments with line. Van Gogh's drawings were a feast of calligraphic lines; Seurat became synonymous with pointillism; and Giacometti was famous for his scribble. Can you find your identity in a pencil stroke?

Using Criss-Crossed Strokes If you like a good deal of fine detail in your work, you'll find that crosshatching allows you a lot of control (see page 11). You can adjust the depth of your shading by changing the distance between your strokes.

Sketching Circular Scribbles If you work with round, loose strokes like these, you are probably very experimental with your art. These looping lines suggest a free-form style that is more concerned with evoking a mood than with capturing precise details.

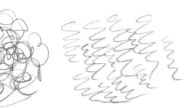

Drawing Small Dots This technique is called "stippling"—many small dots are used to create a larger picture. Make the points different sizes to create various depths and shading effects. Stippling takes a great deal of precision and practice.

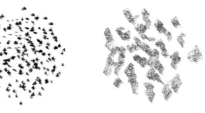

Simulating Brushstrokes You can create the illusion of brushstrokes by using short, sweeping lines. This captures the feeling of painting but allows you the same control you would get from crosshatching. These strokes are ideal for a more stylistic approach.

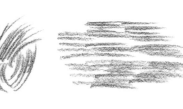

Working with Different Techniques

Below are several examples of techniques that can be done with pencil. These techniques are important for creating more painterly effects in your drawing. Remember that B pencils have soft lead and H pencils have hard lead—you will need to use both for these exercises.

Creating Washes First shade an area with a *water-soluble pencil* (a pencil that produces washes similar to watercolor paint when manipulated with water). Then blend the shading with a wet brush. Make sure your brush isn't too wet, and use thicker paper, such as vellum board.

Rubbing Place paper over an object and rub the side of your pencil lead over the paper. The strokes of your pencil will pick up the pattern and replicate it on the paper. Try using a soft pencil on smooth paper, and choose an object with a strong textural pattern. This example uses a wire grid.

Lifting Out Blend a soft pencil on smooth paper, and then lift out the desired area of graphite with an eraser. You can create highlights and other interesting effects with this technique.

Producing Indented Lines Draw a pattern or design on the paper with a sharp, non-marking object, like a knitting needle or skewer, before drawing with a pencil. When you shade over the area with the side of your pencil, the graphite will not reach the indented areas, leaving white lines.

SMUDGING

Smudging is an important technique for creating shading and gradients. Use a tortillon or chamois cloth to blend your strokes. It is important to not use your finger, because your hand, even if clean, has natural oils that can damage your art.

Smudging on Rough Surfaces Use a 6B pencil on vellum-finish Bristol board. Make your strokes with the side of the pencil and blend. In this example, the effect is very granular.

Smudging on Smooth Surfaces Use a 4B pencil on plate-finish Bristol board. Stroke with the side of the pencil, and then blend your strokes with a blending stump.

LEARNING TO SEE

Many beginners draw without really looking carefully at their subject; instead of drawing what they *actually* see, they draw what they *think* they see. Try drawing something you know well, such as your hand, without looking at it. Chances are your finished drawing won't look as realistic as you expected. That's because you drew what you think your hand looks like. Instead, you need to forget about all your pre-conceptions and learn to draw only what you really see in front of you (or in a photo). Two great exercises for training your eye to see are contour drawing and gesture drawing.

PENCILING THE CONTOURS

In contour drawing, you pick a starting point on your subject and then draw only the contours—or outlines—of the shapes you see. Because you're not looking at your paper, you're training your hand to draw the lines exactly as your eye sees them. Try doing some contour drawings of your own; you'll be surprised at how well you're able to capture the subjects.

◄ **Drawing with a Continuous Line** When drawing this man pushing a wheelbarrow, try glancing only occasionally at your paper to check that you are on track, but concentrate on really looking at the subject and tracing the outlines you see. Instead of lifting your pencil between shapes, keep the line unbroken by freely looping back and crossing over your lines. Notice how this simple technique effectively captures the subject.

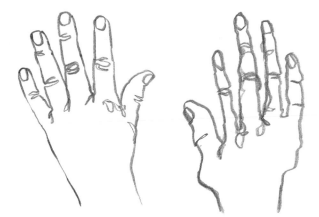

▲ **Drawing "Blind"** For the contour drawing on the left, the artist occasionally looked down at the paper. The drawing on the right is an example of a blind contour drawing, where the artist drew without looking at his paper even once. It's a little distorted, but it's clearly a hand. Blind contour drawing is one of the best ways of making sure you're truly drawing only what you see.

To test your observation skills, study an object very closely for a few minutes, and then close your eyes and try drawing it from memory, letting your hand follow the mental image.

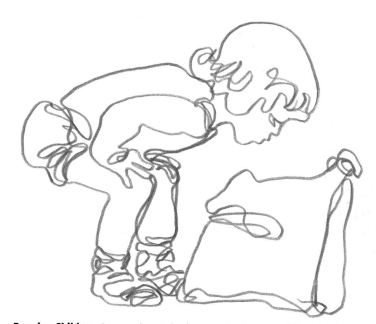

Drawing Children Once you have trained your eye to observe carefully and can draw quickly, you'll be able to capture actions such as this child looking and then reaching into the bag.

DRAWING GESTURE AND ACTION

Another way to train your eye to see the essential elements of a subject—and train your hand to record them rapidly—is through gesture drawing. Instead of rendering the contours, *gesture drawings* establish the movement of a figure. First determine the main thrust of the movement, from the head, down the spine, and through the legs; this is the *line of action*, or *action line.* Then briefly sketch the general shapes of the figure around this line. These quick sketches are great for practicing drawing figures in action and sharpening your powers of observation.

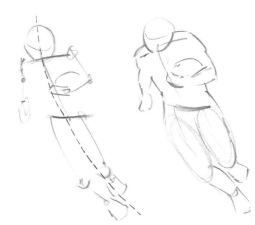

◄ **Starting with an Action Line** Once you establish the line of action, try building a "skeleton" stick drawing around it. Here the artist paid particular attention to the angles of the shoulders, spine, and pelvis. Then he sketched in the placement of the arms, knees, and feet and roughly filled out the basic shapes of the figure.

◄ **Working Quickly** To capture the action accurately, work very quickly, without including even a suggestion of detail. If you want to correct a line, don't stop to erase; just draw over it.

▲ **Studying Repeated Action** Group sports provide a great opportunity for practicing gesture drawings and learning to see the essentials. Because the players keep repeating the same action, you will be able to observe each movement closely and keep it in your memory long enough to sketch it correctly.

Drawing a Group in Motion Once you have compiled a series of gesture drawings, you'll be able to combine them into a scene of football players in action.

PEOPLE IN PERSPECTIVE

Knowing the principles of *perspective* (the representation of objects on a two-dimensional surface that creates the illusion of three-dimensional depth and distance) allows you to draw more than one person in a scene realistically. Eye level changes as your elevation of view changes. In perspective, eye level is indicated by the horizon line. Imaginary lines receding into space meet on the horizon line at what are known as "vanishing points." Any figures drawn along these lines will be in proper perspective. Study the diagrams below to help you.

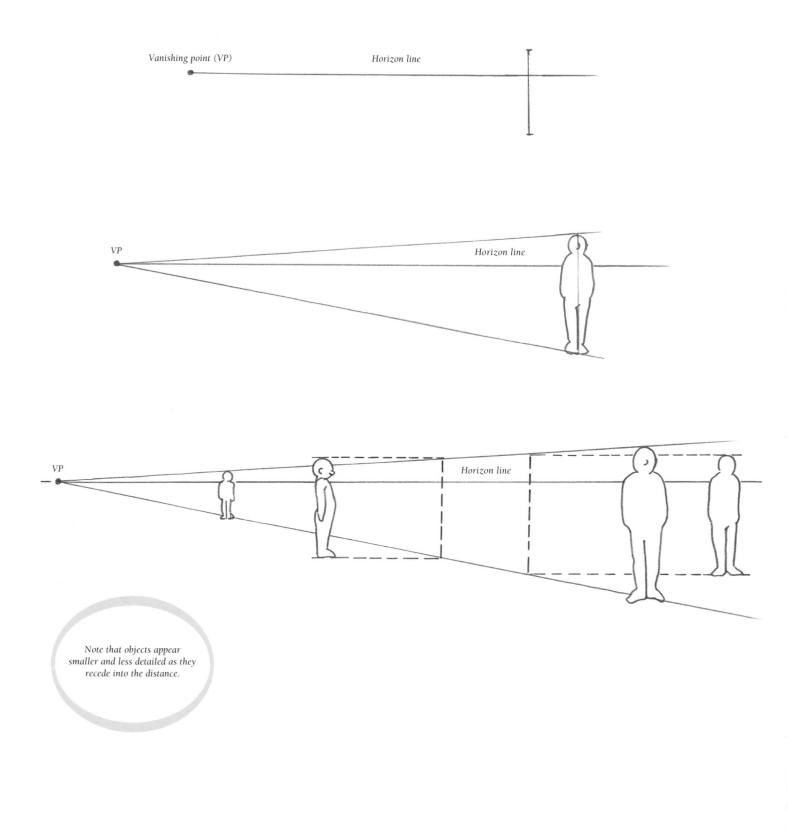

Vanishing point (VP) Horizon line

VP Horizon line

VP Horizon line

Note that objects appear smaller and less detailed as they recede into the distance.

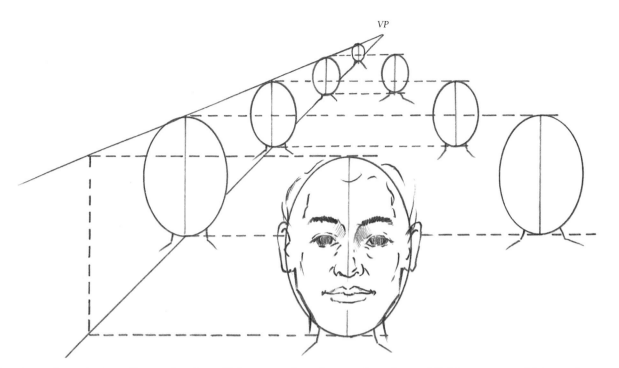

Try drawing a frontal view of many heads as if they were in a theater. Start by establishing your vanishing point at eye level. Draw one large head representing the person closest to you, and use it as a reference for determining the sizes of the other figures in the drawing. The technique illustrated above can be applied when drawing entire figures, shown in the diagram below. Although all of these examples include just one vanishing point, a composition can even have two or three vanishing points.

If you're a beginner, you may want to begin with basic one-point perspective, shown on this page. As you progress, attempt to incorporate two- or three-point perspective.

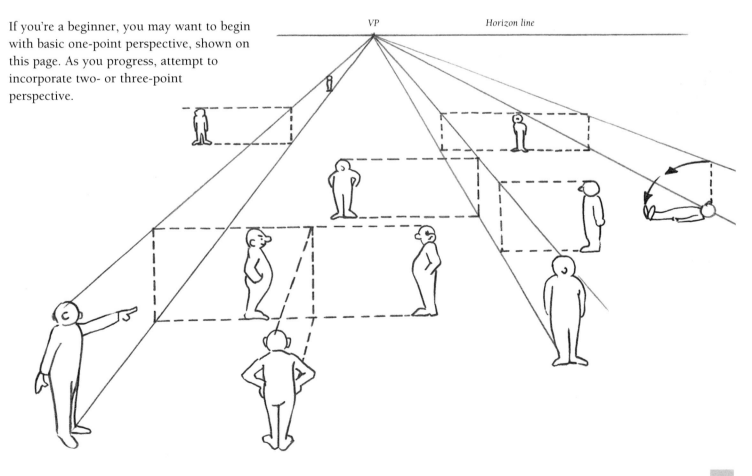

PLACING PEOPLE IN A COMPOSITION

The positioning and size of a person on the *picture plane* (the physical area covered by the drawing) is of utmost importance to the *composition,* or the arrangements of elements on your paper. The open or "negative" space around the portrait subject generally should be larger than the area occupied by the subject, providing a sort of personal space surrounding them. Whether you are drawing only the face, a head-and-shoulders portrait, or a complete figure, thoughtful positioning will establish a pleasing composition with proper balance. Practice drawing thumbnail sketches of people to study the importance of size and positioning.

BASICS OF PORTRAITURE

Correct placement on the picture plane is key to a good portrait, and the eyes of the subject are the key to placement. The eyes catch the viewer's attention first, so they should not be placed on either the horizontal or vertical centerline of the picture plane; preferably, the eyes should be placed above the centerline. Avoid drawing too near the sides, top, or bottom of the picture plane, as this gives an uneasy feeling of imbalance.

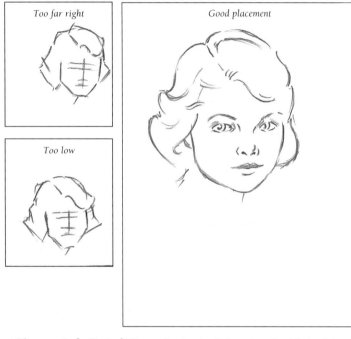

Too far right

Good placement

Too low

▲ Placement of a Portrait The smaller thumbnails here show the girl's head placed too far to the side and too low in the picture plane, suggesting that she might "slide off" the page. The larger sketch shows the face at a comfortable and balanced horizontal and vertical position, which allows room to add an additional element of interest to enhance the composition.

ADDING ELEMENTS TO PORTRAITS

Many portraits are drawn without backgrounds to avoid distracting the viewer from the subject. If you do add background elements to portraits, be sure to control the size, shape, and arrangement of elements surrounding the figure. Additions should express the personality or interests of the subject.

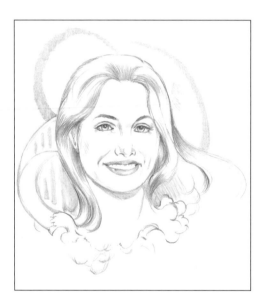

◄ Repetition of Shapes within the Portrait The delicate features of this young woman are emphasized by the simple, abstract elements in the background. The flowing curves fill much of the negative space while accenting the elegance of the woman's hair and features. Simplicity of form is important in this composition; the portrait highlights only her head and neck. Notice that her eyes meet the eyes of the viewer—a dramatic and compelling feature.

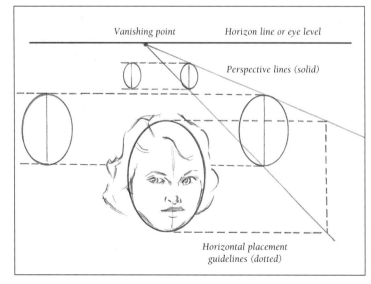

Vanishing point *Horizon line or eye level*

Perspective lines (solid)

Horizontal placement guidelines (dotted)

Multiple Subjects If you are drawing several, similarly sized subjects, use the rules of perspective to determine relative size (see pages 16–17) . Draw a vanishing point on a horizon line and a pair of perspective lines. Receding guidelines extended from the perspective lines will indicate the top of the head and chin of faces throughout the composition. The heads become smaller as they get farther from the viewer.

► Depicting the Subject's Interest This portrait of a young man includes a background that shows his interest in rocketry. The straight lines in the background contrast the rounded shapes of the human form. Although the background detail is complex, it visually recedes and serves to balance the man's weight. The focus remains on the man, but we've generated visual interest by adding elements to the composition.

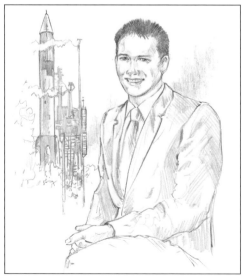

Intentionally drawing your subject larger than the image area, as in the example below, can create a unique composition. Even if part of the image is cut off, this kind of close-up creates a dramatic mood.

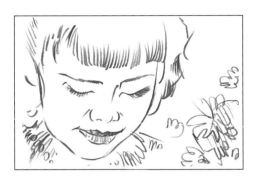

You can create a flow or connection between multiple subjects in a composition by creatively using circles and ellipses, as shown below.

Curved lines are good composition elements—they can evoke harmony and balance in your work. Try drawing some curved lines around the paper. The empty areas guide you in placing figures around your drawing.

Sharp angles can produce dramatic compositions. Draw a few straight lines in various angles, and make them intersect at certain points. Zigzagging lines also form sharp corners that give the composition an energetic feeling.

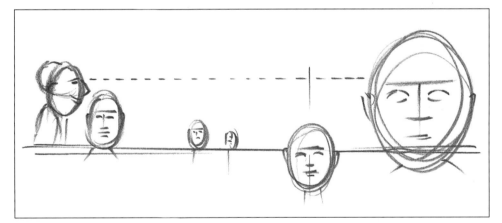

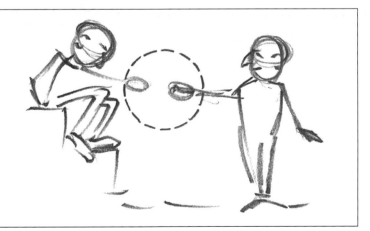

Guiding the Eye The compositions above and to the left illustrate how arm position, eyesight direction, and line intersection can guide the eye to a particular point of interest. Using these examples, try to design some of your own original compositions.

ADDING COMPLETE FIGURES

Creating a composition that shows a complete person can be challenging. A standing figure is much taller than it is wide, so the figure should be positioned so that its action relates naturally to the eye level of the viewer and the horizon line. To place more than one figure on the picture plane, use perspective as we did with the portrait heads. Remember that people appear smaller and less distinct when they are more distant. For comfortable placement of people in a composition, they should be on the same eye level as the viewer with the horizon line about waist high.

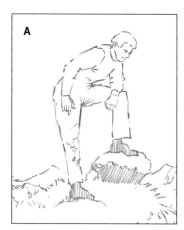

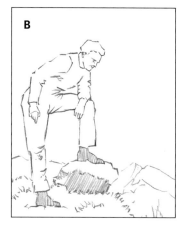

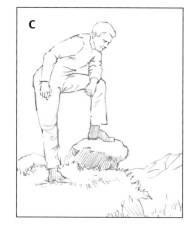

Full Figure Placement In thumbnail A, the subject is too perfectly centered in the picture plane. In thumbnail B, the figure is placed too far to the left. Thumbnail C is an example of effective placement of a human figure in a composition.

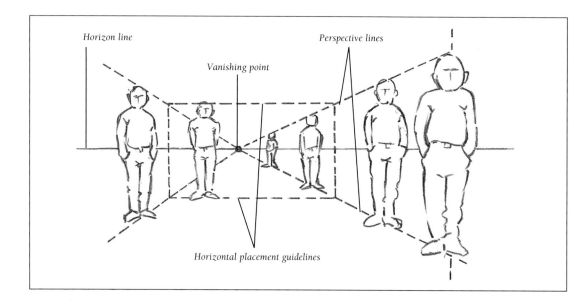

Horizon line *Perspective lines*

Vanishing point

Horizontal placement guidelines

Sizing Multiple Figures For realistic compositions, we need to keep figures in proportion. All the figures here are in proportion; we use perspective to determine the height of each figure. Start by drawing a horizon line and placing a vanishing point on it. Then draw your main character (on the right here) to which all others will be proportional. Add light perspective lines from the top and bottom of the figure to the vanishing point to determine the height of other figures. If we want figures on the other side of the vanishing point, we draw horizontal placement guidelines from the perspective lines to determine his height, and then add perspective lines on that side.

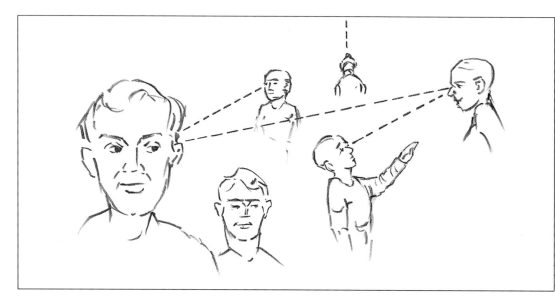

Line of Sight Figures in a composition like this one can relate to one another or to objects within the scene through line of sight (shown here as dotted lines). You can show line of sight with the eyes, but also by using head position and even a pointing hand. These indications can guide the viewer to a particular point of interest in the composition. Though the man on the left is facing forward, his eyes are looking to our right. The viewer's eye follows the line of sight of those within the drawing and is guided around the picture plane as the people interact. The man at the top is looking straight up.

PLACEMENT OF SINGLE AND GROUPED FIGURES

Artists often use the external shape and mass of figures to assist in placing elements within a composition—individual figures form various geometric shapes based on their pose, and several figures in close proximity form one mass. Establish a concept of what you want to show in your composition, and make thumbnail studies before attempting the final drawing. The following exercise is based on using the shape and mass of single and grouped figures to create the drawing at the bottom of the page.

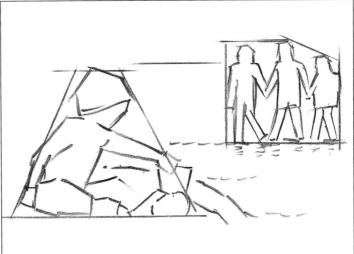

Step One Begin by considering the overall setting—foreground, middle ground, and background—for a subject like these children at the beach. You can use elements from different photos and place them in one setting. Block in the basic shapes of your subjects; the boy in the foreground is a clipped triangular shape, and the group of children forms a rough rectangle. Determine balanced placement of the two masses of people.

Step Two Next, sketch in outlines of the figures. The little boy with the shovel and pail occupies an area close to the viewer. The three children occupy a slightly smaller mass in the middle ground at the water's edge. Even though there are three children in this area, they balance the little boy through size and placement at the opposite corner. The wave and water line unite the composition and lead the eye between the two masses.

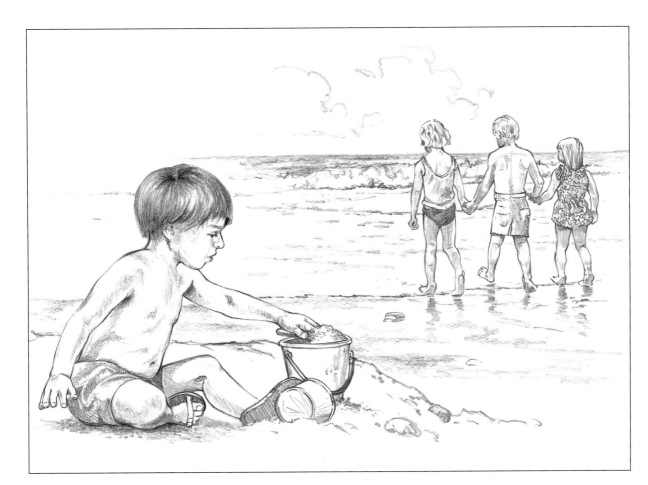

Step Three Place your figures so that they fit comfortably on the picture plane. Add detail and shading to elements that are important in the composition. Use an element in the foreground to help direct the viewer's eye to other areas, such as the outstretched arm of the boy. Placing the small rock between the middle- and foreground creates a visual stepping stone to the three children at right.

BEGINNING PORTRAITURE

A good starting point for drawing people is the head and face. The shapes are fairly simple, and the proportions are easy to measure. And portraiture also is very rewarding. You'll feel a great sense of satisfaction when you look at a portrait you've drawn and see a true likeness of your subject, especially when the model is someone near and dear to you. So why not start with children?

DRAWING A CHILD'S PORTRAIT

Once you've practiced drawing features, you're ready for a full portrait. You'll probably want to draw from a photo, though, as children rarely sit still for very long! Study the features carefully, and try to draw what you truly see, and not what you think an eye or a nose should look like. But don't be discouraged if you don't get a perfect likeness right off the bat. Just keep practicing!

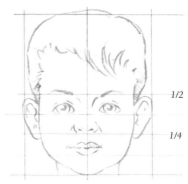

◄ Child Proportions Draw guidelines to divide the head in half horizontally; then divide the lower half into fourths. Use the guidelines to place the eyes, nose, ears, and mouth, as shown.

▶ Starting with a Good Photo When working from photographs, you may prefer candid, relaxed poses over formal, "shoulders square" portraits. Also try to get a close-up shot of the face so you can really study the features. This photograph of 2-1/2-year-old Gage fits the bill perfectly!

▲ Separating the Features Before you attempt a full portrait, try drawing the features separately to get a feel for the shapes and forms. Look at faces in books and magazines, and draw as many different features as you can.

COMMON PROPORTION FLAWS

Quite a few things are wrong with these drawings of Gage's head. Compare them with the photo at left, and see if you can spot the errors before reading the captions.

Thin Neck Gage has a slender neck, but not this slender. Refer to the photo to see where his neck appears to touch his face and ear.

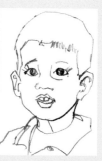

Not Enough Forehead Children have proportionately larger foreheads than adults do. By drawing the forehead too small, you will add years to Gage's age.

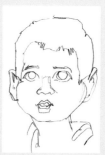

Cheeks Too Round Children do have round faces, but don't make them look like chipmunks. And be sure to make the ears round, not pointed.

Sticks for Eyelashes Eyelashes should not stick straight out like spokes on a wheel. And draw the teeth as one shape; don't try to draw each tooth separately.

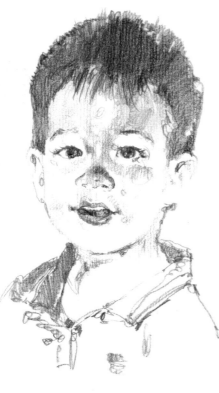

▲ Sketching the Guidelines First pencil an oval for the shape of the head, and lightly draw a vertical centerline. Then add horizontal guidelines according to the chart at the top of the page, and sketch in the general outlines of the features. When you're happy with the overall sketch, carefully erase the guidelines.

◄ Finishing the Portrait With the side of your pencil, start laying in the middle values of the shadow areas, increasing the pressure slightly around the eye, nose, and collar. For the darkest shadows and Gage's straight, black hair, use the side of a 2B and overlap your strokes, adding a few fine hairs along the forehead with the sharp-pointed tip of your pencil.

DRAWING THE ADULT HEAD

An adult's head has slightly different proportions than a child's head, but the drawing process is the same: Sketch in guidelines to place the features, and start with a sketch of basic shapes. And don't forget the profile view. Adults with interesting features are a lot of fun to draw from the side, where you can really see the shape of the brow, the outline of the nose, and the form of the lips.

◄ Portraying the Profile The artist liked this fellow's pronounced features, so he drew the subject in profile. He used the point and the side of an HB for this pose.

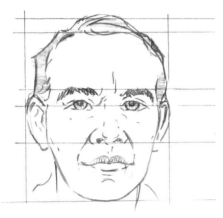

◄ Adult Proportions Look for the proportions that make your adult subject unique; notice the distance from the top of the head to the eyes, from the eyes to the nose, and from the nose to the chin. Look at where the mouth falls between the nose and the chin and where the ears align with the eyes and the nose.

If you can't find a photo of an expression you want to draw, try looking in a mirror and drawing your own expressions. That way you can "custom make" them!

EXPRESSING EMOTION

It's great fun to draw a wide range of different facial expressions and emotions, especially ones that are extreme. Because these are just studies and not formal portraits, draw loosely to add energy and a look of spontaneity, as if a camera had captured the face at just that moment. You usually don't need to bother with a background—you don't want anything to detract from the expression—but you may want to draw the neck and shoulders so the head doesn't appear to be floating in space.

◄ Shocked When you want to show an extreme expression, focus on the lines around the eyes and mouth. Exposing the whole, round shape of the iris conveys a sense of shock, just as the exposed eyelid and open mouth do.

► Happy Young children have smooth complexions, so make their smile lines fairly subtle. Use light shading with the side of your pencil to create creases around the mouth, and make the eyes slightly narrower to show how smiles pull up the cheek muscles.

► Surprised Leave a lot of the face white to keep most of the attention on the eyes and mouth. Use the tip of the pencil for the loose expression lines and the side for the mass of dark hair.

23

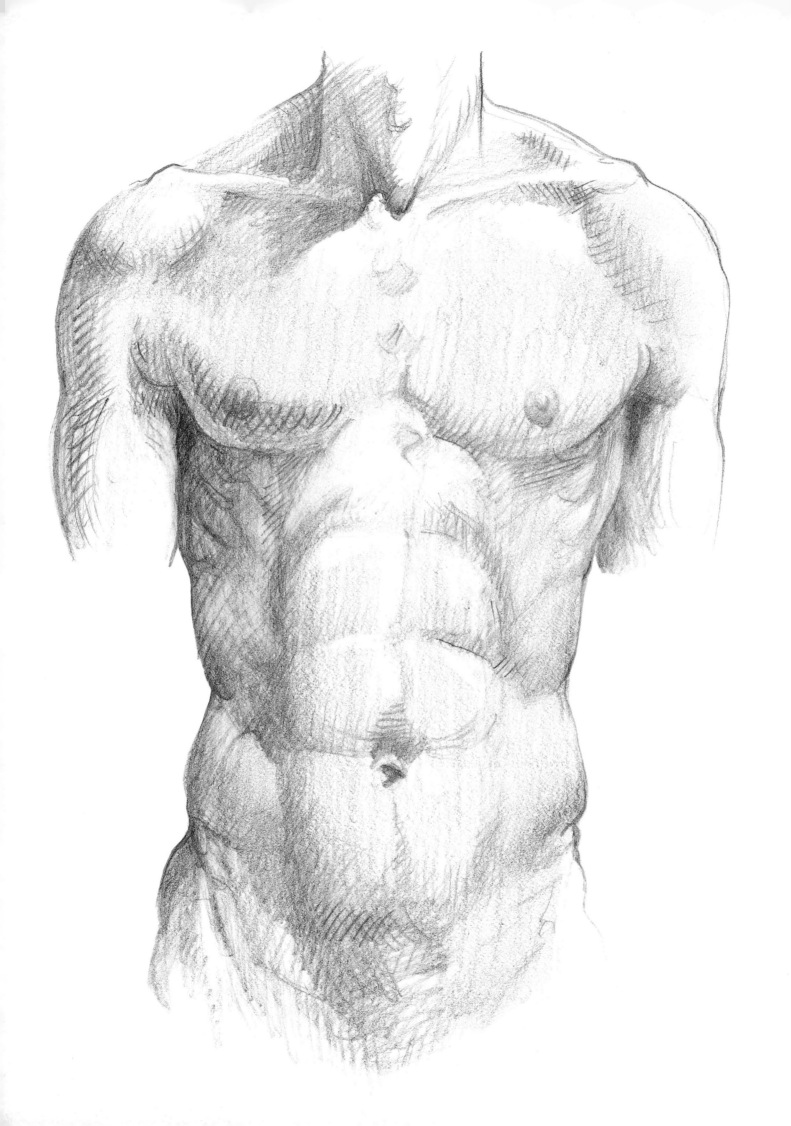

ANATOMY
WITH KEN GOLDMAN

Ken Goldman is a popular instructor at the Athenaeum School of the Arts in La Jolla, California, where he teaches portraiture, artistic anatomy, and landscape painting classes. Ken also is the author of six Walter Foster books, including *Pastel 1*; *Pastel: Landscapes*; *Acrylic 1*; and *Basic Anatomy and Figure Drawing* in the How to Draw and Paint series; as well as *Charcoal Drawing* in the Artist's Library series and *Understanding Values* in the Drawing Made Easy series. Ken received his training in New York at the Art Students League of New York, National Academy, and New York Studio School. A recipient of numerous awards, Ken has exhibited widely in group shows and in more than 30 one-man shows in the United States, Mexico, and Europe. His artwork is featured in the permanent collections of several major museums. Ken lives in San Diego, California, with his artist-wife Stephanie Goldman.

EXPLORING THE TORSO: FRONT VIEW

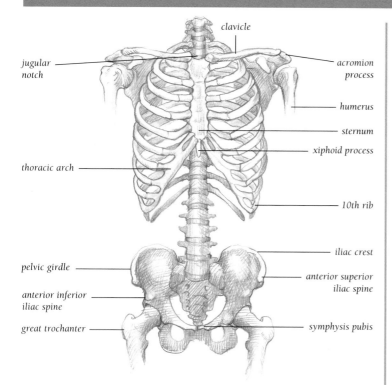

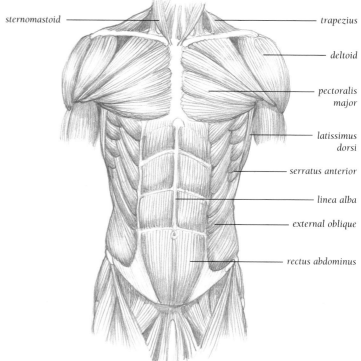

Skeleton Some parts of the skeletal system are important to the artist because they are prominent and so serve as visual landmarks. Several bones of the torso's frontal skeleton are obvious even beneath the skin, including the *clavicles, acromion processes, sternum, thoracic arch, 10th rib, anterior superior iliac spines,* and *great trochanters.* The spinal column comprises 24 vertebrae, divided into 3 sections: The *cervical* (or neck) region has 7 vertebrae, the *thoracic* (or chest) region has 12, and the *lumbar* (or lower back) region has 5.

Trunk Muscles The torso's movement is dependent on and restricted by the spine—both the chest and the pelvis twist and turn on this fixed, yet flexible, column. And the relationship between the rib cage, the shoulders, and the pelvis creates the shape of the trunk muscles. The *pectoral* (breast) muscles are divided by the *sternum*, the *rectus abdominus* is divided by the *linea alba,* and the *external obliques*—which are interwoven with the *serratus anterior*—bind the eight lowest ribs to the *pelvic girdle.*

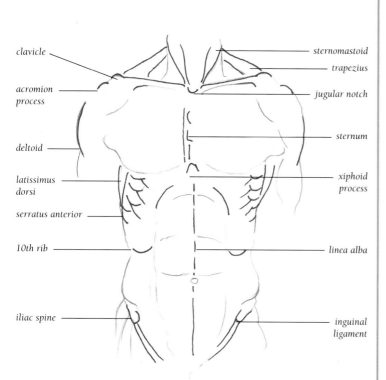

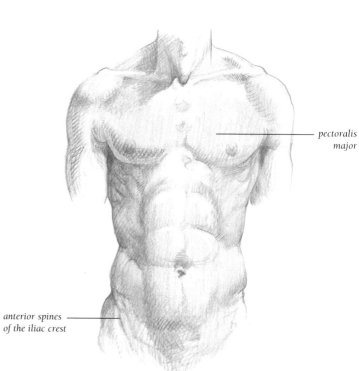

Diagram of Landmarks The observable muscles and bony landmarks labeled on the illustration above are the most important for artists who want to draw the torso's surface anatomy from the front view. Focus on accurately portraying these anatomical features to achieve a lifelike drawing, such as the example at right.

Drawing Tips Use the bony skeletal landmarks, which are apparent despite the layers of muscles, to guide the placement of the features. For example, the nipples align vertically with the *anterior spines* of the *iliac crest*. Note also that the *pectoralis major* sweeps across the chest and over to the arm, ending nearly horizontal to the nipples.

EXPLORING THE TORSO: BACK VIEW

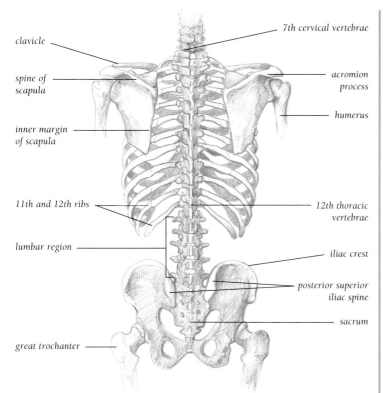

clavicle

spine of scapula

inner margin of scapula

11th and 12th ribs

lumbar region

great trochanter

7th cervical vertebrae

acromion process

humerus

12th thoracic vertebrae

iliac crest

posterior superior iliac spine

sacrum

Skeleton The back is one of the most challenging parts of the body to draw because of its skeletal and muscular complexity. From the artist's point of view, the most important bones visible from the rear skeletal view are the *7th cervical vertebrae,* the *posterior superior iliac spines* (dimples on the pelvic girdle), and the *sacrum,* which together form the *sacral triangle*—a major anatomical landmark at the base of the spine.

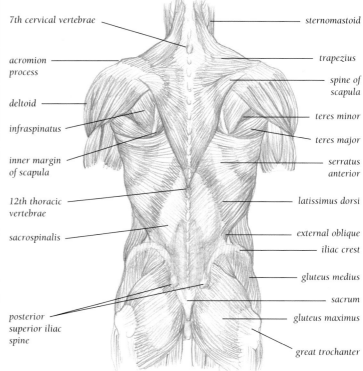

7th cervical vertebrae

acromion process

deltoid

infraspinatus

inner margin of scapula

12th thoracic vertebrae

sacrospinalis

posterior superior iliac spine

sternomastoid

trapezius

spine of scapula

teres minor

teres major

serratus anterior

latissimus dorsi

external oblique

iliac crest

gluteus medius

sacrum

gluteus maximus

great trochanter

Trunk Muscles The back has many overlapping muscles; our focus will be on the upper layer, which is more immediately apparent to the eye. The *trapezius* connects the skull to the *scapula* (shoulder blade) muscles—*deltoid, infraspinatus, teres minor,* and *teres major*—which connect to the arm. The *latissimus dorsi* attaches under the arm, extending to the pelvis. And the *gluteus medius* bulges at the hip before meeting with the *gluteus maximus.*

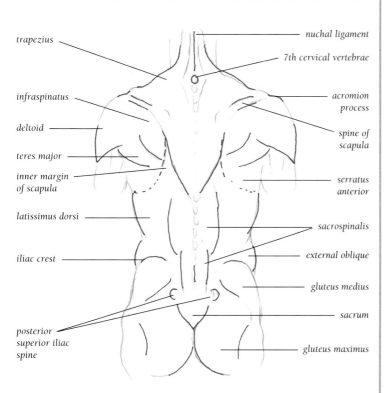

trapezius

infraspinatus

deltoid

teres major

inner margin of scapula

latissimus dorsi

iliac crest

posterior superior iliac spine

nuchal ligament

7th cervical vertebrae

acromion process

spine of scapula

serratus anterior

sacrospinalis

external oblique

gluteus medius

sacrum

gluteus maximus

Diagram of Landmarks The observable muscles and bony landmarks labeled on the illustration above are the most important for artists who want to draw the torso's surface anatomy from the rear view. Focus on accurately rendering these anatomical markers to achieve a lifelike drawing, such as the example at right.

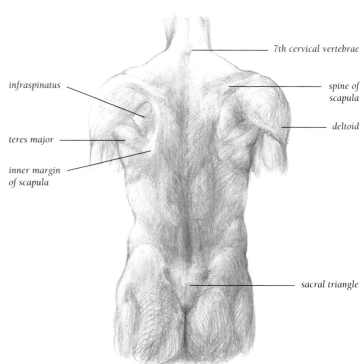

infraspinatus

teres major

inner margin of scapula

7th cervical vertebrae

spine of scapula

deltoid

sacral triangle

Drawing Tips Under the skin, back muscles are not easy to discern. However, the *trapezius, 7th cervical vertebrae, spine of scapula, inner margin of scapula, deltoid, infraspinatus,* and *teres major* are all fairly evident. To depict the *nuchal ligament, 7th cervical vertebrae, spinal column,* and *sacral triangle,* draw a long line and an upside-down triangle.

EXPLORING THE TORSO: SIDE VIEW

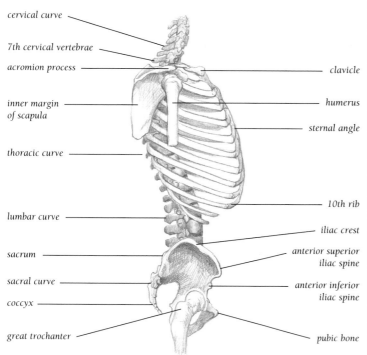

cervical curve
7th cervical vertebrae
acromion process
inner margin of scapula
thoracic curve
lumbar curve
sacrum
sacral curve
coccyx
great trochanter

clavicle
humerus
sternal angle
10th rib
iliac crest
anterior superior iliac spine
anterior inferior iliac spine
pubic bone

Skeleton The visual landmarks of the skeleton in profile are the *7th cervical vertebrae, acromion process, inner margin of scapula,* and backbone. The backbone's four curves—*cervical* (forward), *thoracic* (backward), *lumbar* (forward), and *sacral* (backward)—arrange the head, chest, and pelvic girdle over the legs for balance.

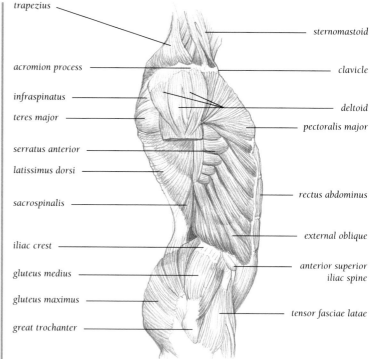

trapezius
acromion process
infraspinatus
teres major
serratus anterior
latissimus dorsi
sacrospinalis
iliac crest
gluteus medius
gluteus maximus
great trochanter

sternomastoid
clavicle
deltoid
pectoralis major
rectus abdominus
external oblique
anterior superior iliac spine
tensor fasciae latae

Trunk Muscles The upper torso muscles—as well as the *scapula,* which is anchored by muscle to the spine, ribs, and arms—follow and influence all arm movement. Mid-torso muscles, such as *external oblique, rectus abdominus,* and *latissimus dorsi,* bend, twist, and stabilize the rib cage and pelvis. Muscles below the *pelvic girdle* activate the legs.

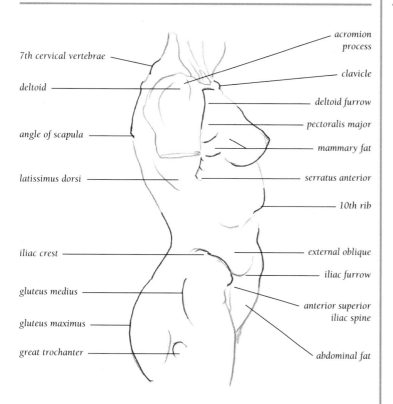

7th cervical vertebrae
deltoid
angle of scapula
latissimus dorsi
iliac crest
gluteus medius
gluteus maximus
great trochanter

acromion process
clavicle
deltoid furrow
pectoralis major
mammary fat
serratus anterior
10th rib
external oblique
iliac furrow
anterior superior iliac spine
abdominal fat

Diagram of Landmarks It is lack of fat in addition to degree of muscularity that determines surface definition. To render the female form, it's important to become familiar with fat deposit areas, including the flank *(iliac crest)*; buttocks *(gluteus)*; and stomach *(abdomin)*, especially below the navel. Mammary fat accounts for the smoothness of the breast.

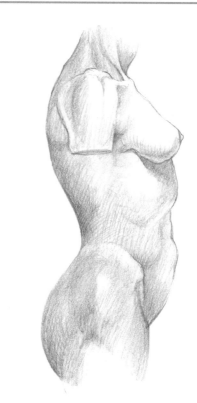

Drawing Tips Female figures display a more fluid contour than do male figures, largely because of the female's extra fatty layer, which serves a reproductive purpose but also obscures muscular form. Muscular structure is basically the same for both sexes, but the width and angle of the pelvis makes the skeleton more recognizably male or female.

EXPLORING THE TORSO: TIPS

FRONT VIEW

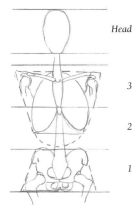

Head

3

2

1

Proportion The *pelvic girdle* is about 1 head high, and the torso—from *trochanters* to *7th cervical vertebrae*—is about 3 heads high.

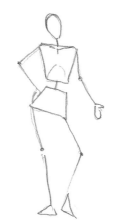

Simplified Figurette Sketching with simple lines and basic shapes is a good way to establish the base of a figure drawing.

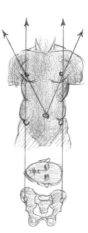

Tips The nipples, 1 head-width apart, are vertically aligned with pelvic landmarks and diagonally aligned with the *acromion processes*.

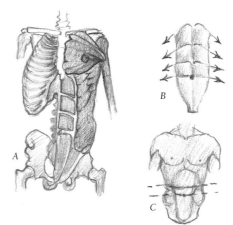

Detail Note the relationship between the skeletal and muscular structures (A). The *linea alba* (interrupting tendons) of the *rectus abdominis* create a "six pack" appearance as they arch progressively higher toward the *sternum* (B). Two of the interrupting tendons line up with the *10th rib* and the navel (C).

BACK VIEW

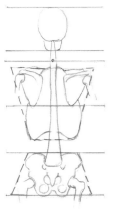

3

2

1

Trapezoids represent the overall bone structure of the torso from both front and rear views. Here you can see the same three-part division.

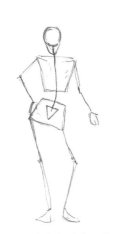

This simplified sketch from the back view includes an important feature: a line from the *7th cervical vertebrae* to the *sacral triangle*.

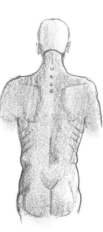

On an erect figure, the bones of both the lower ribs and the upper spine are apparent, whereas the *lumbar* region looks like a furrow.

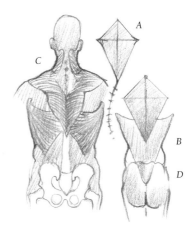

The shape of the *trapezius* is similar to that of a kite (A) or a four-pointed star (C). The simplified shape of the *latissimus dorsi* suggests the appearance of an upside-down triangle (B), with a diamond-shaped sheath removed from its upside-down apex (D).

SIDE VIEW

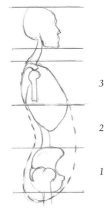

3

2

1

The simplified torso from the side view has a bean-shaped appearance, but the same proportional divisions of the torso apply.

The simplified figurette in profile makes use of the bean and oval shapes that appear in the proportional drawing at left.

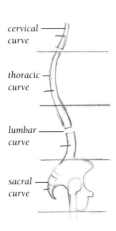

cervical curve

thoracic curve

lumbar curve

sacral curve

Each spinal segment curves more as the column descends toward the *sacrum*. The *thoracic* region has the longest curve.

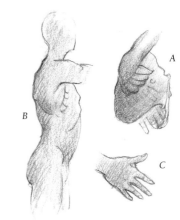

The *serratus anterior* muscle starts alongside the first eight ribs, then ends at the inner margin of the *scapula* (A). Its main mass appears as a bulge underneath the *latissimus dorsi* (B). At the muscle's origin (on the ribs), it looks a little like the fingers of a hand (C).

DEPICTING THE ARM: FRONT VIEW

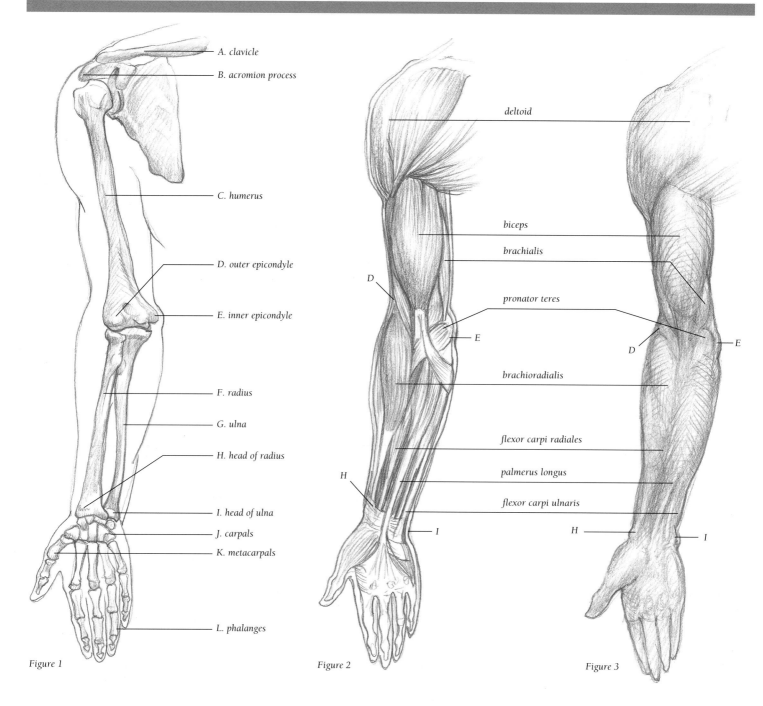

A. clavicle
B. acromion process
C. humerus
D. outer epicondyle
E. inner epicondyle
F. radius
G. ulna
H. head of radius
I. head of ulna
J. carpals
K. metacarpals
L. phalanges

Figure 1

deltoid
biceps
brachialis
pronator teres
brachioradialis
flexor carpi radiales
palmerus longus
flexor carpi ulnaris

Figure 2

Figure 3

Bones The underlying skeletal structure determines much of the overall shape of the arm (figure 1). Several elements of this substructure, such as the *inner epicondyle* (E), act as visual landmarks that are identifiable even under layers of muscle (figure 2) and skin (figure 3).

Muscles The upper and lower portions of the arm each consist of three major muscle masses. The *bicep* and *brachialis* of the upper arm bend the lower arm, the *tricep* (see page 31) straightens it, and the *deltoid* raises the entire arm. In the lower arm, the *flexors (flexor carpi radiales, palmerus longus,* and *flexor carpi ulnaris)* bend the palm and clench the fingers; the *extensors* on the back of the arm (see page 31) straighten the palm and open the fingers; and the *supinators (brachioradialis,* see page 31), attached to the *outer epicondyle* (D, figure 1) on the outside arm, rotate the hand outward. A fourth, smaller muscle, the *pronator teres,* rotates the palm inward.

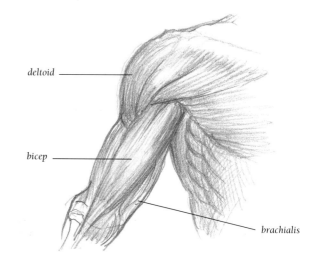

deltoid
bicep
brachialis

Drawing Tips The *bicep* does not extend across the full width of the upper arm. The *deltoid* inserts in between the *brachialis* and the *bicep.*

DEPICTING THE ARM: BACK VIEW

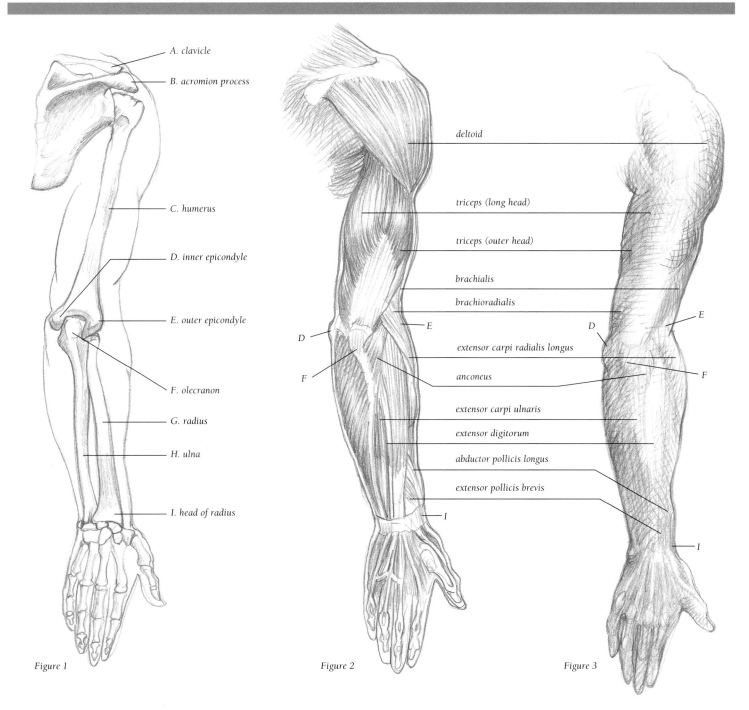

A. clavicle

B. acromion process

C. humerus

D. inner epicondyle

E. outer epicondyle

F. olecranon

G. radius

H. ulna

I. head of radius

Figure 1

deltoid

triceps (long head)

triceps (outer head)

brachialis

brachioradialis

extensor carpi radialis longus

anconeus

extensor carpi ulnaris

extensor digitorum

abductor pollicis longus

extensor pollicis brevis

D

E

F

I

Figure 2

D

E

F

I

Figure 3

Bones Much of the overall shape of the arm in the back view is determined by the underlying skeletal structure, just as with the front view. The *inner* and *outer epicondyle* (D) and (E), are again identifiable, even under layers of muscle. And from this view, the *olecranon,* or elbow (F), also is evident.

Muscles Muscles work in opposing pairs: *Flexors* (see page 30, figures 2 and 3) pull and *extensors* extend, moving in the opposite direction. When a *flexor* or *extensor* muscle becomes active, its opposite becomes passive. From the back view, when the hand is pronate (illustrated in figures 2 and 3 above), *extensor* groups are the most prominent muscles. On the upper arm, the *tricep* is the most visible *extensor*. On the lower arm, *extensor carpi radialis longus, extensor carpi ulnaris,* and *extensor digitorum,* which all originate on the *outer epicondyle,* are evident.

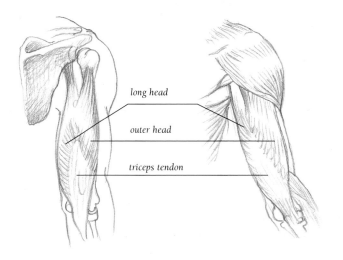

long head

outer head

triceps tendon

Drawing Tips The *tricep* has three heads (the long and outer heads are shown here; the medial head lies beneath). All share a common tendon: a flattened form on the back of the upper arm.

DEPICTING THE ARM: SIDE VIEW

CLENCHED FIST

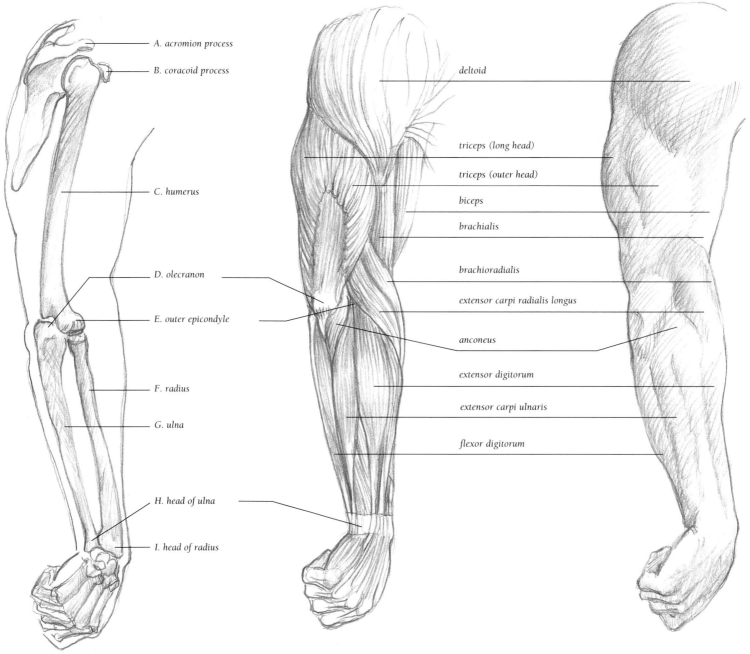

A. acromion process

B. coracoid process

C. humerus

D. olecranon

E. outer epicondyle

F. radius

G. ulna

H. head of ulna

I. head of radius

deltoid

triceps (long head)

triceps (outer head)

biceps

brachialis

brachioradialis

extensor carpi radialis longus

anconeus

extensor digitorum

extensor carpi ulnaris

flexor digitorum

Bones Here the arm is not viewed in full profile; rather it is seen from an angle that is a combination of a side view and a back view. Because of the angle, the bony landmarks most apparent under the muscle are the *olecranon, outer epicondyle*, and *head of ulna.*

Muscles The side view provides a good angle for observing the *extensors* and *flexors* of the upper and lower arm. The *brachioradialis,* located where the upper and lower arms meet, is particularly important. It originates on the lateral side of the *humerus* (C), above the *outer epicondyle* (E), and then attaches to the lateral side of the wrist above the *head of radius* (I).

DRAWING TIPS

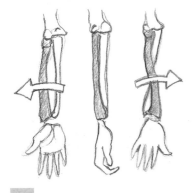

Rotated arm

The *brachioradialis* is responsible for turning the palm up *(supinate),* and the *pronator teres* (see page 30) for turning the palm down *(pronate).* The *radius* (shaded) rotates around the fixed *ulna,* permitting pronation and supination of the palm.

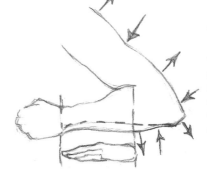

Bent arm

The span between the inside bend of the elbow and the wrist is usually about one hand length. The arrows show the inward and outward curvature of the muscles, and the dashed line shows the line of the *ulna,* called the "ulnar furrow."

PORTRAYING THE HAND

OPEN PALM

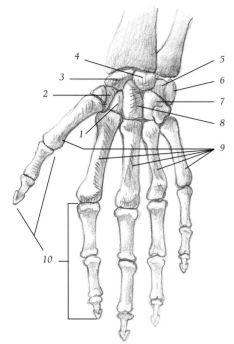

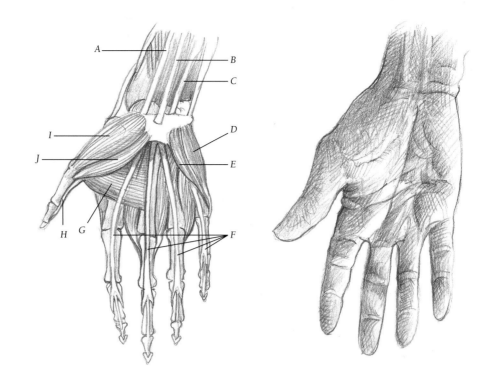

Bones The hand contains 8 wrist *(carpal)* bones: *minor multangular* (1), *major multangular* (2), *navicular* (3), *lunate* (4), *triquetrum* (5), *pisiform* (6), *hamate* (7), and *capitate* (8). The hand also features 5 *metacarpals* (9) and 14 *phalanges* (10).

Muscles The *flexor tendons* (A, B, C) from the forearm muscles (see page 30) extend into the hand. The teardrop-shaped muscle masses, the *thenar eminence abductors* of the thumb (I, J) and the *hypothenar eminence abductor* (D) and *flexor* (E) of the little finger, are known as the "palmer hand muscles." The *adductor* of the thumb (G) lies under the *flexor tendons* (F). The visible creases of the palm result from the way the skin folds over the fat and muscles of the hand.

BACK

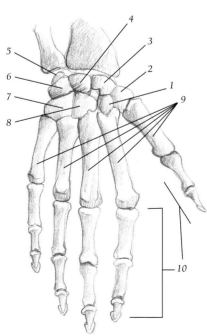

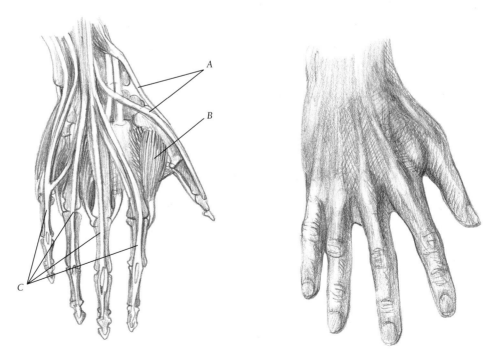

Bones From this view of the hand, all the same bones are visible, but the carpal bones appear convex rather than concave. From this angle, the bones have more influence on the shape of the fleshed-out hand.

Muscles Whereas the palm side of the hand is muscular and fatty, the back of the hand is bony and full of tendons. The *extensor tendons* of the thumb (A) are visible when contracted, as are the other four *extensor tendons* (C). The first *dorsal interosseous* (B) is the largest of the four *dorsal interosseous* muscles, and it is the only one that shows its form through the skin's surface; when the thumb is flexed, this muscle appears as a bulging teardrop shape.

SKETCHING THE LEG: FRONT VIEW

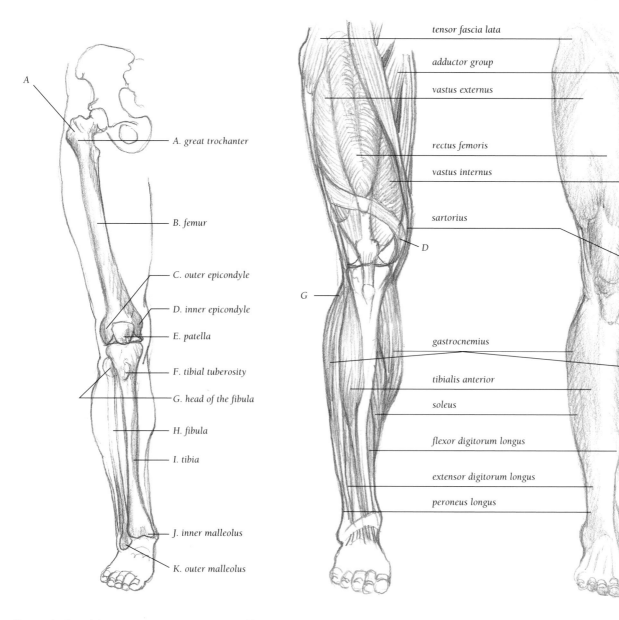

A. great trochanter

B. femur

C. outer epicondyle

D. inner epicondyle

E. patella

F. tibial tuberosity

G. head of the fibula

H. fibula

I. tibia

J. inner malleolus

K. outer malleolus

tensor fascia lata

adductor group

vastus externus

rectus femoris

vastus internus

sartorius

gastrocnemius

tibialis anterior

soleus

flexor digitorum longus

extensor digitorum longus

peroneus longus

Bones The *femur* (B), with its *great trochanter* at the top (A) and *outer epicondyles* (C) and *inner epicondyles* (D) at the base, is the heaviest and longest bone of the skeletal system. The knee cap *(patella)* sits in between the *outer epicondyles* and *inner epicondyles* on the patellar surface. The lower leg consists of the thick *tibia* (I) and the slender *fibula* (H). The *tibial tuberosity* (F) and *head of the fibula* (G) are important landmarks at the top, as are the ankle bones (the *inner malleolus* and *outer malleolus)*.

Muscles The upper leg has four major muscle masses: *vastus externus,* which attaches to the knee cap (E); *rectus femoris,* which engulfs the *patella* (E) and continues toward the *tibial tuberosity* (F); *vastus internus,* a medial bulge; and the *adductor group* on the inside of the leg. There also are two other masses: the *tensor fascia lata* and the *sartorius.* The *sartorius* is the longest muscle in the body. The lower leg has six long muscles visible: *gastrocnemius,* protruding on both sides; *tibialis anterior,* running along the shin toward the big toe; *soleus; flexor digitorum longus; extensor digitorum longus;* and *peroneus longus.*

Drawing Tips The legs angle in toward the middle, positioning the body's weight over the gravitational center. (See figures 1 and 2.) The muscle masses on the outside of the leg are higher than those on the inside. (See figure 3.) The ankles are just the reverse — high inside, low outside.

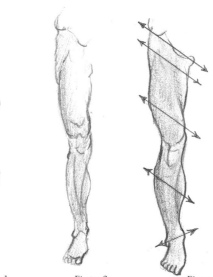

Figure 1 Figure 2 Figure 3

SKETCHING THE LEG: BACK VIEW

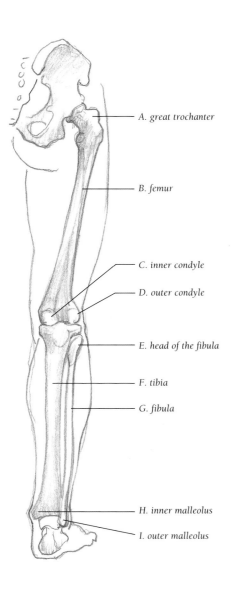

A. great trochanter

B. femur

C. inner condyle

D. outer condyle

E. head of the fibula

F. tibia

G. fibula

H. inner malleolus

I. outer malleolus

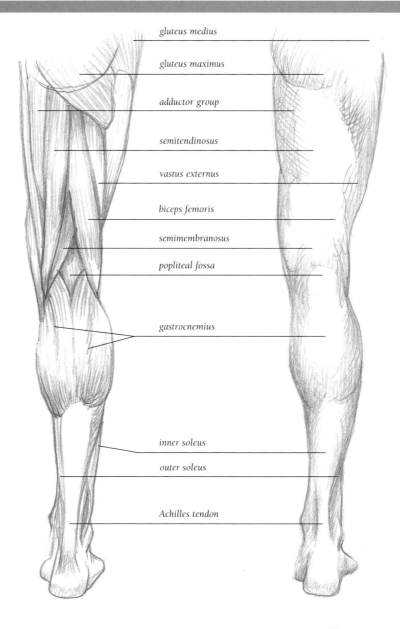

gluteus medius

gluteus maximus

adductor group

semitendinosus

vastus externus

biceps femoris

semimembranosus

popliteal fossa

gastrocnemius

inner soleus

outer soleus

Achilles tendon

Bones From the back view, the same leg bones that appear in the front view are visible. Their appearance is slightly altered, however, because the bone attachments in the front are designed to allow muscles to extend, and the back attachment is designed for muscles to flex.

Muscles The upper leg consists of five large muscle masses: *gluteus maximus*; *gluteus medius*; the hamstring group (*biceps femoris, semitendinosus,* and *semimembranosus*); the *adductor group*; and the *vastus externus,* which can be seen peeking out from behind the *biceps femoris*.

The lower leg also features five masses: three larger ones and two smaller. The larger masses are the two heads of the calf: the *gastrocnemius* and the *Achilles tendon,* which connects to the heel bone. The two smaller masses are the *inner soleus* and *outer soleus.* Also notice the hollow area behind the knee where the calf tendons attach, called the "popliteal fossa"; this fatty hollow makes deep knee bends possible.

Drawing Tips The calf is lower and rounder on the inside than it is on the outside. (See figure 1.)

The hamstring tendons grip below the knee on both sides, almost like a pair of tongs. (See figure 2.)

Figure 1

Figure 2

SKETCHING THE LEG: SIDE VIEW

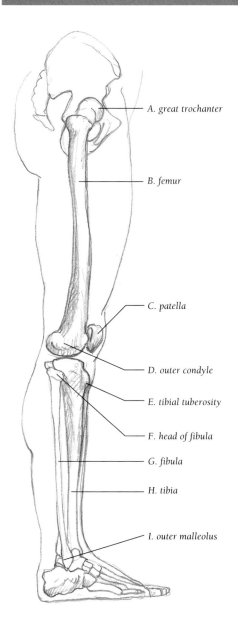

A. great trochanter

B. femur

C. patella

D. outer condyle

E. tibial tuberosity

F. head of fibula

G. fibula

H. tibia

I. outer malleolus

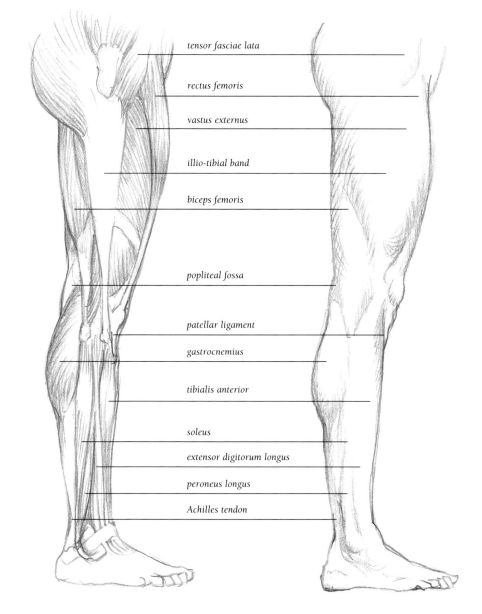

tensor fasciae lata

rectus femoris

vastus externus

illio-tibial band

biceps femoris

popliteal fossa

patellar ligament

gastrocnemius

tibialis anterior

soleus

extensor digitorum longus

peroneus longus

Achilles tendon

Bones and Muscles Because the long femur (B), and large tibia (H) carry the weight of the body, they sit directly on top of each other. But in a side-view drawing, the upper and lower leg appear staggered; the front of the shin lines up directly below the *illio-tibial band* muscles and behind the upper-leg masses of the *rectus femoris* and *vastus externus*.

In the lower leg, the forms to look for are the *gastrocnemius;* the long, straight form of the *Achilles tendon;* the *peroneus longus tendon*, which passes behind the *outer malleolus* (I) and the bulk of the *extensor digitorum longus;* and the *tibialis anterior*, toward the front of the leg.

Figure 1 *Figure 2*

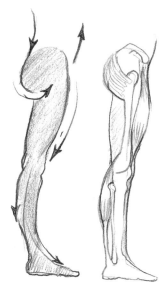

Drawing Tips The six arrows in figure 1 show the overall gesture of the leg. The upper thigh and lower calf create the gesture. (See figure 2.) Figure 3 shows the pattern of tendons in the foot. (See page 19.)

Figure 3

DRAWING THE FOOT

TOP

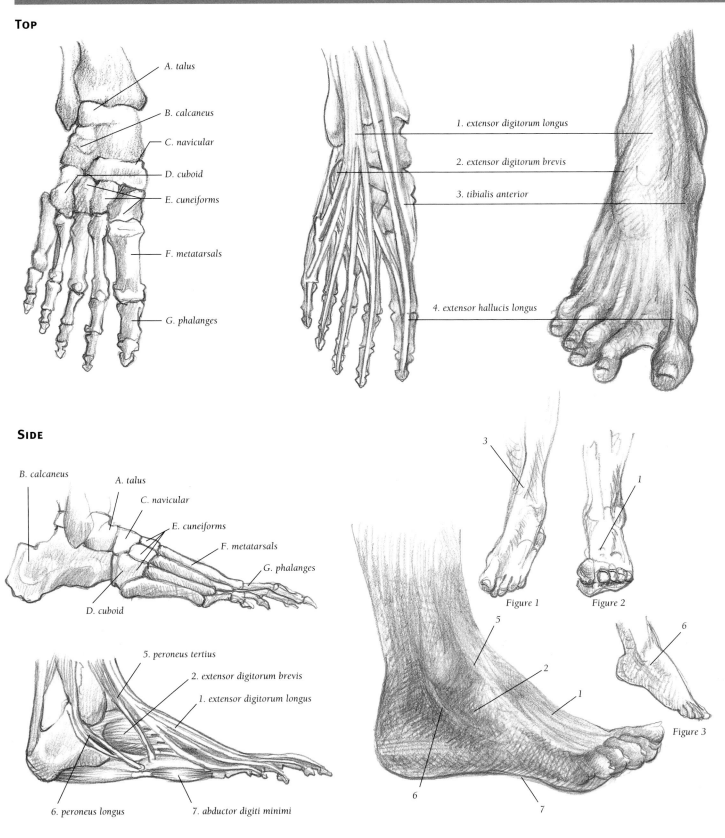

A. talus
B. calcaneus
C. navicular
D. cuboid
E. cuneiforms
F. metatarsals
G. phalanges

1. extensor digitorum longus
2. extensor digitorum brevis
3. tibialis anterior
4. extensor hallucis longus

SIDE

B. calcaneus
A. talus
C. navicular
E. cuneiforms
F. metatarsals
G. phalanges
D. cuboid

5. peroneus tertius
2. extensor digitorum brevis
1. extensor digitorum longus
6. peroneus longus
7. abductor digiti minimi

3

1

Figure 1

Figure 2

5

2

1

6

6

7

Figure 3

Bones Like the hand, the foot also comprises three parts: seven *tarsal* bones (A–E), five *metatarsals* (F), and fourteen *phalanges* (G). The *tarsal* bones include the ankle, heel, and instep. The *metatarsals* are longer and stronger than the five *metacarpals* of the hand, and they end at the ball of the foot. The *phalanges* of the toes are shorter than those of the fingers and thumb; the four small toes press and grip the ground surface, and the big toe tends to have a slight upward thrust.

Muscles When the foot is flexed upward, these tendons are evident: *extensor digitorum longus* (1), *extensor digitorum brevis* (2), *tibialis anterior* (3), and *extensor hallucis longus* (4). (From the side view, *extensor digitorum brevis* appears as a round shape inside a triangular pocket.) *Peroneus longus* (6) curves around the ankle, whereas *abductor digiti minimi* (7) appears as a bulge on the outer side of the foot.

Drawing Tips The *tibialis anterior* (3) is an obvious landmark on the inverted foot. (See figure 1, above.) In figure 2, *dorsi-flexion* makes visible the *extensor digitorum* (1). In figure 3, *plantar-flexion* lets you see the *tendons of peroneus* (6).

STUDYING THE HEAD & SKULL

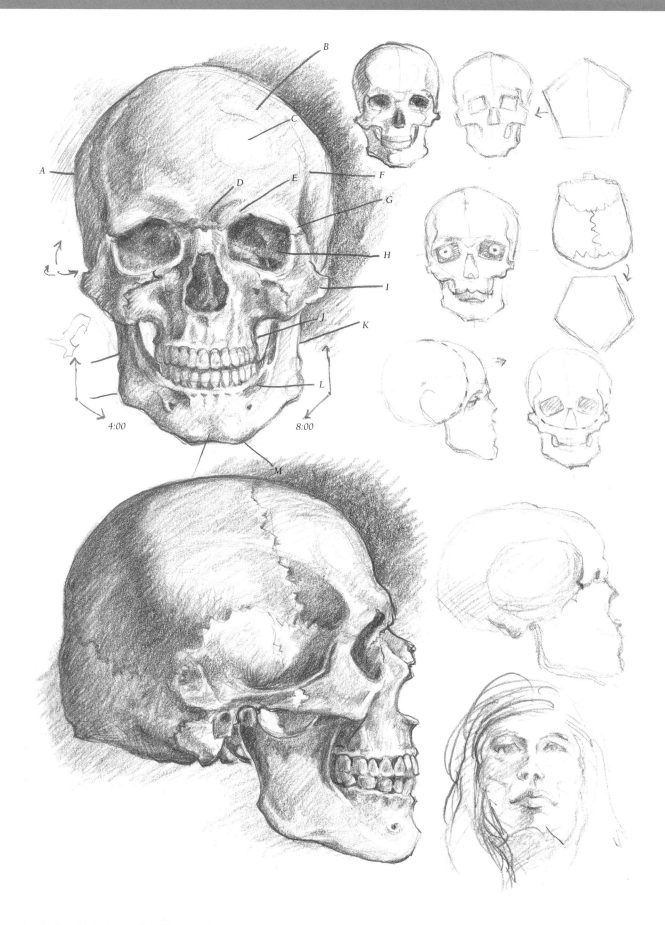

Becoming familiar with the head and skull is an excellent way to improve your portraiture skills. If you purchase a plastic skull, you can practice drawing the skull from all angles, as shown in the charcoal pencil studies above. Start with an outline of the basic shape of the skull; then block in the shapes of the main features and refine the lines (shown in the upper-right corner). The important skull bones for an artist to know are the *parietal eminence* (A), *frontal bone* (B), *frontal eminence* (C), *glabella* (D), *superciliary crest* or "brow ridge" (E), *temporal line* (F), *zygomatic process* (G), *orbit* (H), *zygomatic bone* (I), *maxilla* (J), *ramus of mandible* (K), *mandible* (L), and *mental protuberance* (M).

FRONT VIEW

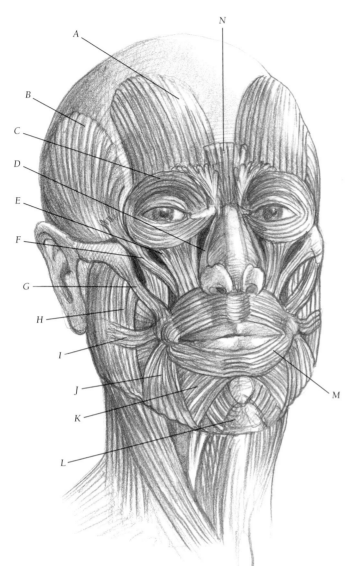

Most of the facial muscles originate from bone and insert into muscle fibers of other facial muscles. They do not create surface form directly, as the skeletal muscles do, because they are much more delicate and usually concealed by facial fat. The visible forms on the face are created by several factors— skin, fatty tissue, underlying skull, cartilage, eyeballs, and some muscles.

SIDE VIEW

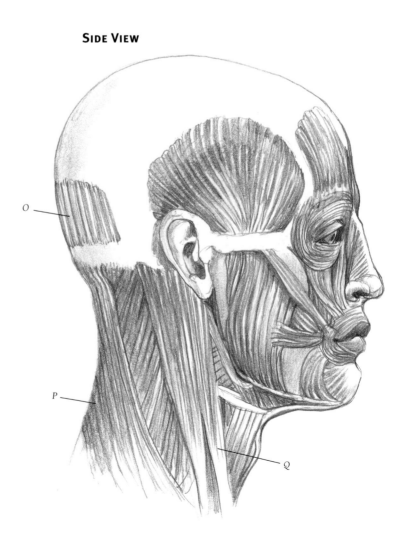

A. frontalis
B. temporalis
C. obicularis oculi
D. nasalis
E. levator labii superioris
F. zygomaticus minor
G. zygomaticus major
H. masseter
I. risorius
J. depressor anguli oris
K. depressor labii inferioris
L. mentalis
M. obicularis oris
N. procerus
O. occipitalis
P. trapezius
Q. sternocleidomastoid

FRONT VIEW

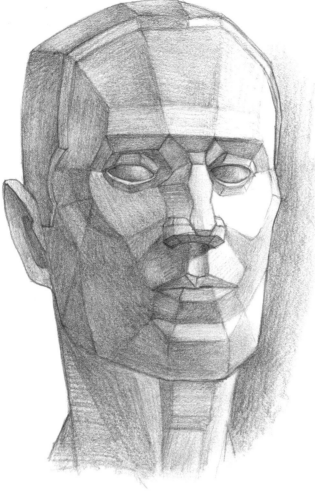

Simplifying the Features When facial muscles contract, they affect the shape of the fatty forms, skin, and other facial muscles, causing the wrinkles, furrows, ridges, and bulges that convey various facial expressions. Simplifying these complex shapes into easily recognizable geometric planes (the "planes of the head") can help guide an artist in the proper placement of light and shadow. As an artist, there's no need to actually sketch the planes, but it helps to understand the planes and visualize them when approaching complex features and shading.

Visualizing Light and Shadow In this final stage, light and shadow are translated from simple planes onto a more subtle, realistic portrait. Self-portraiture is a great way to practice identifying the planes of the head from many different angles. Using a mirror as reference, focus on the placement of the light and dark values that create the form of your face. Just remember to draw what you really see in the mirror, not what you expect to see.

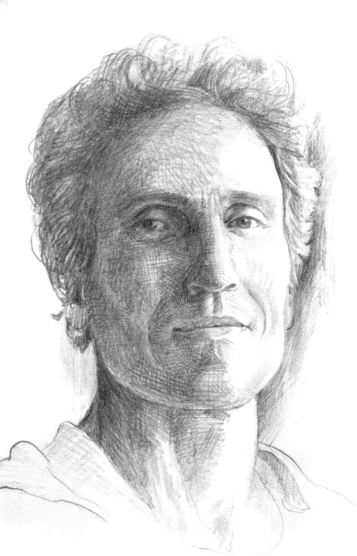

Capturing Facial Features

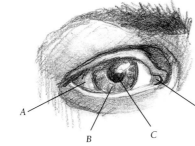

Drawing Tips The *sclera* (A) is the white of the eye. The *iris* (B) is a colored disc that controls the amount of light entering the round opening of the *pupil* (C). The domelike, transparent *cornea* (E) sits over the *iris*. The *inner canthus* (D) at the corner of the eye is an important feature of the shape of the eye.

The Eye The eyeball is a moist sphere. Because its surface is glossy, the *cornea* (E) often features a highlight.

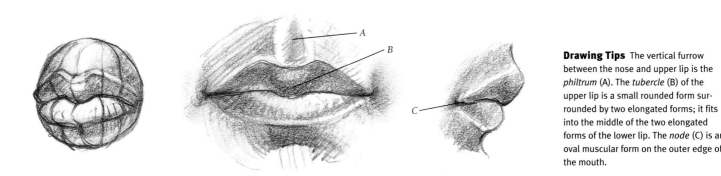

Drawing Tips The vertical furrow between the nose and upper lip is the *philtrum* (A). The *tubercle* (B) of the upper lip is a small rounded form surrounded by two elongated forms; it fits into the middle of the two elongated forms of the lower lip. The *node* (C) is an oval muscular form on the outer edge of the mouth.

The Lips Because the lips curve around the cylinder of the teeth, it's helpful to draw and shade the mouth as if it were a sphere.

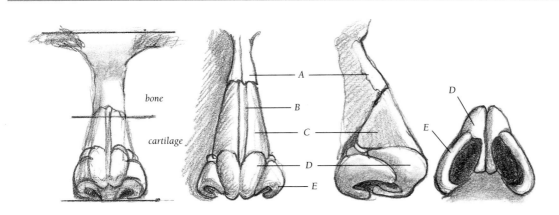

Drawing Tips The bridge of the nose is formed by two *nasal bones* (A). The middle section of the nose is made of a rigid *septal cartilage* (B), surrounded by two *lateral cartilages* (C). The bulb of the nose is formed by two *greater alar cartilages* (D). Two *wings* (E) create the nostrils.

The Nose The nose is made up of bone, cartilage, and fatty tissue. Halfway down from the eyebrows, cartilage replaces the bone.

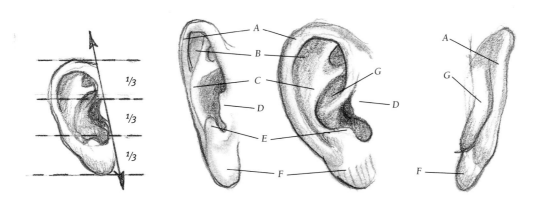

Drawing Tips The cartilaginous *helix* (A) forms the outer rim of the ear. The *antihelix* (C) lies just inside the *helix*, running roughly parallel to it; the two are divided by the *scapha* (B). The *tragus* (D) is a cartilaginous projection, located over the bowl (the *concha*, G). The *antitragus* (E) is located opposite the *tragus* and just above the fatty *lobe* (F).

The Ear Think of the ear as an oval disc divided into three sections and placed on a diagonal angle.

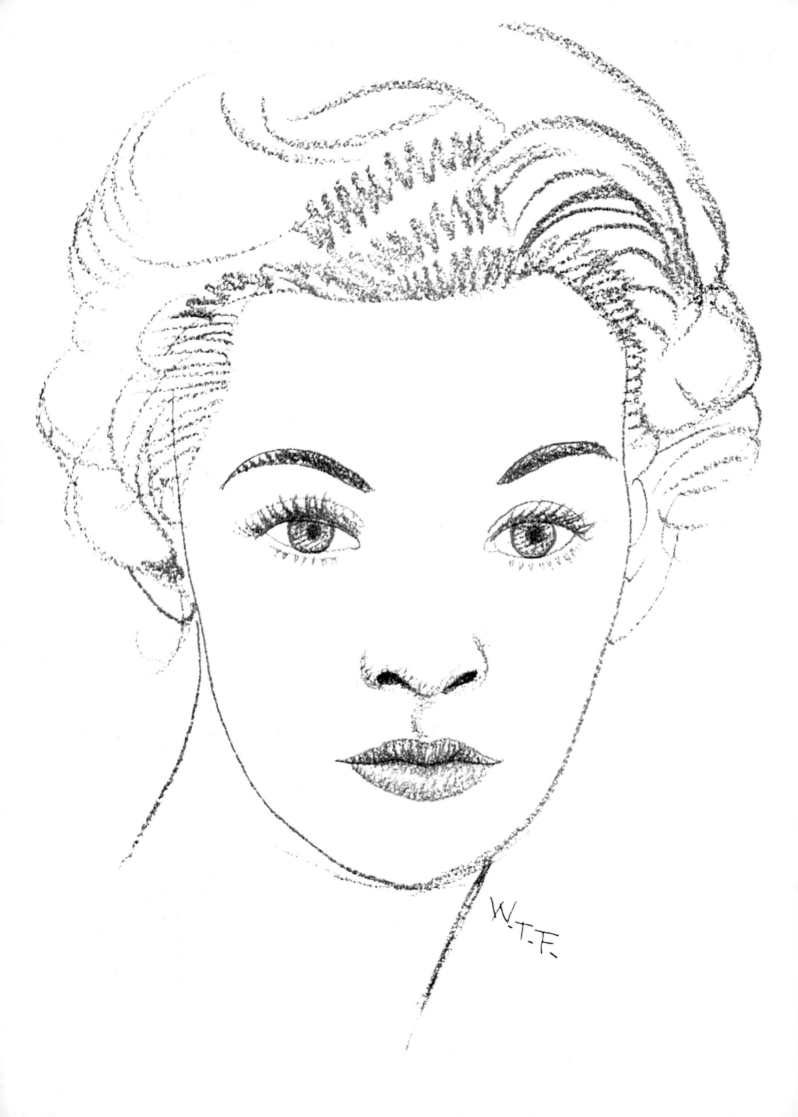

FACES
WITH WALTER T. FOSTER

Walter T. Foster was born in Woodland Park, Colorado, in 1891. In his younger years, he worked as a sign painter and a hog medicine salesman. He also performed in a singing and drawing vaudeville act. Mr. Foster invented the first postage-stamp vending machine and drew political caricatures for several large newspapers. In the 1920s, while running his own advertising agency and instructing young artists, Mr. Foster began writing self-help art instruction books. The books were first produced in his home in Laguna Beach, California, where he wrote, illustrated, and printed them himself. In the 1960s, as the product line grew, he moved the operation to a commercial facility, which allowed him to expand the company and achieve worldwide distribution. Mr. Foster passed away in 1981, but he is fondly remembered for his warmth, dedication, and unique instruction books.

PEOPLE

Many people believe that drawing the human face is difficult, but it's really only a matter of proportion and properly placing the features. The lines and forms involved are just simple curves and basic shapes. The easiest way to learn to draw people is to start with individual features such as the eyes and mouth. It's best to draw from a photo or a live model. A reference makes rendering the head much easier!

EYE

A

B

In this view, the iris is set somewhat off center, so place your guidelines just to the right of center.

C

Highlight

Whether from a frontal view or in profile, eyes and lips are drawn around horizontal and vertical guidelines. Both guidelines are perpendicular in the frontal view, and the vertical line is slanted slightly in the profile view. Then you can build on these guidelines with circles and simple curved lines. Study the outlines on this page, and practice drawing them several times.

The dotted line indicates the shape of the eyeball beneath the eyelid. The curve of the eyelid follows the curve of the eyeball.

EYE IN PROFILE

A

Notice that a good portion of the eyeball is covered by the eyelid, no matter what the viewpoint.

B

C

D

MOUTH IN PROFILE

A

B

C

D

Most of the upper lip falls to the left of the vertical guideline, whereas most of the lower lip falls to the right.

MOUTH

A

B

C

These human profiles are built on two slanted guidelines: one for the line of the plane of the face, and one for the line of the nose. There is a variety of sizes and shapes of noses, eyes, and mouths; study your subject closely and make several practice sketches of his or her features. Then combine the features into a simple profile.

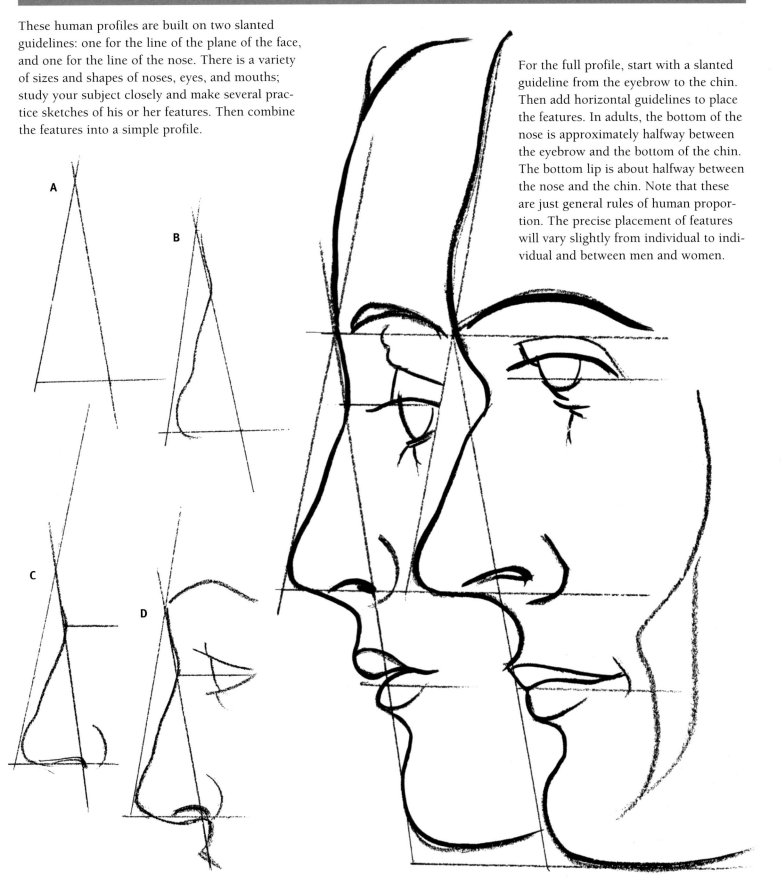

For the full profile, start with a slanted guideline from the eyebrow to the chin. Then add horizontal guidelines to place the features. In adults, the bottom of the nose is approximately halfway between the eyebrow and the bottom of the chin. The bottom lip is about halfway between the nose and the chin. Note that these are just general rules of human proportion. The precise placement of features will vary slightly from individual to individual and between men and women.

To draw the nose, block in a triangle, and draw the basic outline of the nose within the triangle, as in steps A and B. Refine the outline, and add a small curve to suggest the nostril in step C.

Then add the centerline for the eye at the top of the bridge of the nose. Next place the eye, eyebrow, and upper lip. Once you are satisfied with your sketches, try a complete profile.

WOMEN: PROFILE

These heads were drawn from photos (photos serve as good models because they hold still). Try profile views like the ones you see here, keeping them fairly simple. Don't worry about rendering the hair for now; spend time learning how to draw the face, and work on the hair later.

Step A illustrates the proportions of the face. In this close-up profile, the bottom of the nose is about halfway between the eyebrows and chin. The mouth is about halfway between the bottom of the nose and the chin. Once the proportions are established, sketch the actual features. Study each one closely to achieve an accurate resemblance. This drawing was done on plate-finish Bristol board, which usually is used for pen and ink drawings.

A

Eyebrow

Eye

1/2

Nose

1/4

1/2

Mouth

1/4

Chin

B

When drawing portraits, make sure you're comfortably seated and that the drawing board is at a good angle. Rotate the drawing often to prevent your hands from smudging areas you've already drawn.

C

D

Tortillon

A tortillon is helpful for blending the contours of the face.

All figure and portrait renderings have been drawn directly from the artist's imagination or from paid professional models. Any likeness to persons other than those hired for this purpose is purely coincidental.

Draw the guidelines in step A to lay out the correct proportions. Lay down each line in the numbered order shown. In step B, sketch the nose, eyebrow, chin, and eyes on the guidelines; then refine them into more recognizable parts of the face. All of these elements must be resolved before shading.

B

A

Draw this line first.

Focus on the dark and light values of the lips in step C, as well as the direction of the strokes. The value contrasts make the lips appear soft and round, especially because the shading is lighter toward the middle of the lip. Note in the final rendering that the hair is merely implied as a surrounding element.

Keep the shading lighter toward the middle of the lips to create highlights and make them appear full.

The type of paper you use will affect your drawings. This portrait was done on vellum-finish paper, which has a slight tooth that works well with pencil or crayon.

WOMEN: THREE-QUARTER VIEW

Drawing a three-quarter view is slightly more difficult than the frontal view—but you can do it! Study your subject carefully, and follow the steps. Block in the basic shapes, and use guidelines to place the features. Note that because the face is angled, the features are all set off center, with the nose at the three-quarter point. Curve the line for the bridge of the nose all the way out to the edge of the face, so it partially blocks her left eye.

A

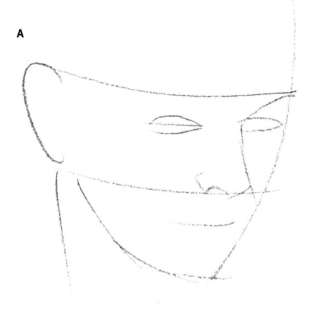

C

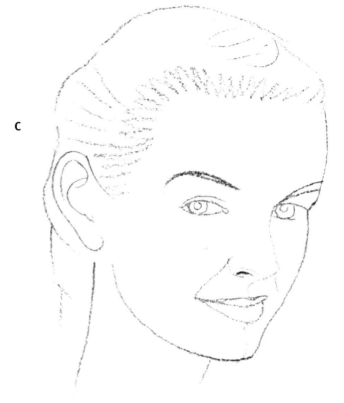

Check the proportions and the placement of the features. When you're happy with your sketch, refine the features, and add some light shading to finish off your drawing. Shade as much or as little as you like; sometimes simpler is better.

B

When you block in the hair, think of it as one mass that has a curved outline. You can suggest some of the individual hairs later.

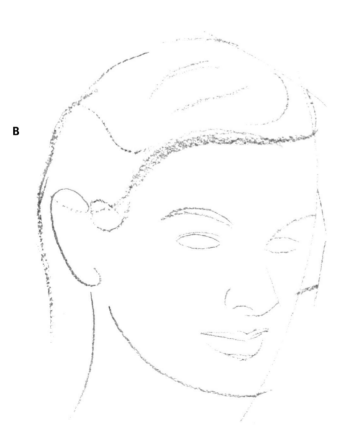

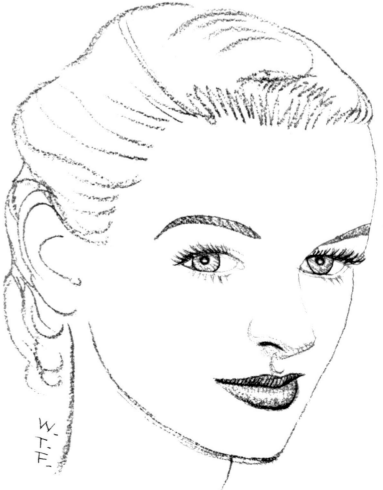

Browse through books and magazines for subjects to draw, or even look in the mirror and draw yourself. The more you practice and the more diverse your subjects, the better your drawings will become. Young or old, male or female, all portraits start with the same basic steps.

A

B

Use the curved, vertical guidelines to help maintain the roundness of the lips and chin.

WOMEN: FRONTAL VIEW

For these frontal-view drawings, you will need to pay special attention to the position of the features. In a profile, for example, you don't have to worry about aligning the eyes with each other. Study your subject closely, because a small detail such as the distance between the eyes may determine whether or not your drawing achieves a strong likeness to your model.

Step A shows minimal proportion guidelines. You will be able to start with fewer lines as you become more comfortable with your drawing and observation skills. Even the two lines shown are helpful for determining placement of the features.

A

B

A few loose, curving strokes with a chisel-tipped pencil can create the appearance of a full head of hair.

In step B, make the facial features more recognizable, and begin to suggest the hair. Notice that features rarely are symmetrical; for instance, one eye usually is slightly larger than the other. To finish the drawing, create depth by shading the eyes, nose, and lips. If you wish, practice developing form by shading along the planes of the face and around the eyes.

W.T.F.

Notice that the nose is barely suggested; the viewer's eye fills in the form.

The features of this subject's face differ from those in the previous drawing. Here the nose is much thinner, and the eyes are closer together. You will need to make these adjustments during the block-in stage.

In step A, use an HB pencil to block in the proportions. Use the guidelines to place and develop the features in step B. Notice the types of strokes used for the hair; they are loose and free. Quick renderings like this one are good for practice; do many of them!

B

A

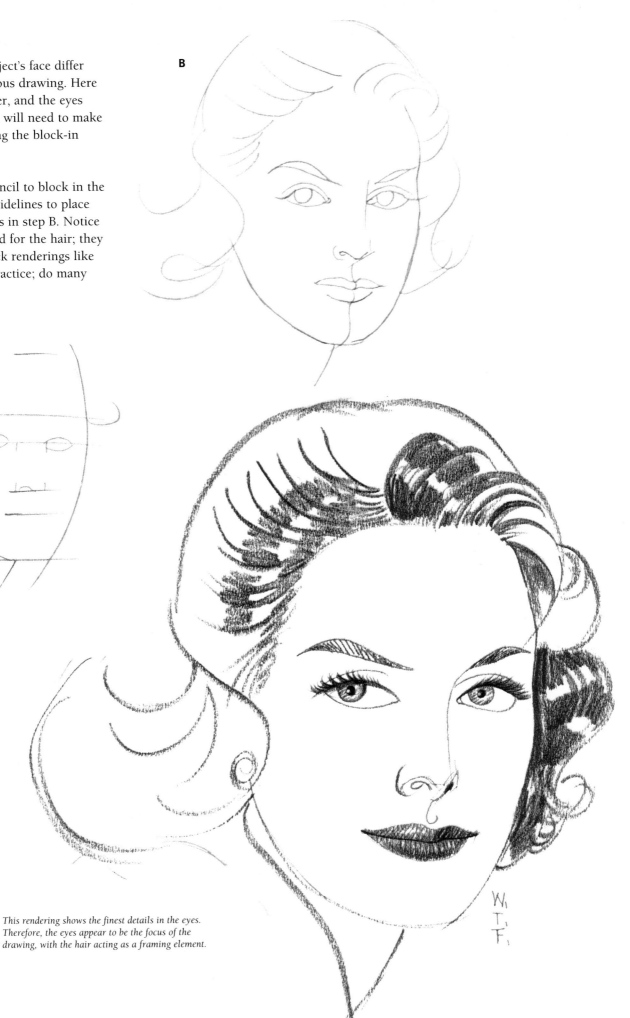

Remember that your preliminary drawing must be correct before continuing. No amount of shading will repair the drawing if the proportions are not accurate.

This rendering shows the finest details in the eyes. Therefore, the eyes appear to be the focus of the drawing, with the hair acting as a framing element.

MEN: THREE-QUARTER VIEW

The three-quarter view is more challenging than the profile and frontal views, but if you begin with the usual proportion guidelines, you shouldn't have any trouble. Simply take your time, and observe closely.

Follow the steps as shown, using charcoal for the block-in stage. When you begin shading, use dark, bold strokes for the eyebrows, mustache, and beard. Notice this subject's facial expression; his dark eyes are intense. Fill in the irises with the darkest values, but be sure to leave tiny white highlights.

A

Clothing can be used to identify a character; here the headdress emphasizes the model's Middle-eastern heritage.

B

The dark vertical strokes of the background are used to define the outline of the subject's face.

Use photos from books or magazines to draw people of all types and ethnicities in various styles of dress.

52

This drawing was done after an old master's painting. Copying a master's work is excellent practice; it helps to improve your artistic skills and understanding. When copying a great work, think about the reasons the original artist may have done certain things, and then use your insights to better your own works.

A

Follow the steps as illustrated, blocking in each of the features with quick, confident strokes. Look for the basic shapes in your subject; then refine them as necessary to achieve a likeness.

B

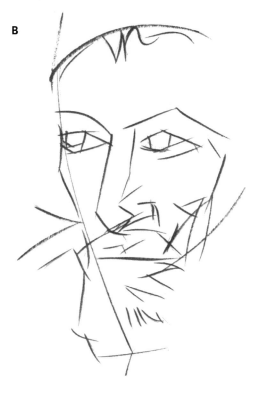

Use overlapping brush strokes to create the beard.

The tip of the brush is used to create fine lines.

Notice this character's piercing expression, which is enhanced by the thick, dark eyebrows.

Most of the shading and details for this drawing were done with a brush and India ink, although charcoal was used for the guidelines and initial sketching. Brush and ink is a good choice for creating the thick, dark facial hair.

Keep practicing if you want to become a modern-day master!

ELDERLY WOMEN

These more advanced renderings bring out the character of the subjects. The elderly woman on this page, for example, appears stern and serious, whereas the woman on the opposite page evokes a certain kindness and gentle spirit.

Using the usual proportion guidelines, block in the face. Remember to include the hat as part of the initial sketch, as shown in step A. Add shapes to indicate the wrinkles and loose skin in step B.

As people age, certain features will begin to sag and perhaps become less symmetrical. Notice that the shading strokes are rather harsh and bold. This technique creates the appearance of rough, weathered skin.

Be sure to include the pronounced creases around the mouth and under the eyes; these details give your subject character.

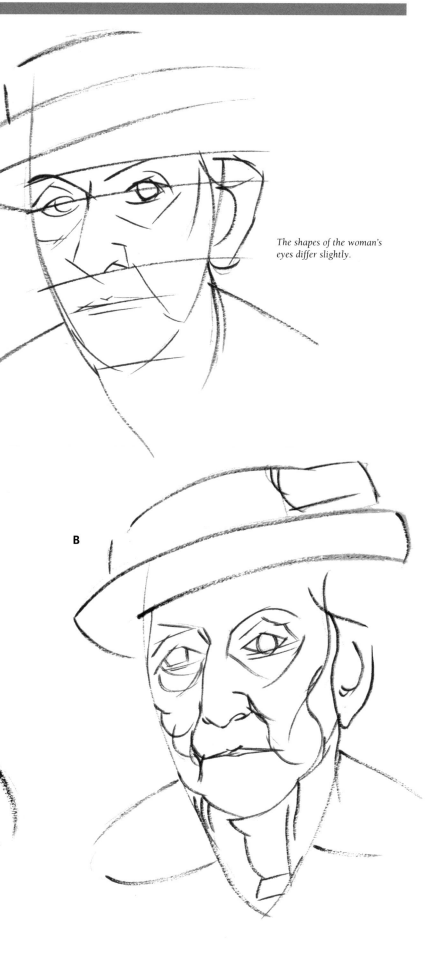

A

The shapes of the woman's eyes differ slightly.

B

The small, sparkling eyes and fragile hand of this woman create an entirely different mood from the previous subject. Here the facial expression is more delicate, giving a feeling of compassion and sympathy.

A

In step A, lay down the guidelines for the features, and lightly block in the ears, nose, and mouth. In steps B, C, and D, continue to develop the features, adding craggy lines for the wrinkles. In the final drawing, shade the face to create the aged appearance.

B

C

Hands can be difficult to draw. Study your own hands, and practice drawing them on scrap paper. Check the proportions to make sure your drawings are accurate. For example, the length of the hand is approximately equal to the length of the face. What other hand-proportion rules do you see?

Occasionally step back from your drawing to get a new perspective. Ask yourself if you've created the right mood and personality. If not, make adjustments!

D

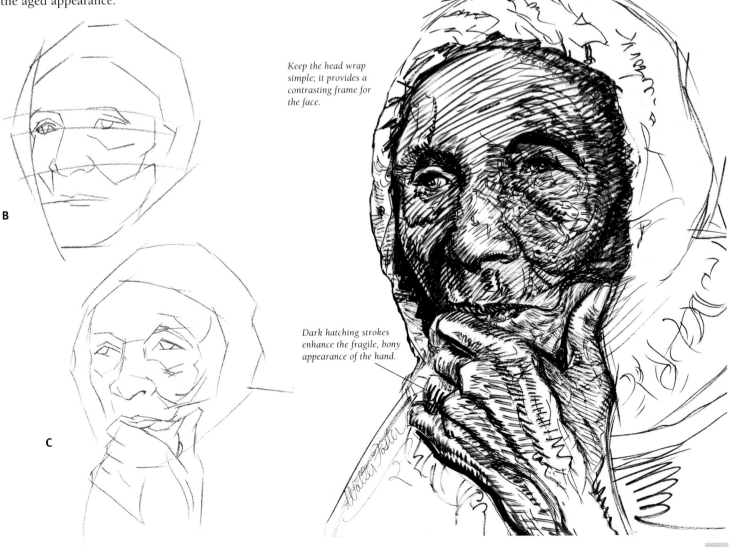

Keep the head wrap simple; it provides a contrasting frame for the face.

Dark hatching strokes enhance the fragile, bony appearance of the hand.

ELDERLY MEN

Elderly men are good subjects for practicing a variety of techniques, such as drawing wrinkles, thinning white hair, and aging features. Pay close attention to the details to create an accurate rendering.

Minimal shading on the head suggests thinning white hair.

Coarse shading over the entire face creates the rough skin texture.

A

This model exhibits a somewhat worried expression; notice how the eyebrow angles down slightly in step A. Use bold lines to develop the features and hairline in step B. Begin shading with diagonal strokes, changing direction slightly to accommodate the uneven surface.

Notice the loose skin on the neck; the neck blends into the chin.

B

Indicate the shirt and tie to finish the drawing; the head shouldn't appear as though it's floating on the paper.

Two media were used for this drawing. A chisel-tipped 6B pencil was used for the shading on the face, and a brush and black India ink were used for the darkest details. Experiment with different drawing media to create new effects.

Use a brush and ink to bring out fine strands in the hair, eyebrow, and mustache. Keep the shading to a minimum to indicate the white hair.

A

Practice will allow you to develop your own artistic style. Keep at it!

D

Shade the darkest areas first. Be sure to leave light areas for highlights.

When observing your subject, look for unique characteristics such as the pronounced brow and the bump on the nose.

B

As always, begin with quick proportion guidelines. Then sketch the basic shapes of the features, including the bushy mustache. Keep referring to your subject, checking the proportions and shapes. When the sketch is to your liking, create form through shading.

C

PEOPLE OF THE WORLD

Wen drawing subjects of ethnic background, it is important to study their features and proportions closely. Although you may find some characteristics typical of a certain ethnicity, there still are many variances between individuals. Your observation skills will be tested with these drawings! For this young boy, begin as usual with guidelines and a block-in sketch. Look for the features that make the subject unique—for example, large, round eyes, a wide nose, and full lips. Notice that the eyes are especially dark in value, providing a striking contrast to the white highlights.

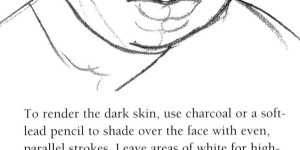

A

B

The diverse population provides endless opportunities for drawing subjects; continue to observe people around you to challenge and improve your skills.

C

To render the dark skin, use charcoal or a soft-lead pencil to shade over the face with even, parallel strokes. Leave areas of white for highlights, especially on the tip of the nose and the center of the lower lip.

The slightly darker area here illustrates the cast shadow created by the bill of the cap.

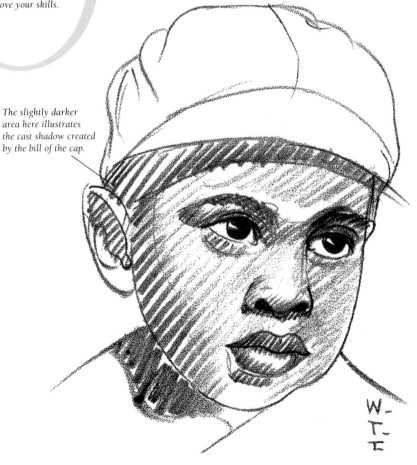

This Asian girl has her head tilted forward, which requires you to adjust the proportions. In this position, where the chin is close to the chest, the length of the face should be shortened, leaving a larger area for the top of the head. This adjustment is an example of foreshortening. For further information on foreshortening, see *Perspective* (AL13) in Walter Foster's Artist's Library series.

B

C

Don't try to draw from your imagination; always use a live model or photograph for reference.

A

The length of the face must be shortened because her head is tilted forward. The best way to master foreshortening is through plenty of practice!

Notice how the guidelines are altered in step A. Observe your subject closely to determine the differences. In steps B and C, develop the features, and suggest the hair and costume. Try using a brush and India ink, as shown in step D, to achieve the shiny black hair. Leave small white areas for highlights, enhancing the sheen of the hair.

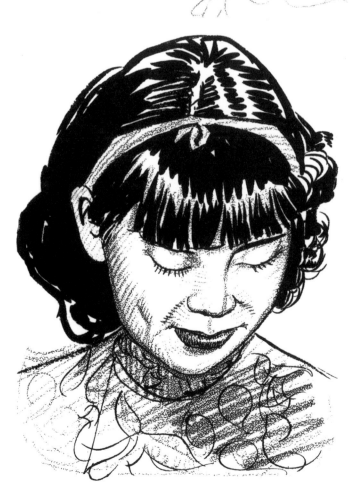

D

Draw curved lines for the closed eyes, adding short, thick strokes for the lashes.

DEVELOPING YOUR OWN STYLE

These two subjects have distinctive characteristics that will lead to interesting artistic works. As you follow the steps, notice the manner in which the facial features are developed and how shading is used to add depth and create interest.

A

B

A dark background can be used to create the shape of the profile.

C

To develop your own artistic style, experiment with different techniques, and use all kinds of media. Try minimal shading or heavy shading; keep your lines loose or make them deliberate. It's all up to you!

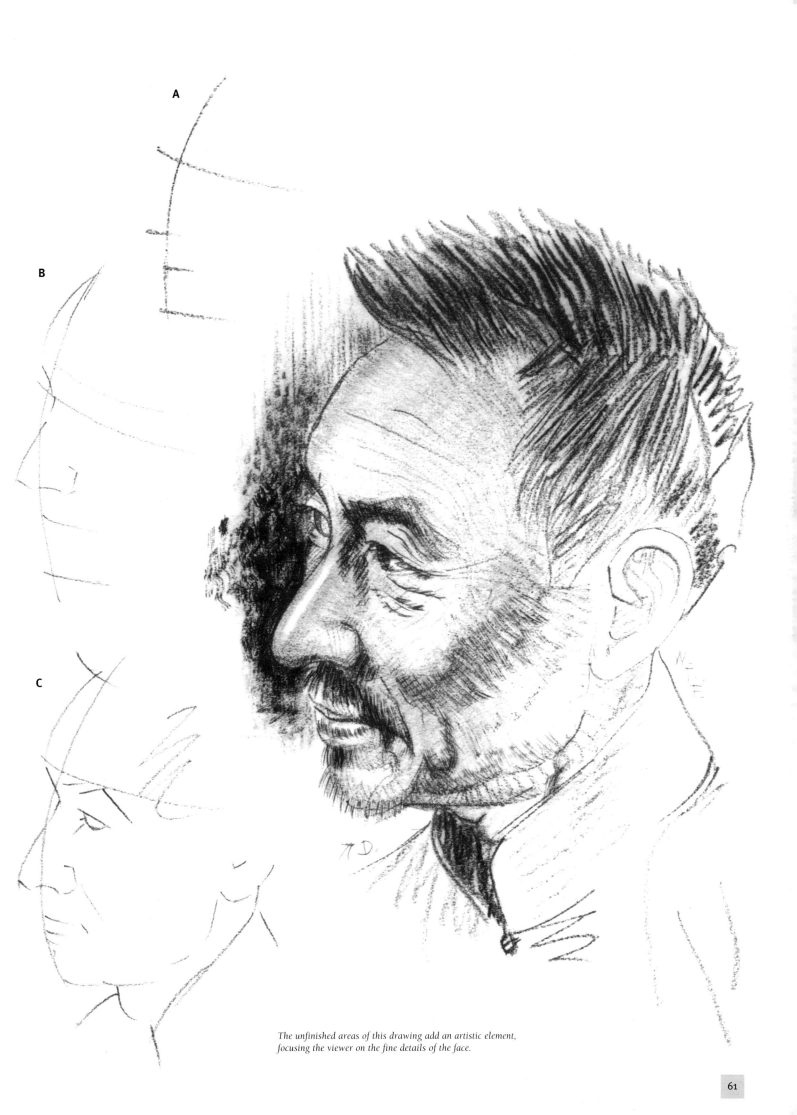

A

B

C

The unfinished areas of this drawing add an artistic element,
focusing the viewer on the fine details of the face.

Male Faces

A photo of a well-known artist served as the model for this sketch. In steps A and B, place the facial features according to the proportions. Develop some of the details in step C; then add some outlines for the hair.

A

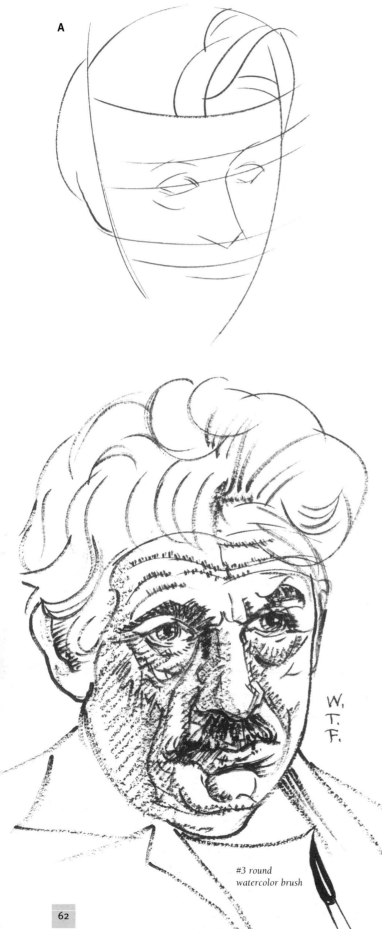

B

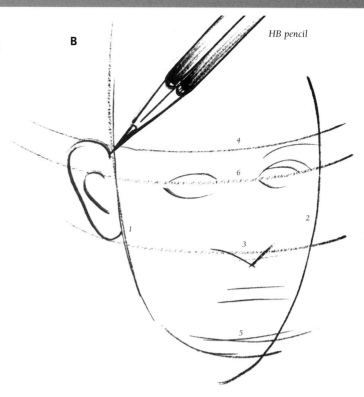

HB pencil

As you can see, the final drawing is fairly simple, yet it preserves the likeness of the person. More detail easily could be added, but you might lose the pleasing artistic quality the drawing has at this stage.

C

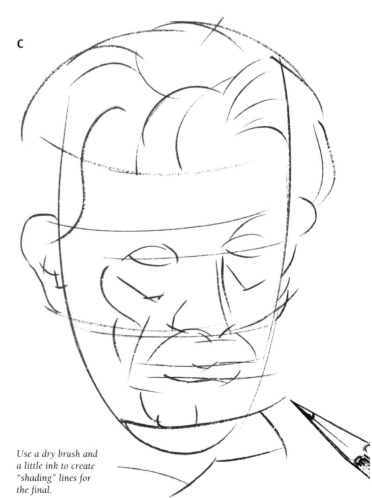

W. T. F.

#3 round watercolor brush

Use a dry brush and a little ink to create "shading" lines for the final.

Although this face appears to be a difficult drawing subject, if you follow the step-by-step illustrations, you may be surprised at how well you do. When you reach step B, lightly sketch the wrinkles. Step C demonstrates how to use the paper stump to blend and shade the crevices. This combination of both lines and shading creates a terrific aged effect.

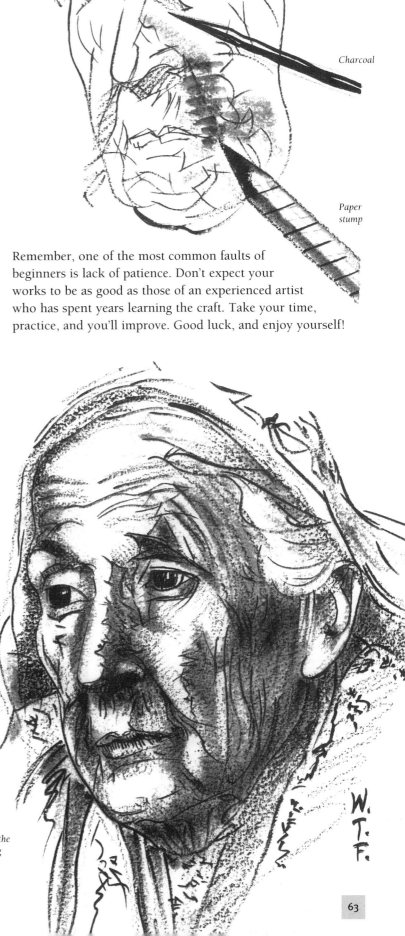

HB pencil

A

C

Charcoal

Paper stump

Remember, one of the most common faults of beginners is lack of patience. Don't expect your works to be as good as those of an experienced artist who has spent years learning the craft. Take your time, practice, and you'll improve. Good luck, and enjoy yourself!

B

#3 round watercolor brush

You can emphasize the wrinkles by drawing heavy lines over the blended shading.

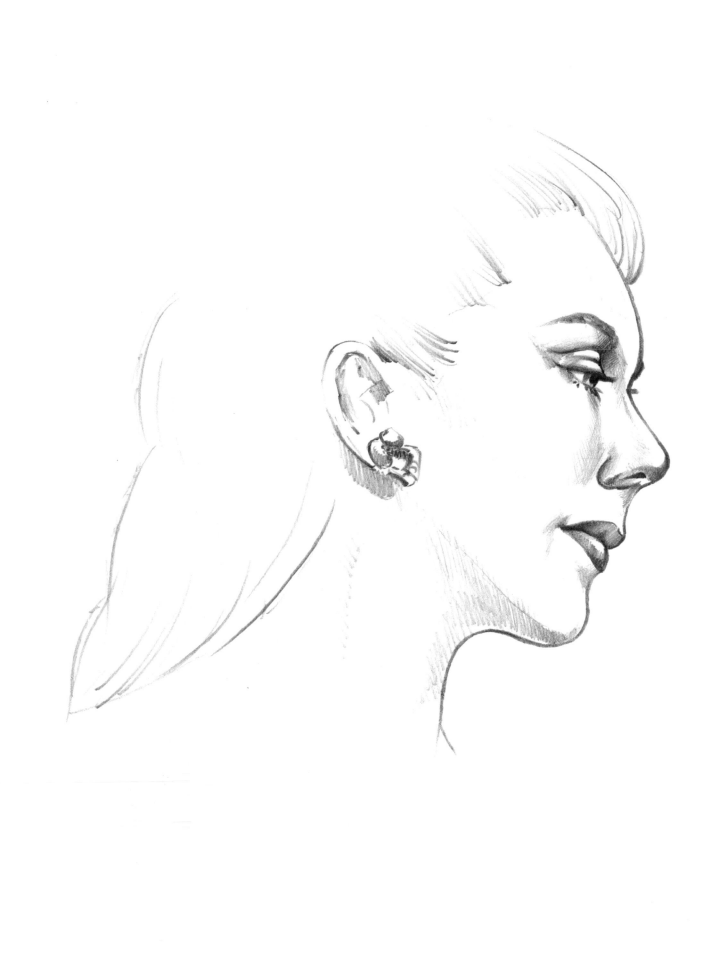

PEOPLE
WITH WILLIAM F. POWELL

William F. Powell is an internationally recognized artist and one of America's foremost colorists. A native of Huntington, West Virginia, Bill studied at the Art Student's Career School in New York; Harrow Technical College in Harrow, England; and the Louvre Free School of Art in Paris, France. He has been professionally involved in fine art, commercial art, and technical illustrations for more than 45 years. His experience as an art instructor includes oil, watercolor, acrylic, colored pencil, and pastel—with subjects ranging from landscapes to portraits and wildlife. He also has authored a number of art instruction books including several popular Walter Foster titles. His work has included the creation of background sets for films, model making, animated cartoons, and animated films for computer mockup programs. He also produces instructional painting, color mixing, and drawing videos.

ADULT HEAD PROPORTIONS

Learning proper head proportions will enable you to accurately draw the head of a person. Study the measurements on the illustration below left. Draw a basic oval head shape, and divide it in half with a light, horizontal line. On an adult, the eyes fall on this line, usually about one "eye-width" apart. Draw another line dividing the head in half vertically to locate the position of the nose.

Facial mass

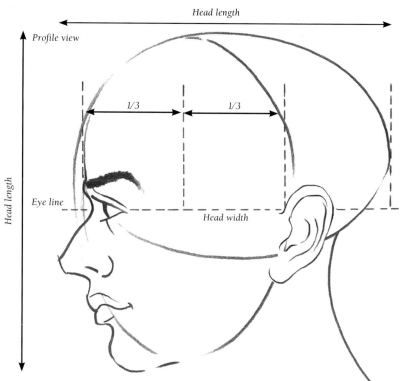

Profile view

Head length

1/3 1/3

Eye line

Head width

Head length

The horizontal length of the head, including the nose, is usually equal to the vertical length. Divide the cranial mass into thirds to help place the ear.

The diagram below illustrates how to determine correct placement for the rest of the facial features. Study it closely before beginning to draw, and make some practice sketches. The bottom of the nose lies halfway between the brow line and the bottom of the chin. The bottom lip rests halfway between the nose and the chin. The length of the ears extends from brow line to the bottom of the nose.

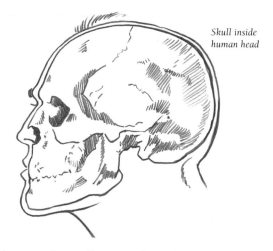

Skull inside human head

This drawing above illustrates how the skull "fills up" the head. Familiarizing yourself with bone structure is especially helpful at the shading stage. You'll know why the face bulges and curves in certain areas because you'll be aware of the bones that lie underneath the skin. For more information, see page 38.

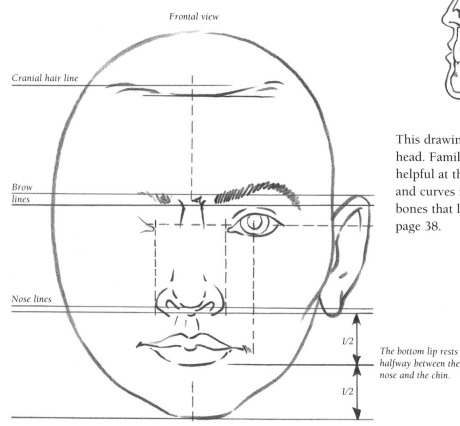

Frontal view

Cranial hair line

Brow lines

Nose lines

1/2

1/2

The bottom lip rests halfway between the nose and the chin.

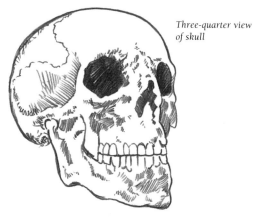

Three-quarter view of skull

HEAD POSITIONS & ANGLES

The boxes shown here correlate with the head positions directly below them. Drawing boxes like these first will help you correctly position the head. The boxes also allow the major frontal and profile planes, or level surfaces, of the face to be discernible. Once you become comfortable with this process, practice drawing the heads shown on this page.

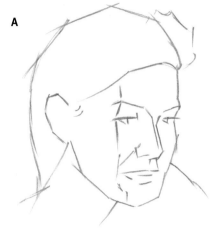

A

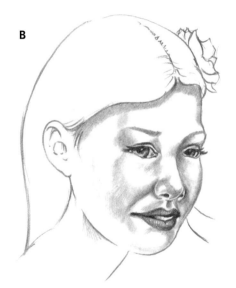

B

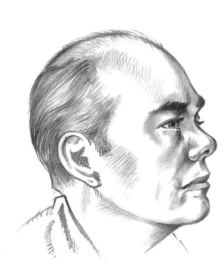

A

B

A

A

B

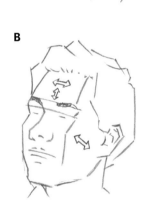

Your shading strokes should follow the arrow directions to bring out the contours of the face.

C

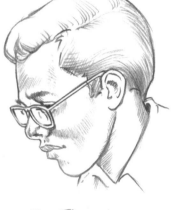

C

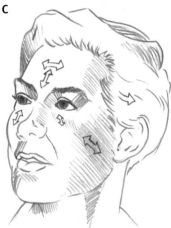

B

C

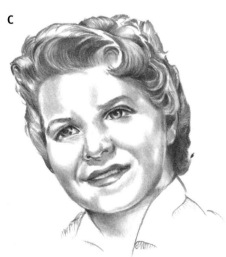

Keep all guidelines very light so they won't show in your actual drawing.

67

FACIAL FEATURES: EYES

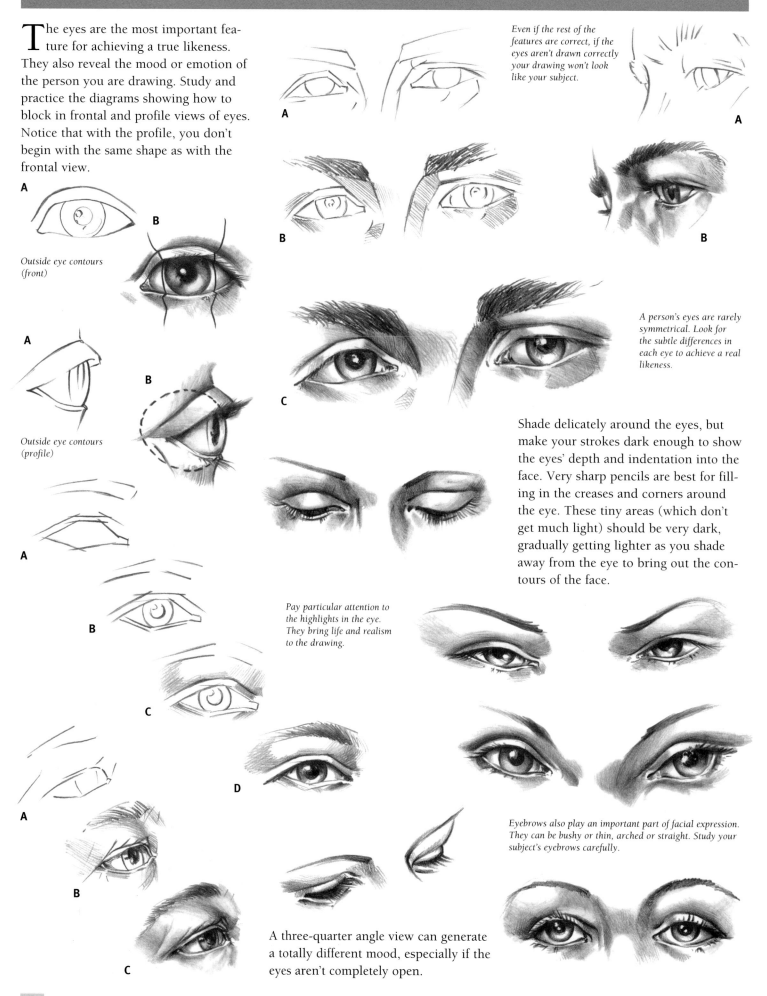

The eyes are the most important feature for achieving a true likeness. They also reveal the mood or emotion of the person you are drawing. Study and practice the diagrams showing how to block in frontal and profile views of eyes. Notice that with the profile, you don't begin with the same shape as with the frontal view.

Outside eye contours (front)

Outside eye contours (profile)

Even if the rest of the features are correct, if the eyes aren't drawn correctly your drawing won't look like your subject.

A person's eyes are rarely symmetrical. Look for the subtle differences in each eye to achieve a real likeness.

Shade delicately around the eyes, but make your strokes dark enough to show the eyes' depth and indentation into the face. Very sharp pencils are best for filling in the creases and corners around the eye. These tiny areas (which don't get much light) should be very dark, gradually getting lighter as you shade away from the eye to bring out the contours of the face.

Pay particular attention to the highlights in the eye. They bring life and realism to the drawing.

Eyebrows also play an important part of facial expression. They can be bushy or thin, arched or straight. Study your subject's eyebrows carefully.

A three-quarter angle view can generate a totally different mood, especially if the eyes aren't completely open.

FACIAL FEATURES: NOSES & EARS

Noses easily can be developed from simple straight lines. The first step is to sketch the overall shape as illustrated by the sketches below. Then smooth out the corners into subtle curves in accordance with the shape of the nose. A three-quarter view also can be drawn with this method. Once you have a good preliminary drawing, begin shading to create form. The nostrils enhance the personality of the nose as well as the person. Make sure the shading inside the nostrils isn't too dark or they might draw too much attention. Men's nostrils generally are angular, whereas women's nostrils are more gently curved. Observe your subject closely to ensure that each feature of your drawing is accurate.

Profile view *Frontal view* *Upward view* *Upraised three-quarter view*

The tip of the nose usually slants upward.

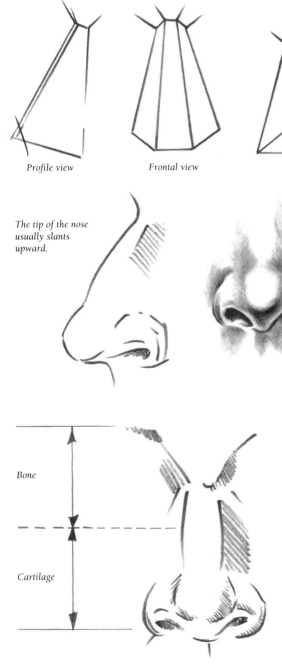

Bone

Cartilage

Ears usually connect to the head at a slight angle. To draw an ear, first sketch the general shape, and divide it into thirds, as shown above. Sketch the "ridges" of the ear with light lines, studying where they fall in relation to the division lines. These ridges indicate where to bring out the grooves in the ear; you should shade heavier inside them.

The lower portion of the nose is made of cartilage, whereas the upper portion is supported by bone. Also, the tip of the nose usually has a slight ball shape.

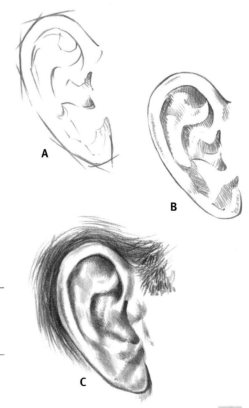

A

B

C

The diagram to the right illustrates how the nose changes as a person ages. In many cases, the tip begins to sag and turn downward. All of these details are important for producing a realistic work.

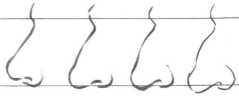

Process of an aging nose

FACIAL FEATURES: LIPS

Lips can be very easy to draw if you study their forms closely. For example, notice that the top lip often protrudes slightly over the bottom one. You should also familiarize yourself with the various planes of the lips to shade them well.

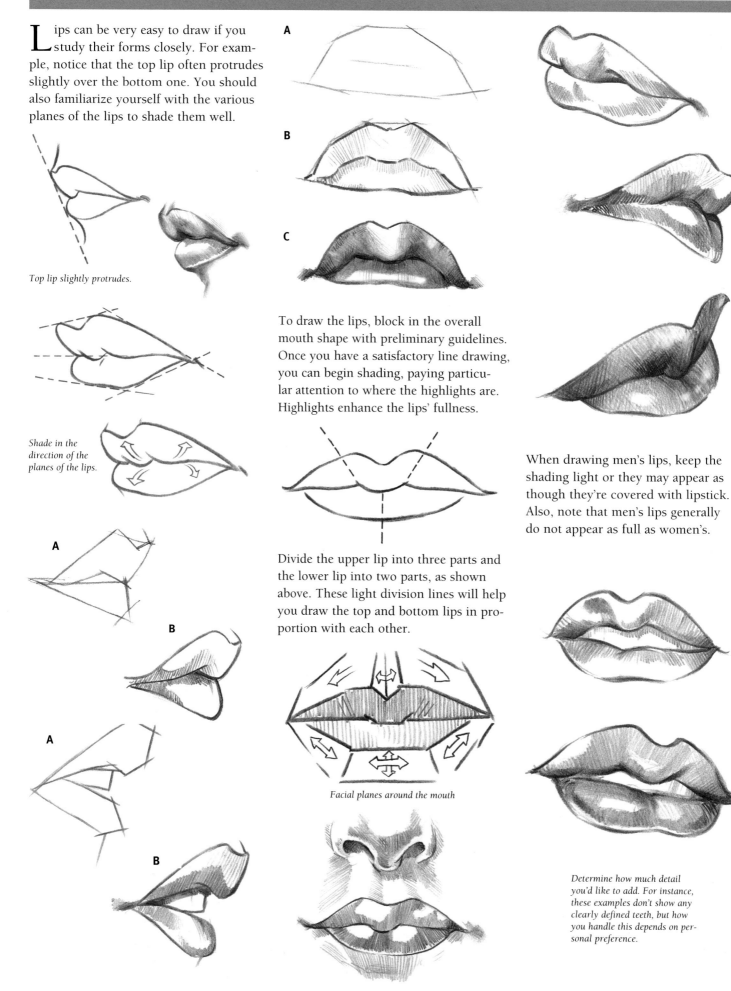

Top lip slightly protrudes.

Shade in the direction of the planes of the lips.

To draw the lips, block in the overall mouth shape with preliminary guidelines. Once you have a satisfactory line drawing, you can begin shading, paying particular attention to where the highlights are. Highlights enhance the lips' fullness.

Divide the upper lip into three parts and the lower lip into two parts, as shown above. These light division lines will help you draw the top and bottom lips in proportion with each other.

Facial planes around the mouth

When drawing men's lips, keep the shading light or they may appear as though they're covered with lipstick. Also, note that men's lips generally do not appear as full as women's.

Determine how much detail you'd like to add. For instance, these examples don't show any clearly defined teeth, but how you handle this depends on personal preference.

FACIAL FEATURES: THE SMILE

Facial expressions will add life to your artistic work because your drawings will seem more realistic. One of the most basic ways to create expression is with a smile. The illustrations on this page demonstrate steps for drawing smiles.

A

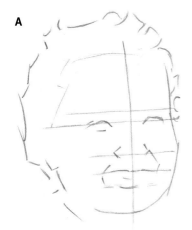

When a person smiles, the rest of the facial features are affected. For example, the bottom eyelids move slightly upward, making the eyes appear smaller.

B

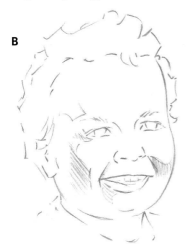

A

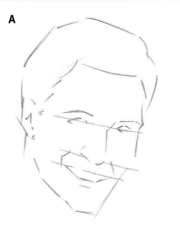

B

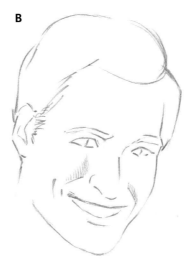

A

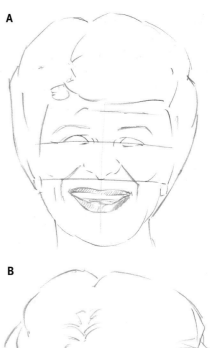

B

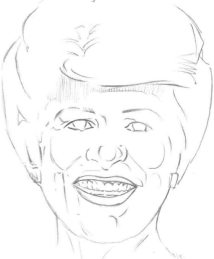

Once you've mastered drawing separate facial features, combine them to build the entire face. Use the head proportions you've already learned to correctly place the features.

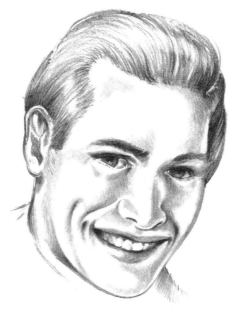

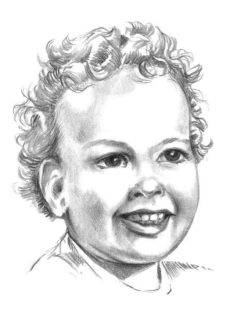

Smiling also causes creases around the mouth and produces more highlights on the cheek area because the cheeks are fuller and rounder. The lips, on the other hand, require fewer highlights because the smile causes them to slightly flatten out.

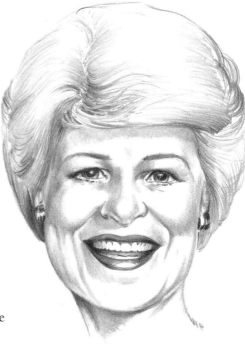

THE PROFILE

A profile drawing can be very dramatic. This drawing was done on plate-finish Bristol board. With an HB pencil, first sketch the lines to establish the head angle. You might want to use the technique of drawing a box first to position the head, as demonstrated earlier on page 67.

B

C

A

When shading the profile or any view of the face, it's important to recognize the different planes of the face. These are illustrated in the drawing to the right. When you reach the shading stage, use a sharp 2B pencil to fill in darker areas such as wrinkles or creases. Use a paper stump to soften smoother features, such as cheeks.

You can produce a very effective drawing with simple, delicate shading.

Planes of the face

Although the nose is a prominent part of the profile, make certain it doesn't dominate the entire drawing. Take as much time drawing the other features as you would the nose.

A

C

B

THE THREE-QUARTER VIEW

Although the three-quarter view may seem difficult, it can be drawn by following all of the techniques you've already learned. With an HB pencil, use the proper head proportions to lightly sketch the guidelines indicating where the main features will be located.

A

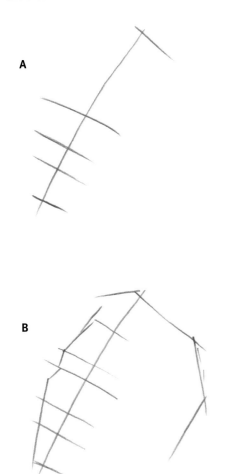

B

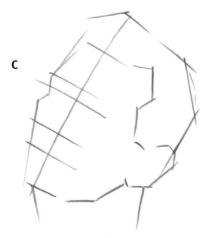

C

D

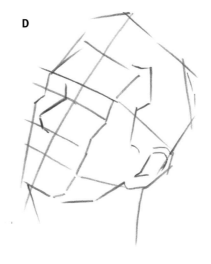

E

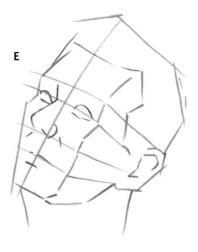

Begin blocking in the shape of the head; then add the hairline, and sketch the ear. Bring out the planes of the face (imagine a box), and position the nose correctly. Sketch the eyes and mouth on the guidelines you've drawn.

F

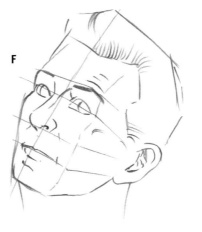

G

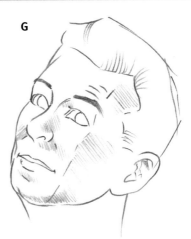

Begin to smooth out your block-in lines, shading lightly with an HB pencil to bring out the face's three-dimensional form. Fill in the creases and details with a sharp-pointed pencil; then use a kneaded eraser molded into an edge or point to pull out the highlights in the hair.

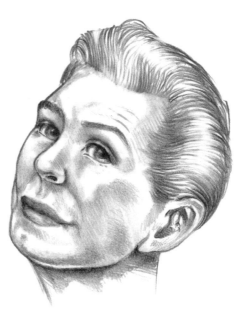

Ask your friends to pose for your drawings. They might get a nice portrait out of it!

CHILD HEAD PROPORTIONS

The proportions of a child's head differ from those of an adult. Children generally have bigger foreheads; therefore the eyebrows—not the eyes—fall on the center horizontal division line. Also, the eyes of youngsters usually are larger and rounder than the eyes of adults.

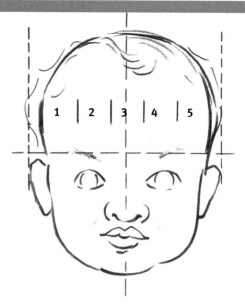

The forehead can be divided into five equal sections with vertical lines. You can position the other facial features in relation to these lines as well.

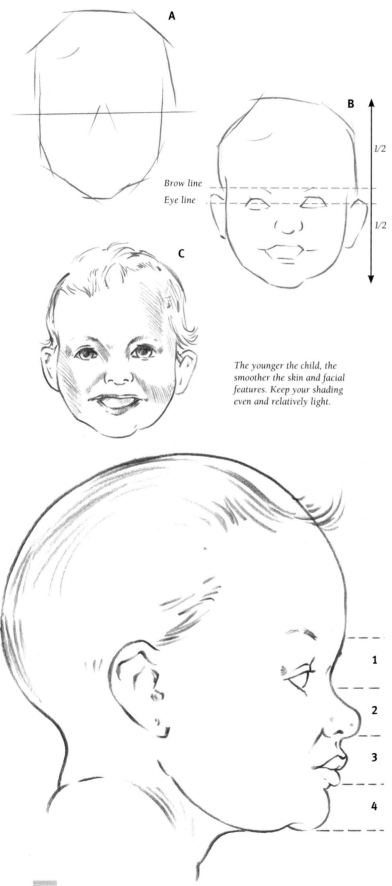

The younger the child, the smoother the skin and facial features. Keep your shading even and relatively light.

Children are fascinating drawing subjects; they bring vitality and life to your work.

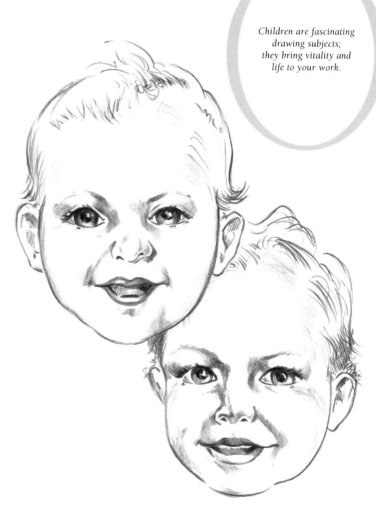

To correctly place the features, use the horizontal lines shown to the left to divide the region between the child's brow line and the chin into four equal sections. Study where each feature falls in relation to these division lines.

Practice drawing boys and girls of various ages in different head positions. Keep the shading simple and smooth in these drawings to capture each child's youthful qualities.

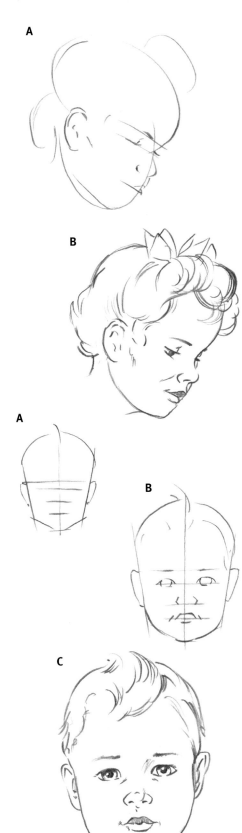
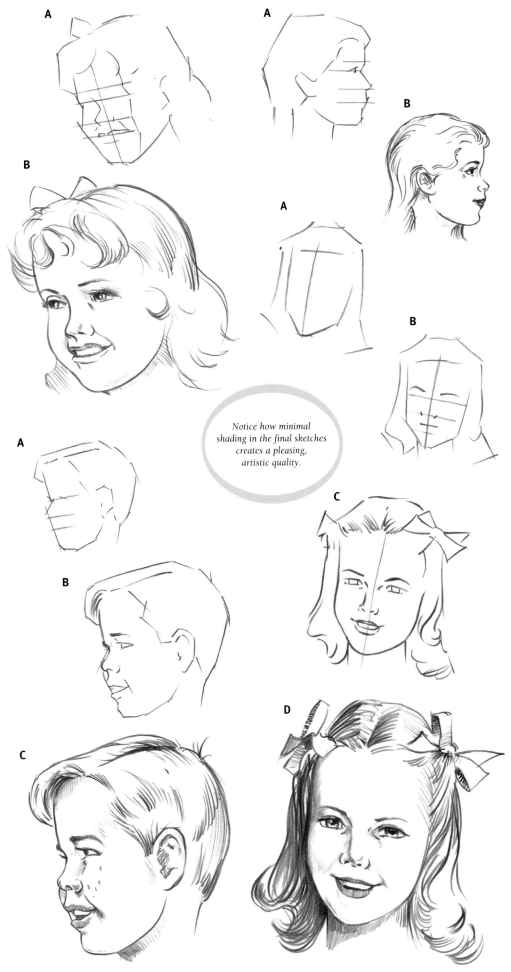

A

A

A

B

A

B

A

B

A

B

Notice how minimal shading in the final sketches creates a pleasing, artistic quality.

C

A

B

B

A

B

C

C

C

D

Mature Faces

Portraits of older individuals require more detail because fine lines and wrinkles must be included. Attempt this drawing on vellum-finish Bristol board, using an HB pencil to block in your guidelines and facial features. Then find your own drawing model.

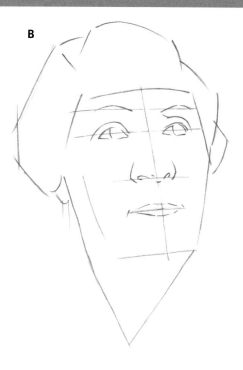

Once you've drawn the basic head shape, lightly indicate where the wrinkles will be. Some of the minor lines can be "suggested" through shading rather than drawing each one. This process can be used for drawing all older individuals.

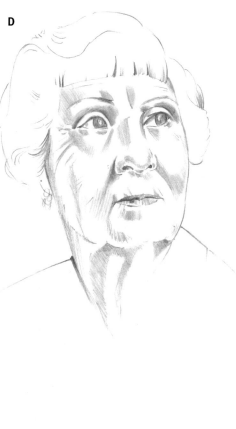

Shade delicately with a sharpened 2B pencil. A sharp, dark lead is best for drawing tiny details, such as creases in the lips, fine hair strands, and the corners of the eyes. Your shading should help the features "emerge" from the face. Again, notice the areas where there is no shading and how these areas seem to come toward you. Practice this drawing; then find your own model or a photograph.

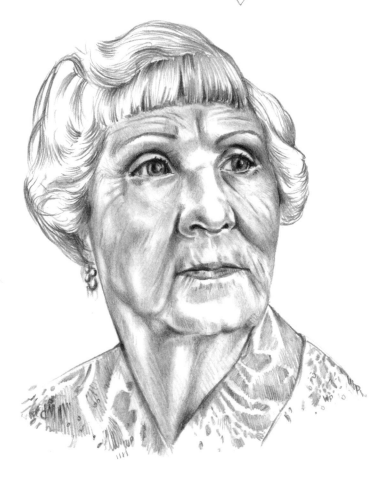

A

B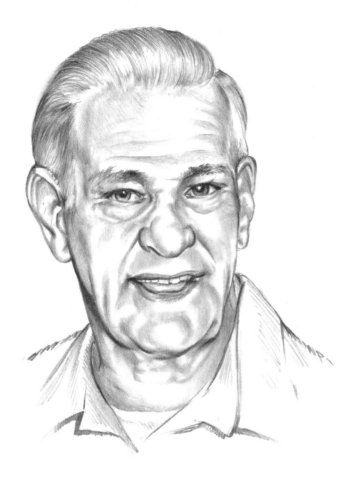

When drawing the face of an older man, you can be more aggressive with the lines and shading, because men usually have more rugged features and pronounced creases than women.

Develop the curves and planes of an older man's face with darker shading than for the woman on the previous page. This enhances the rough quality of his skin.

This man's face looks even more rugged and aged than the previous drawing. His cheek bones also are more defined, and he has a wider chin. It's helpful to envision the skull inside this fellow's head to accurately shade the outer features.

B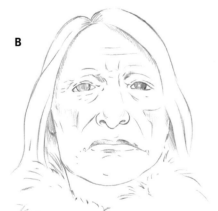

A

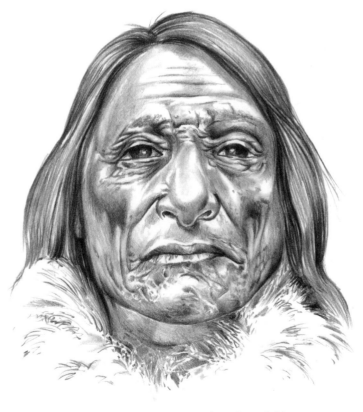

Drawn from a photograph of Big Star.
© American Museum of Natural History, New York.

A paper stump is helpful for the smoother areas of this subject's face, whereas a sharp 2B will aid in rendering the craggy texture of his chin and the distinct wrinkles around his eyes.

ADULT BODY PROPORTIONS

Just as there are proportion rules for drawing the head, guidelines exist for drawing the human body. You can use average or artistic measurements. The diagrams on this page effectively illustrate the differences between these types of proportions. Study them, and make many practice sketches. As you probably know, an unrealistic figure drawing is easy to spot.

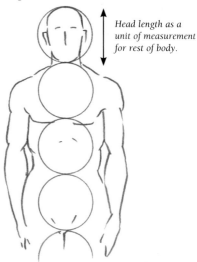

Head length as a unit of measurement for rest of body.

Generally the male figure is widest at the shoulders, whereas the female is widest at the hips.

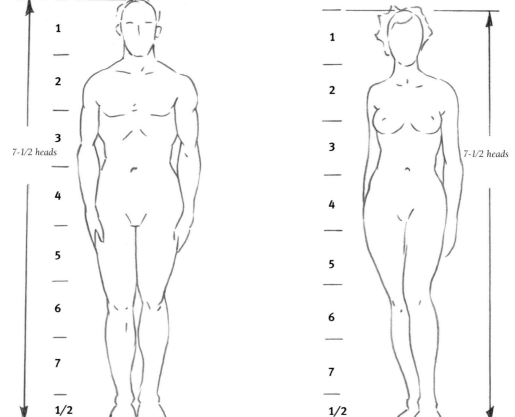

7-1/2 heads

7-1/2 heads

Average proportions

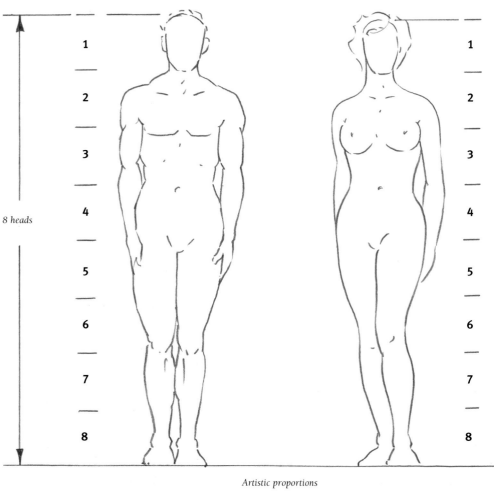

8 heads

Artistic proportions

Realistically, most bodies are about 7-1/2 heads tall (average), but we usually draw them 8 heads tall (artistic) because a figure drawn only 7-1/2 heads tall appears short and squatty.

Try drawing some of your own figures. The first renderings may not look quite right, but keep practicing until you get the hang of it. Remember that figure drawing is much easier when you use a reference, such as a live subject or good photograph.

Artistic proportions have been used by artists since the ancient Greek times.

CHILD BODY PROPORTIONS

The illustrations at the bottom of the page explain how to use the size of the head as a measuring unit for drawing children of various ages. If you're observing your own model, measure exactly how many heads make up the height of the subject's actual body. Begin the drawing below by lightly sketching a stick figure in the general pose. Use simple shapes such as circles, ovals, and rectangles to block in the body. Smooth out the shapes into the actual body parts, and add the outline of the clothing.

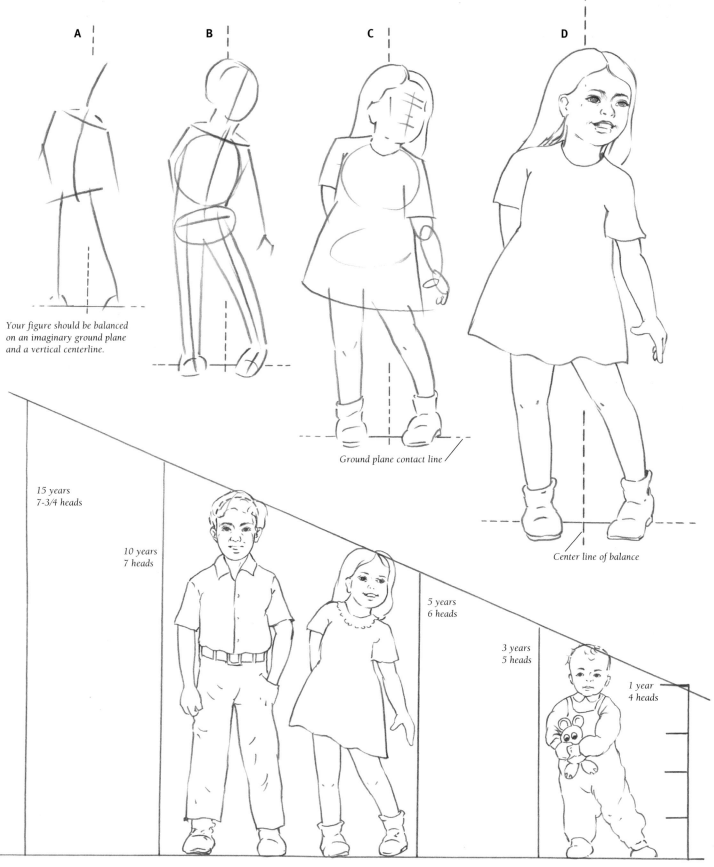

A

B

C

D

Your figure should be balanced on an imaginary ground plane and a vertical centerline.

Ground plane contact line

Center line of balance

15 years
7-3/4 heads

10 years
7 heads

5 years
6 heads

3 years
5 heads

1 year
4 heads

Children are great fun to draw, but because they generally don't remain still for long periods, start out using photographs as models.

THE BODY

The human body is challenging to render; therefore, it's important to start with a quick drawing of the basic skeletal structure. The human skeleton can be compared to the wood frame of a house; it supports and affects the figure's entire form.

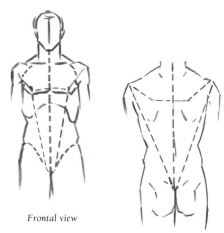

Frontal view

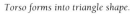

Torso forms into triangle shape.

The frontal view illustrates the planes of the body which are created from the skeleton's form. In men's bodies especially, the torso forms a triangle shape between the shoulder blades and the waist. In women's torsos, the triangle shape generally is less pronounced, and their bodies can even resemble an inverted triangle.

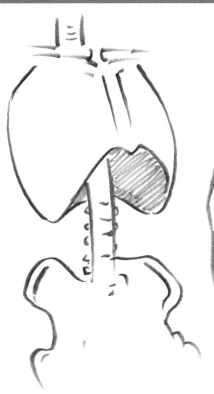

Basic skeletal structure

Skeletal structure inside body

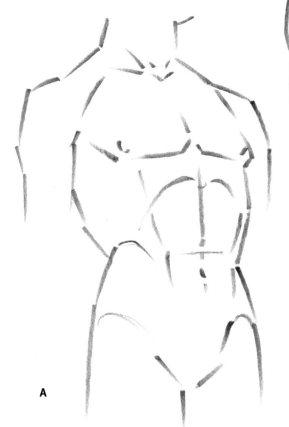

A

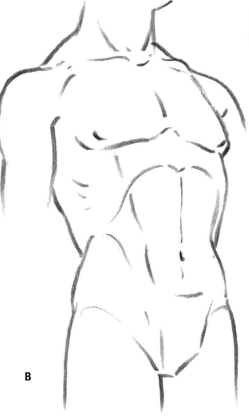

B

Michelangelo dissected human cadavers to learn about skeletal and muscle structure!

The muscles also affect the body's form. To gain further insight into shading the contours of the body, study the human muscular structure in chapter 2.

HANDS & FEET

Hands and feet are very expressive parts of the body and also are an artistic challenge. To familiarize yourself with hand proportions, begin by drawing three curved lines equidistant from each other. The tips of the fingers fall at the first line, the second knuckle at the middle line, and the first knuckle at the last one. The third knuckle falls halfway between the finger tips and the second knuckle. The palm, coincidentally, is approximately the same length as the middle finger.

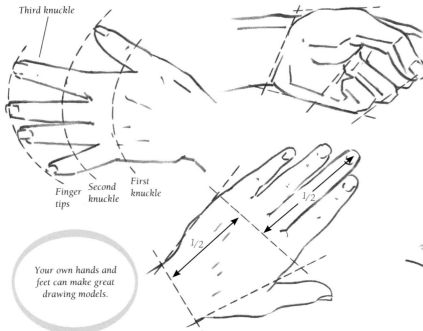

Third knuckle

Finger tips *Second knuckle* *First knuckle*

Your own hands and feet can make great drawing models.

1/2

1/2

Every time a finger bends at the knuckle, a new plane is created. Picture the three-dimensional shape of the hand in various positions. This will help you correctly draw the hand.

Follow the steps shown to draw the feet. Block in the shape in two parts: the main part of the foot and the toes. Once you've drawn a good outline, add minimal shading so you don't call too much attention to the feet.

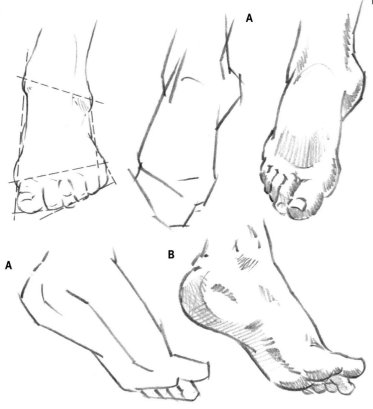

A

B

A

B

A

B

C

D

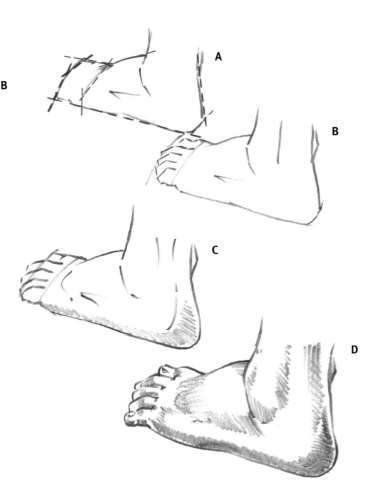

CLOTHING FOLds

Now that you've mastered drawing the body, you need to know certain techniques that will improve the quality of your work. Drawing realistic clothing folds is one of those techniques.

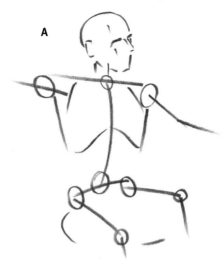

A

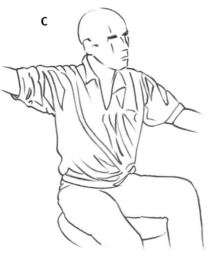

C

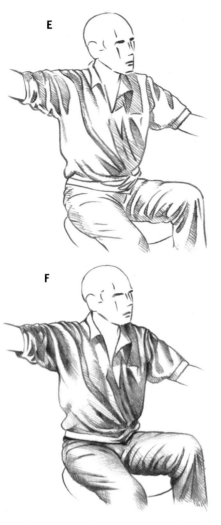

E

F

Begin by drawing a stick figure, indicating the location of each joint with some light circles. Then sketch the outline of the clothing, along with preliminary guidelines for the folds; the guidelines will later provide a map for your shading. Indicate only the major folds at this point, while continuing to add light guidelines.

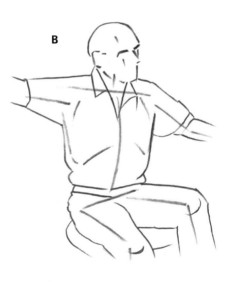

B

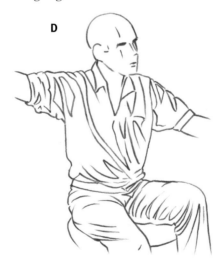

D

To shade, darken the areas inside the folds with short, diagonal strokes using the point of a 2B pencil. Overlap your strokes at different angles, making them darker toward the center of the folds. Use a paper stump for the finishing touches, blending the edges of the folded areas. You might also want to leave some shading lines to give the drawing an artistic feel.

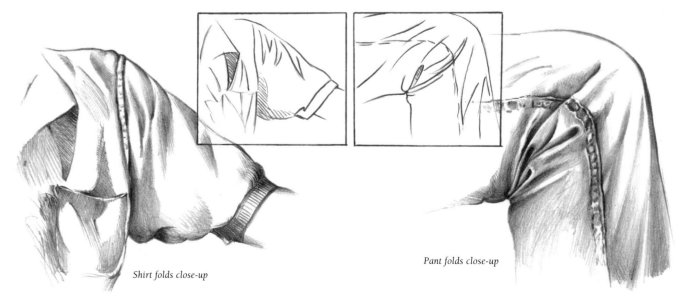

Shirt folds close-up

Pant folds close-up

FORESHORTENING

Foreshortening allows you to create the illusion of an object coming toward you in space. While the principles of perspective still exist, body parts are more difficult to draw in this manner because they don't have straight edges. In addition, the body proportions are somewhat skewed, or shortened, in a drawing that includes foreshortened subjects. (See pages 90–91 for more information.)

A

B

The arm resting on the keyboard appears to be receding back into space. The parts of the body closest to you should be shaded the least because they have the most light on them. Also keep in mind that as objects move farther away, they become less detailed and more blurred.

A

With crossed legs, most of the shading falls on the part of the leg farthest away, enhancing the perception of depth in the drawing. Be certain to rough in both legs and the major folds correctly before you begin shading.

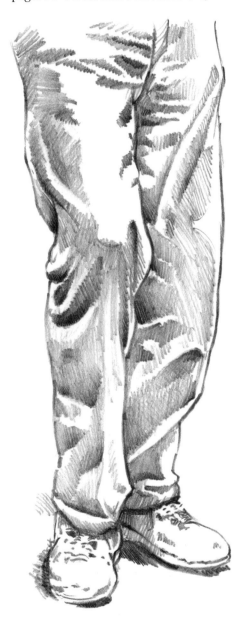

Foreshortening means you are shortening what is coming forward. Notice at the dinner table, when someone passes you something, how his or her arm is foreshortened.

MOVEMENT & BALANCE

Another way to make drawings more realistic is to draw the figures in action. Because people hardly ever sit or stand still, your figure drawings of them shouldn't either. You can begin by using simple sketch lines to lay out the dominant action of the figure.

A

Line of action

B

A

B

Center line
of balance

Try employing an imaginary *centerline of balance* that seems to hold or balance the figure in its position. Otherwise, the figure may look as though it's going to fall over. The best way to achieve balance is to place approximately the same amount of weight on either side of this center line.

B

A

Line of Action

Another tip is to draw a line that represents the spine of the figure in its action pose; you can develop the pose from this *line of action*. Using both the center line of balance and the line of action help establish effective action figure drawings.

No matter what position a figure takes, you always can find a center of balance, illustrated by the dotted lines on these examples.

BENDING & TWISTING FIGURES

When people are involved in something active, they bend and twist their bodies. You should be able to render these movements in your drawings. Clothing helps convey the appearance of a twisting body because the folds form into a twisting design. When drawing figures in a twisting motion, use what you've already learned about shading folds, but keep in mind that folds on a twisting body will be tighter than folds on a person in a still pose.

A

B

Folds form a twisting pattern.

To accurately position the active body, sketch some guidelines to indicate the angles of the shoulders, hips, and knees, as shown in the examples.

Don't forget that you can make terrific drawings from photographs too.

B

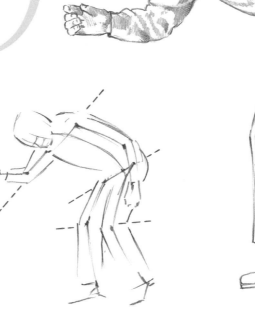

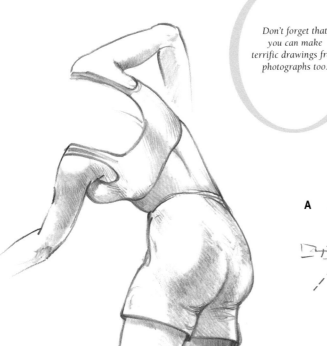

A

SPORTS FIGURES IN ACTION

Drawing figures playing sports is a great way to practice all the techniques you've learned. It's especially important to sketch the line of action in such dramatic poses because the body often stretches, bends, and twists in all sorts of contortions during these kinds of activities.

A

A

B

C

B

Angles will play a fundamental role in effectively rendering these figures. Use your knowledge of proportions extensively to capture the body movements.

A

B

C

C

People playing sports often display expressions that contort their facial features, such as looks of grimace, shock, joy, or pain.

CHILDREN IN ACTION

The same principles of drawing adults in action can be applied to drawing children. But remember, children's arms and legs usually are pudgier than those of an adult, and the proportions of children's bodies are different.

Before using children in public places as drawing models, it's a good idea to get their parents' permission to do so.

Recognize how the line of action differs from the boy jumping for the ball and the girl gathering flowers. Also, adding a ground, field, or river also enhances your work by providing a nice background for your subject.

There is nothing better than the simple innocence of a child at play. Try to bring out this quality in your drawings.

DEVELOPING A PORTRAIT

Drawing a person really is no different than drawing anything else. A human face has contours just like a landscape, an apple, or any other subject—and these contours catch the light and create shadow patterns just as they do on any other object. The difference is that the contours of the face change slightly from individual to individual. The "trick" to portraiture is observing these differences and duplicating them in your drawings.

CAPTURING A LIKENESS

You don't need to memorize all the bones, muscles, and tendons in the human head to draw a portrait; just follow the general rules of proportions, as shown in the chart at right. Simply divide the face into thirds, and note where the features fall in relation to the face and to one another. Then study your model to determine how his or her face differs from the chart (that is, how it is unique). Look for subtle changes, such as a wider nose or thinner lips, wide- or close-set eyes, or a higher or lower forehead. It also is important to practice drawing faces from different viewpoints—front, side, and three-quarter views—keeping the proportions the same but noting how the features change as the head turns. Remember: Draw what you really see, and your portrait will look like your model!

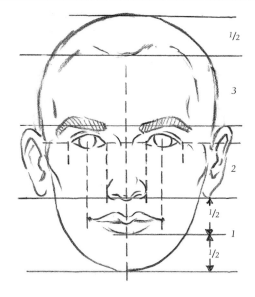

◀ **Facial Proportions** This chart shows some general guidelines for facial proportions. The eyes sit in the middle of the head. The distance from the hair line to the brow line is usually the same distance as from the brow line to the bottom of the nose and from the bottom of the nose to the chin. The lower lip rests halfway between the bottom of the nose and the chin. The eyes are one eye-width apart, and each eye is the same width as the nose. The width of the mouth is the distance from the center of one eye to the center of the other eye. The top of the ear aligns with the brow line; the bottom of the ear aligns with the nose.

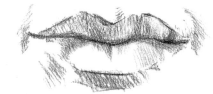

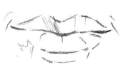

▲ **Lips** In a frontal view, the upper lip has two "peaks" and a slight protrusion in the center. The lower lip is fleshier and has no sharp peaks. When shading, I defined the bottom edge of the lower lip by shading the area directly below it.

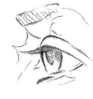

▲ **Eyes** In a side view, the eye has a triangular shape. The iris has an oval shape, and the eyelids slightly cover it at the top and bottom. When shading, I concentrated on developing the iris, lashes, and lids, leaving most of the brow white.

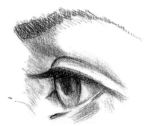

◀ **Nose** In a three-quarter view, the far nostril is partially hidden from sight. The light strikes most strongly on the center ridge, so I created the form by shading the side of the nose, under the tip, and outside the nostril.

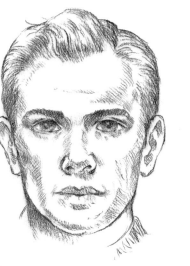

Front View In a frontal view, we can see that the face is not perfectly symmetrical. One eye is generally smaller than the other, or one might sit at a slightly different angle. The same is true of the ears, cheeks, and the sides of the nose and the mouth.

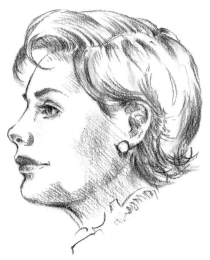

Profile The head shape changes in a side view, but the features remain in the same relative positions. Although the nose is a prominent feature in profile, take care not to let it dominate the face. Also pay attention to where the eye sits and how the lower lip curves into the chin.

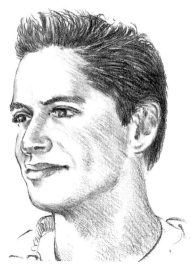

Three-Quarter View This view can be challenging because you have to distort the features to make them look realistic. Here I changed the eye and lip shapes to curve with the face. You might want to start with a contour drawing to work out how the features really look.

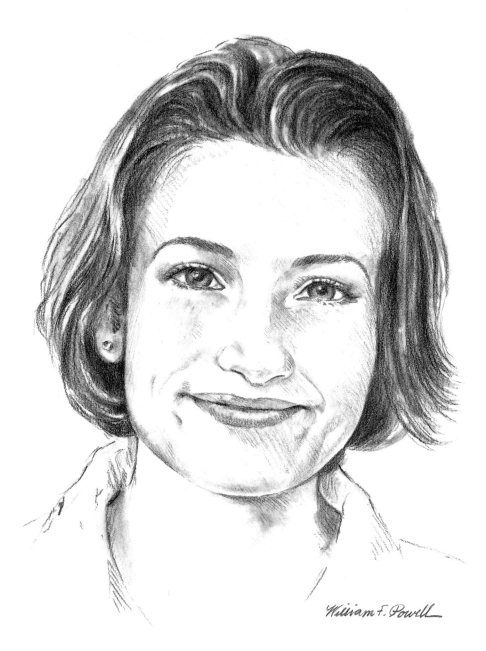

William F. Powell

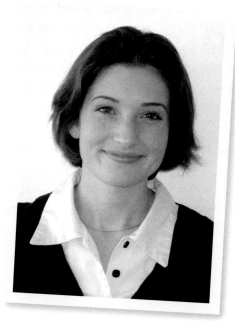

▲ Drawing from a Snapshot Although I prefer to draw portraits from a live model, sometimes a black-and-white photo works just as well—and it doesn't get tired of posing! In this photo of Jenna, I see her delicate features, smooth skin, and sparkling eyes. But I'm also going to try to capture the features that are unique to her: the slightly crooked mouth, smile lines, and wide-set eyes. Note also that you can barely see her nostrils. It's details like these that will make the drawing look like Jenna and no one else.

Step Four I continued building up the shading with the charcoal pencil and willow stick. For gradual blends and soft gradations of value, I rubbed the area gently with my finger. (Don't use a brush or cloth to remove the excess charcoal dust; it will smear the drawing.) When I was finished, I took the drawing outside, turned it over, and gently tapped the back side to release any loose charcoal dust. Finally, I sprayed it lightly with fixative to protect it from further smudging.

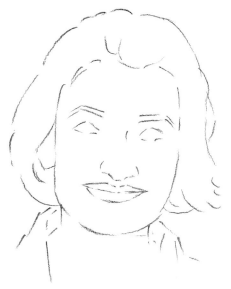

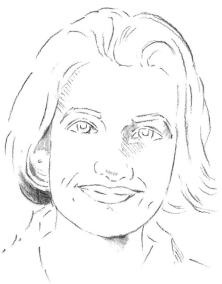

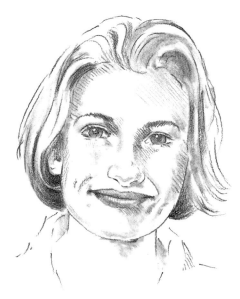

Step One I started with a sharp HB charcoal pencil and very lightly sketched the general shapes of Jenna's head, hair, and collar. (I chose charcoal for this drawing because it allows me to achieve very subtle value changes.) Then I lightly placed her features.

Step Two Next I began refining her features, adding the pupil and iris in each eye, plus dimples and smile lines. At this stage, I studied the photo carefully so I could duplicate the angles and lines that make these features uniquely Jenna's. Then I began adding a few shadows.

Step Three As I developed the forms with shading, I used the side of an HB charcoal pencil and followed the direction of the facial planes. I shaped a kneaded eraser to a point to lift out the eye highlights, and I used a soft willow charcoal stick for the dark masses of hair.

FOCUSING ON FORESHORTENING

Drawing is all about illusion, but not the sleight-of-hand variety magicians perform. In my drawings, I create the illusion of three dimensions in a variety of ways, but in every case I'm just drawing what I see in front of me. *Foreshortening* is an important method of creating the illusion of depth, and it works hand in hand with perspective; that is, the part of the subject that is closest to us appears to be larger than the parts that are farther away.

TAKING A DIFFERENT VIEW

So what exactly *is* foreshortening in terms of drawing? It's a technique for rendering objects that aren't parallel to the picture plane in which you shorten the lines on the sides of the object that is closest to you. (It may sound confusing, but it's really not once you get the hang of it.) For example, if you look at someone holding his arm straight down against the side of his body, the arm is perfectly vertical and so looks in proportion to the rest of the figure. But if he raises his arm and points directly at you, the arm is now angled (and not parallel to the picture plane), so it appears distorted. In other words, the hand looks bigger and the arm looks shorter. So, in turn, you would draw a big hand and an arm with shortened sides. That's foreshortening!

▶ **Recognizing Foreshortening**
This photo of Justin is an excellent example of foreshortening. Notice the difference in the size of his tiny head compared to his huge feet. This is because his feet are closer to us, so they appear much larger. Additionally, I know his legs must be longer than they appear from this viewpoint, and I know that his foot can't be the same length as his shin. But these are the size relationships I see, so these are the size relationships I will draw.

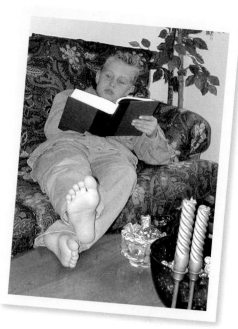

Be selective when you draw. Analyze the scene or subject matter, and change it around if you think it will make a stronger visual statement.

Step One I began, as always, by lightly blocking in the outlines of only the major shapes—no details yet. The most important thing was to study the photo carefully and make sure I had all the size relationships correct. However, although I followed the photo faithfully, I noticed that the book appeared to be unnaturally supported, so I added the right arm and hand. Even though I keep repeating "draw what you see," sometimes you need to take what is called *artistic license* and make a few changes, or no one will believe that's really what you saw!

Step Two Next I lightly added secondary curves to represent the roundness of the figure and the folds in the clothes. I am still blocking in basic information at this point, so I kept these lines light so they wouldn't interfere when I refined the outlines.

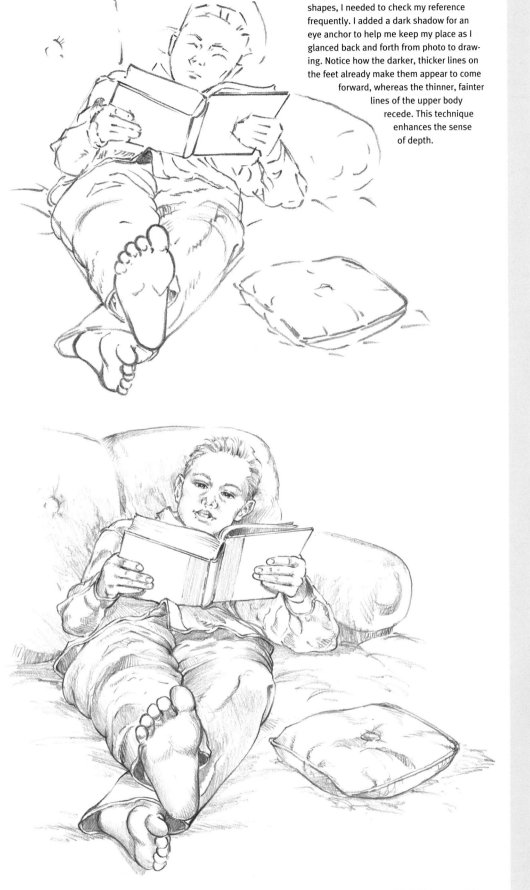

Step Three As I began refining the shapes, I needed to check my reference frequently. I added a dark shadow for an eye anchor to help me keep my place as I glanced back and forth from photo to drawing. Notice how the darker, thicker lines on the feet already make them appear to come forward, whereas the thinner, fainter lines of the upper body recede. This technique enhances the sense of depth.

Step Four In the final stage, I added some light shading and all the details of fabric folds and facial features. Within the overall foreshortened pose, there are secondary areas of foreshortening. For instance, notice how Justin's left foot is foreshortened (because it points toward us) and his right one is not (because it points straight up). The backs of his hands, wrists, and forearms also are foreshortened (because they point toward us), whereas his fingers are not.

FORESHORTENING SIMPLIFIED

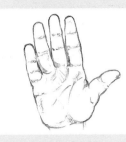

Fingers Straight Up Hold your hand in front of a mirror, palm forward. Notice that your fingers are the right length in relation to your palm. Nothing is foreshortened here.

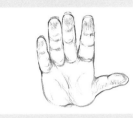

Fingers Angled Toward You Now tip your hand a little, and see how the length of the fingers and the palm appears shortened. This is subtle foreshortening. Of course, your fingers didn't really get shorter; it just looks that way!

Fingers Pointing Front Now point them straight at you. This is the most extreme foreshortened view; the fingers appear to be mere stubs. Notice the shape of the fingernails as they curve over the cylindrical fingers.

Fingers Angled Down The fingers appear longer now but still not full length, yet the fingertips are still visible. This pose shows some foreshortening; the fingers seem too long and thick in relation to the back of the hand.

Fingers Pointing Straight Down No foreshortening is at work in this position—another frontal view. The tips of the fingers cannot be seen, and the length of the fingers and hand are not distorted at all.

Applying Your Skills

Now that you've mastered all the techniques in this chapter, you can incorporate them into one finished work. As you can see, this drawing demonstrates principles of perspective, line of action, and center of balance. It also illustrates successful renderings of figures bending and twisting, sitting, and moving in a variety of action poses. It's important that you attempt to draw a challenging work like this to improve your artistic skills. On location, record your subjects with quick simple lines, creating a reference for a tighter, more polished work back at home. Remember, success requires patience and a lot of practice.

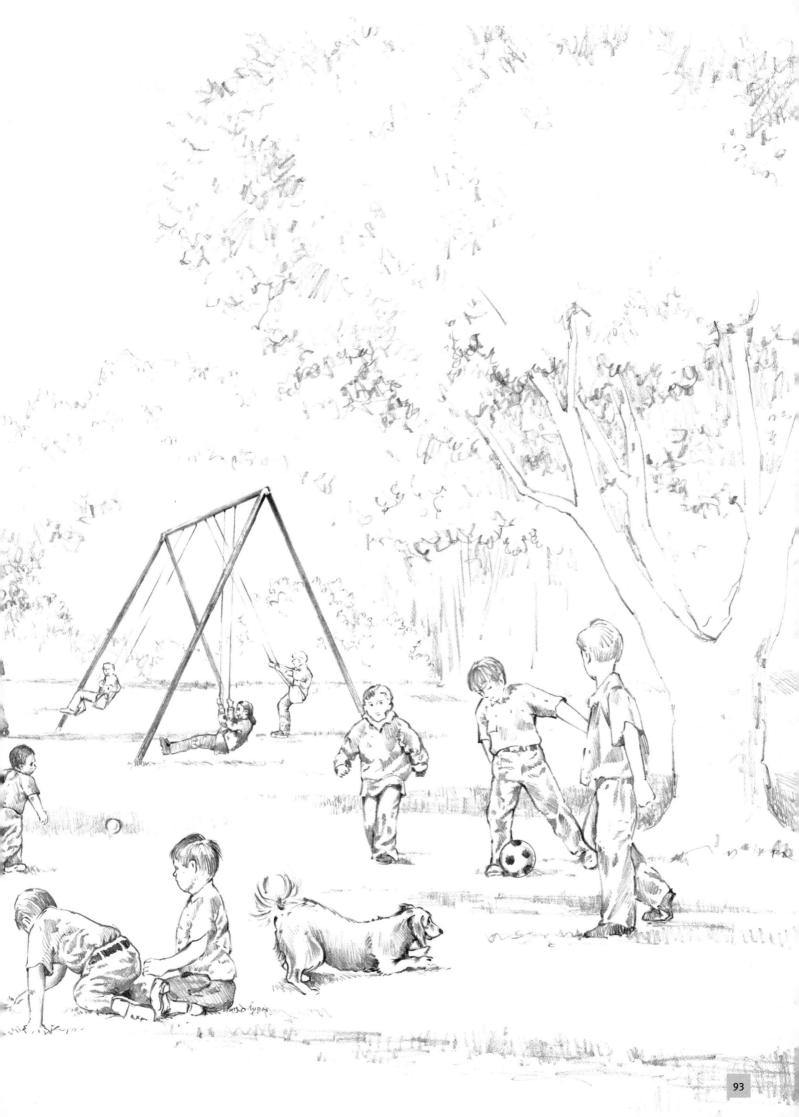

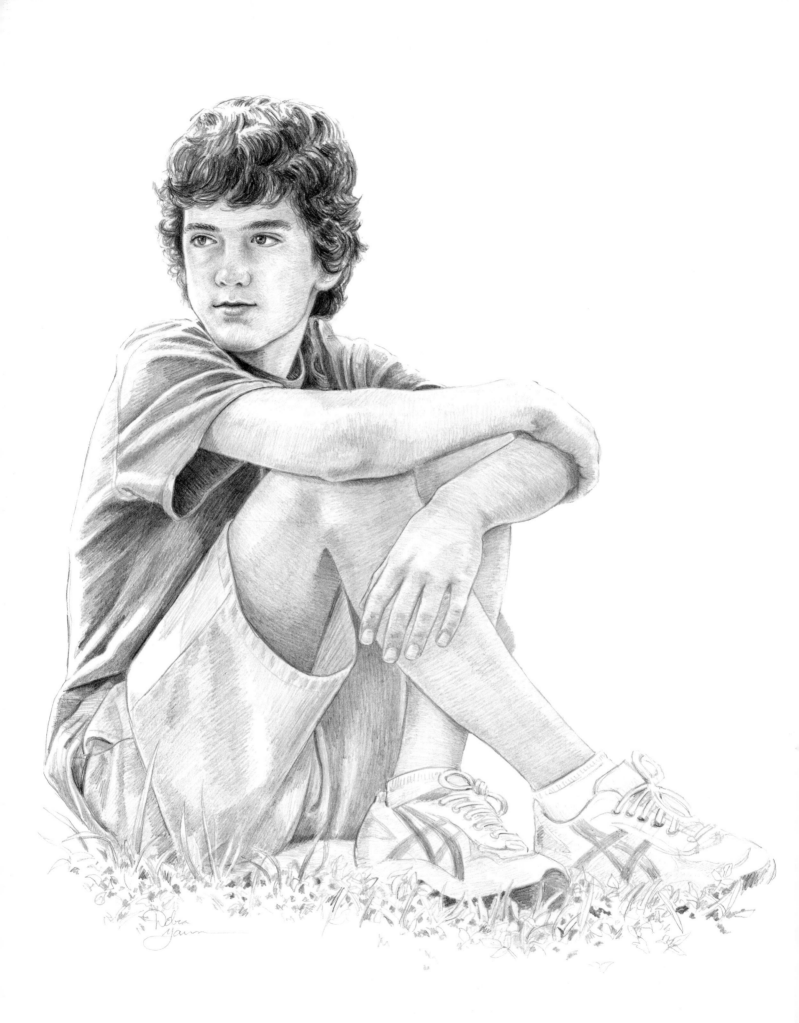

PEOPLE

WITH
DEBRA KAUFFMAN YAUN

Debra Kauffman Yaun discovered that she had a knack for drawing people when she was a young girl growing up in Tampa, Florida. After graduating from the Ringling School of Art and Design in Sarasota, Florida, Debra worked as a fashion illustrator. Debra's artwork has been published in several art magazines and books, and she has won numerous awards, including an international award. She is a signature member of the Colored Pencil Society of America, having served as president of the Atlanta chapter, and she is a juried member of the Portrait Society of Atlanta. Debra's work is featured in four Walter Foster titles: *Drawing: Faces & Features* and *Drawing: People with Debra Kauffman Yaun* in the How to Draw and Paint series; and *Colored Pencil Step by Step* and *Watercolor Pencil Step by Step* in the Artist's Library series. Debra and her artist-husband have two grown sons and reside in Georgia.

UNDERSTANDING FACIAL ANATOMY

When drawing faces, it is important to be aware of the underlying structures of the head. Although the bones and muscles weren't visible in a final portrait, they provide the framework for the drawing, establishing the shape of the head and guiding the placement of the features. Having an understanding of the basic anatomy of the head will lend realism and credibility to your drawings.

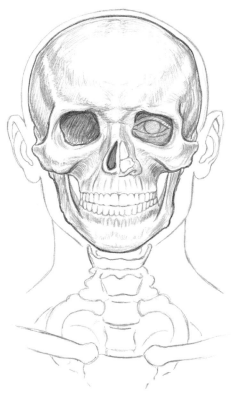

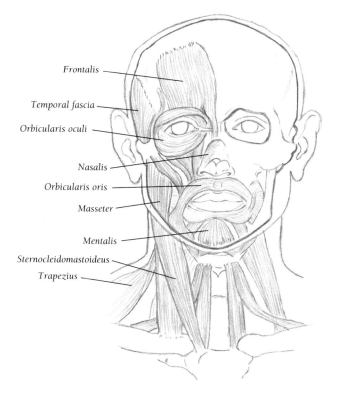

- Frontalis
- Temporal fascia
- Orbicularis oculi
- Nasalis
- Orbicularis oris
- Masseter
- Mentalis
- Sternocleidomastoideus
- Trapezius

Understanding Bone Structure Becoming familiar with the bones of the skull and the way they affect the surface of the skin is essential for correctly placing the curvatures, ridges, and other prominent features of the head.

Understanding Muscle Structure When facial muscles contract, they affect the shape of the skin, cartilage, and underlying fatty tissues that cause the bulges, furrows, and other forms that create various facial expressions.

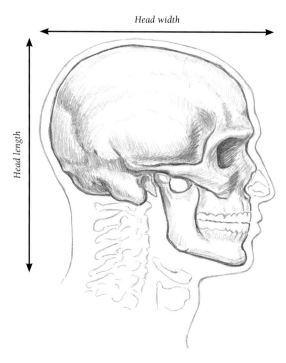

Head width

Head length

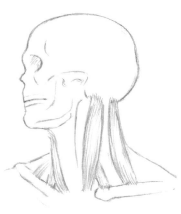

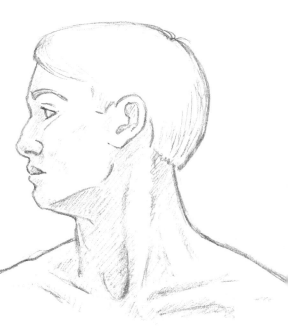

Visualizing the Underlying Muscles
The large muscles of the neck and the clavicle bone twist when the head is turned. The muscles and clavicle are visible, even underneath the skin; they can create a bulge or tension that is evident on the surface.

Seeing the Skull in Profile In a profile view, it is easy to see how much area the back of the skull takes up. Notice that the length of the skull is just shy of its width.

96

LEARNING THE PLANES OF THE FACE

Once you understand the basic structure of the head, you can simplify the complex shapes of the skull into geometric planes. These planes are the foundation for shading, as they act as a guide to help you properly place highlights and shadows.

THE EFFECTS OF LIGHT

▼ **Lighting the Planes from Above** When light comes from above, the more prominent planes of the face—such as the bridge of the nose and the cheekbones—are highlighted. The eyes, which recede slightly, are shadowed by the brow; the sides of the nose, bottom of the chin, and underside of the neck also are in shadow.

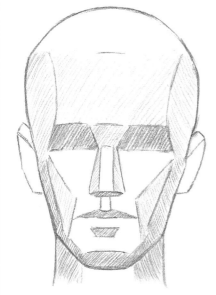

▼ **Lighting the Planes from the Side** Features are shaded differently when light hits the side of the face: The eyes are still in shadow, but the side of the face and neck are now highlighted. The shading on the head becomes darker as it recedes toward the neck; the sides of the cheeks appear "sunken"; and the ear casts a shadow on the back of the head.

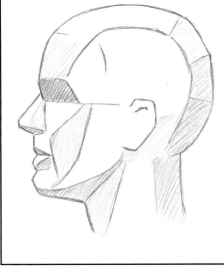

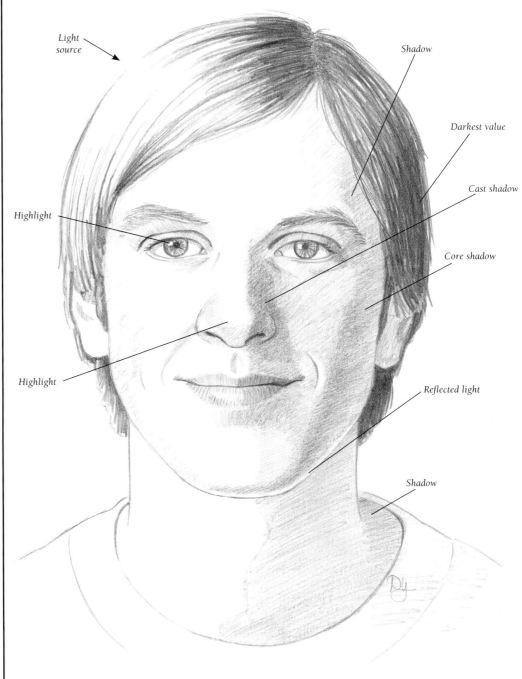

Light source

Shadow

Darkest value

Cast shadow

Core shadow

Highlight

Highlight

Reflected light

Shadow

Shading the Planes of the Face Many types and values of shadows contribute to the piecing together of all the planes of the face. *Core shadows*—or the main value of the shadows—are a result of both the underlying structure and the light source. Protruding objects, such as the nose, produce *cast shadows*, like the dark area on the left of this subject's nose. Highlights are most visible when directly in the light's path; here the light source is coming from above left, so the lightest planes of the face are the top of the head and the forehead. The darkest areas are directly opposite the light source, here the left side of the subject's face and neck. Even in shadow, however, there are areas of the planes that receive spots of reflected light, such as those shown here on the chin and under the eye.

ADULT FACIAL PROPORTIONS

Understanding the basic rules of human *proportions* (meaning the comparative sizes and placement of parts to one another) is imperative for accurately drawing the human face. Understanding proper proportions will help you determine the correct size and placement of each facial feature, as well as how to modify them to fit the unique, individual characteristics of your subject.

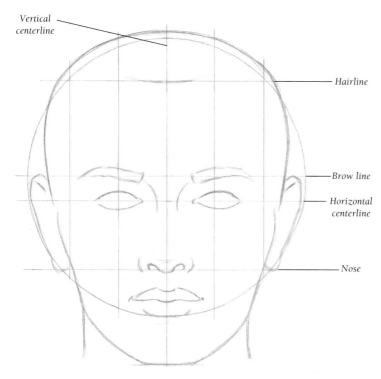

Vertical centerline

Hairline

Brow line

Horizontal centerline

Nose

Establishing Guidelines Visualize the head as a ball that has been flattened on the sides. The ball is divided in half horizontally and vertically, and the face is divided horizontally into three equal parts: the hairline, the brow line, and the line for the nose. Use these guidelines to determine the correct placement and spacing of adult facial features.

Placing the Features The eyes lie between the horizontal centerline and the brow line. The bottom of the nose is halfway between the brow line and the bottom of the chin. The bottom lip is halfway between the bottom of the nose and the chin, and the ears extend from the brow line to the bottom of the nose.

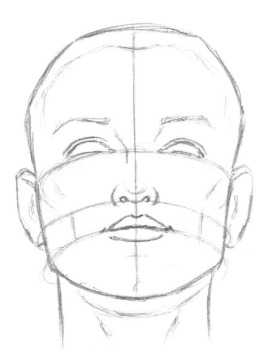

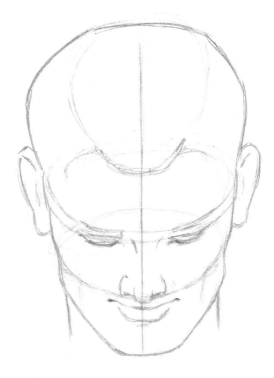

Looking Up When the head is tilted back, the horizontal guidelines curve with the shape of the face. Note the way the features change when the head tilts back: The ears appear a little lower on the head, and more of the whites of the eyes are visible.

Looking Down When the head is tilted forward, the eyes appear closed, and much more of the top of the head is visible. The ears appear higher, almost lining up with the hairline and following the curve of the horizontal guideline.

EXPLORING OTHER VIEWS

Beginning artists often study profile views first, as this angle tends to simplify the drawing process. For example, in a profile view, you don't have to worry about aligning symmetrical features. But the rules of proportion still apply when drawing profile views, as well as the more complex three-quarter views.

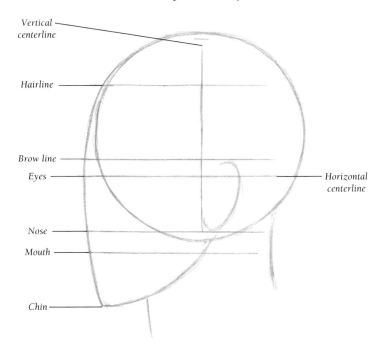

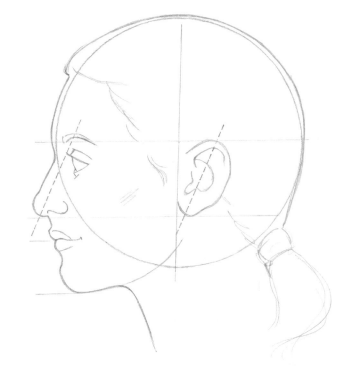

Simplifying the Profile To draw an adult head in profile, start by blocking in the cranial mass with a large circle. Add two curved lines that meet at a point to establish the face and chin. Place the ear just behind the vertical centerline.

Placing the Features Use the large cranial circle as a guideline for placing the features. The nose, lips, and chin fall outside the circle, whereas the eyes and ear remain inside. The slanted, broken lines indicate the parallel slant of the nose and ear.

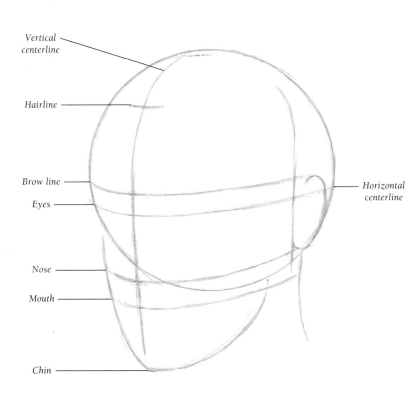

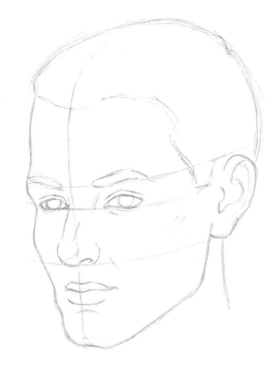

Drawing a Three-Quarter View In a three-quarter view, the vertical centerline shifts into view. More of the left side of the subject's head is visible, but you still see only the left ear. As the head turns, the guidelines also curve, following the shape of the head.

Distorting the Features When the head turns, the eye closest to the viewer (in this case the left eye) appears larger than the other eye. This is a technique called "foreshortening," in which elements of a drawing are distorted to create the illusion of three-dimensional space; objects closer to the viewer appear larger than objects that are farther away.

DEPICTING ADULT FEATURES

If you're a beginner, it's a good idea to practice drawing all the facial features separately, working out any problems before attempting a complete portrait. Facial features work together to convey everything from mood and emotion to age. Pay attention to the areas around the features, as well; wrinkles, moles, and other similar characteristics help make your subject distinct.

EYES

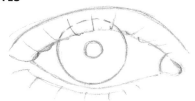

Step One Make a circle for the iris first; then draw the eyelid over it. (Drawing an entire object before adding any overlapping elements is called "drawing through.") Note that part of the iris is always covered by the eyelid.

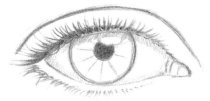

Step Two Start shading the iris, drawing lines that radiate out from the pupil. Then add the eyelashes and the shadow being cast on the eyeball from the upper lid and eyelashes, working around the highlight on the iris.

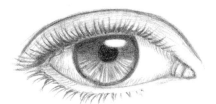

Step Three Continue shading the iris, stroking outward from the pupil. Then shade the eyelid and the white of the eye to add three-dimensional form.

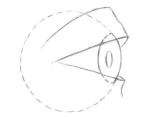

Step One Draw through a circle for the eye first; then draw the eyelid around it, as shown. In a profile view, the iris and pupil are ellipses; the top and bottom of the iris are covered by the upper and lower eyelids.

Step Two To draw eyelashes in profile, start at the outside corner of the eye and make quick, curved lines, always stroking in the direction of growth. The longest lashes are at the center of the eye.

Step Three When shading the eyelid, make light lines that follow the curve of the eyelid. As with the frontal view, the shading in the iris radiates out from the pupil.

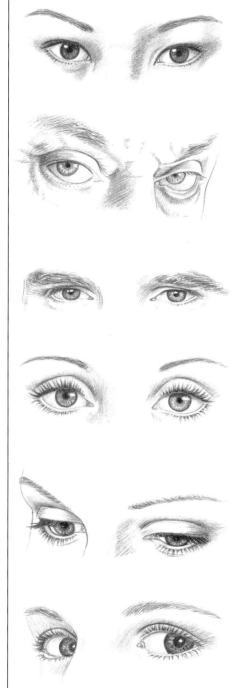

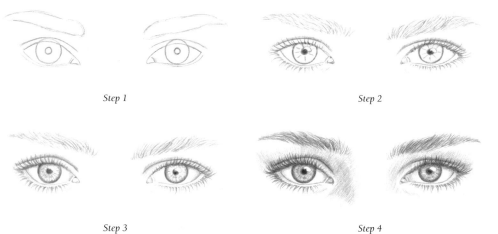

Step 1

Step 2

Step 3

Step 4

Rendering a Pair of Eyes After becoming comfortable with drawing the eye itself, start developing the features around the eye, including the eyebrows and the nose. Be sure to space adult eyes about one eye-width apart from each other. And keep in mind that eyes are always glossy—the highlights help indicate this. It's best to shade around the highlights, but if you accidentally shade over the area, you can pull out the highlight with a kneaded eraser.

NOSES

Rendering Noses To draw a nose, I first block in the four planes—two for the bridge and two for the sides (see "Combining Features" below). Then I study the way each plane is lit before adding the dark and light values. The nostrils should be shaded lightly; if they're too dark, they'll draw attention away from the rest of the face. Generally men's nostrils are more angular, whereas women's are more gently curved.

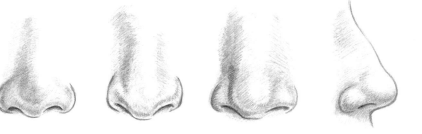

Round nose *Flat nose* *Bulbous nose* *Ridged nose* *Hooked nose*

EARS

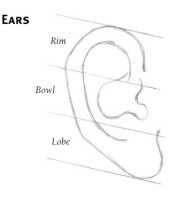

Rim

Bowl

Lobe

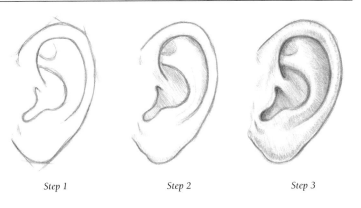

Step 1 *Step 2* *Step 3*

Dividing the Ear The ear is shaped like a disk that is divided into three parts: the rim, the bowl, and the lobe.

Sizing the Ear The ear usually connects to the head at a slight angle; the width is generally about one-half of the length.

Developing the Ear in Profile I first block in the general shape, visually dividing it into its three parts. Next I start shading the darkest areas, defining the ridges and folds. Then I shade the entire ear, leaving highlights in key areas to create the illusion of form.

LIPS

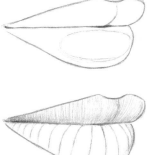

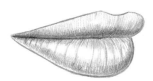

Step One When drawing lips, I first sketch the basic outline. The top lip slightly protrudes over the bottom lip; the bottom lip is also usually fuller than the top lip.

Step Two Next I begin shading in the direction of the planes of the lips. The shading on the top lip curves upward, and the shading on the bottom lip curves downward.

Step Three I continue shading, making the darkest value at the line where the lips meet. Then I pull out some highlights to give the lips shine and form. Highlights also enhance the lips' fullness, so it's often best to include larger highlights on the fuller bottom lip.

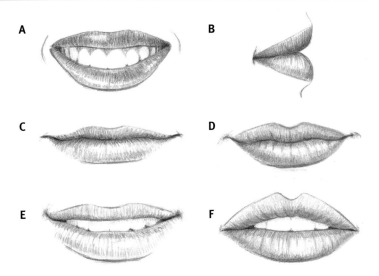

A B

C D

E F

Detailing the Lips Determine how much detail you'd like to add to your renderings of lips. You can add smile lines and dimples (A, B, and D), you can draw clearly defined teeth (A) or parts of the teeth (E and F), or you can draw closed lips (B, C, and D).

COMBINING FEATURES

Step One First I simplify the nose by dividing it into four planes—plus a circle on the tip to indicate its roundness. Then I draw the outline of the lips. I add a small circle to connect the base of the nose with the top of the lip. The arrows on the lips indicate the direction in which I will shade them.

Step Two Now I lightly shade the sides of the nose, as well as the nostrils and the area between the nose and lips. I begin shading the lips in the direction indicated by the arrows in step 1. Then I shade the dark area between the top and bottom lips. This helps separate the lips and gives them form.

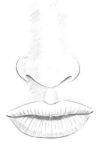

Step Three I continue shading to create the forms of the nose and mouth. Where appropriate, I retain lighter areas for highlights and to show reflected light. For example, I use a kneaded eraser to pull out highlights on the top lip, on the tip of the nose, and on the bridge of the nose.

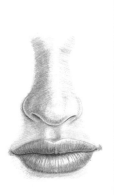

CAPTURING A LIKENESS

Once you've practiced drawing the individual features, you're ready to combine them in a full portrait. Use your understanding of the basics of proportion to block in the head and place the features. Study your subject carefully to see how his or her facial proportions differ from the "average"; capturing these subtle differences will help you achieve a better likeness to your subject.

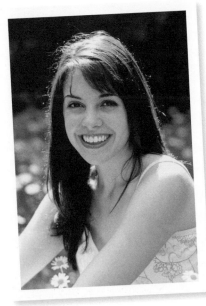

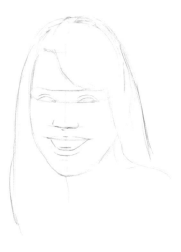

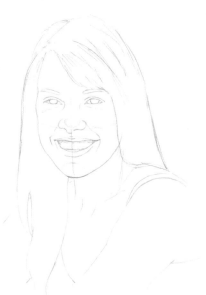

Drawing What You See Working from a photo helps you draw what you really see—as opposed to what you expect to see—because you can change your viewpoint. Try turning both the photo and your drawing upside down as you work; you'll find that you can represent many shapes more accurately.

Step One Using an HB pencil, I sketch the general outline of the subject's face. Then I place the facial guidelines before blocking in the eyes, nose, and mouth. (Notice that the mouth takes up about one-fourth of the face.) I also block in the shape of her hair, including the bangs.

Step Two Switching to a 2B pencil, I indicate the roundness of the facial features. I compare my sketch to the photograph often, making sure that I've captured the things that make this individual unique, like the turned-up nose, slightly asymmetrical eyes, and wide smile.

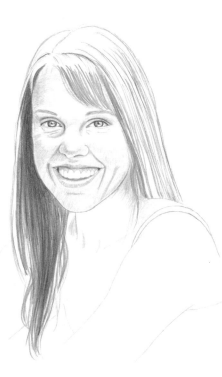

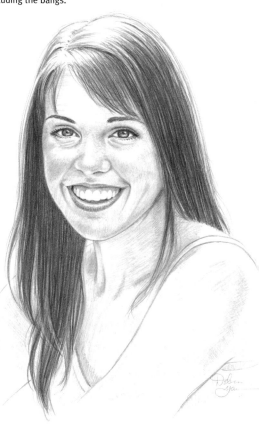

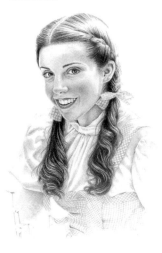
Step Three I erase my guidelines and then begin shading, following the form of the face with the 2B pencil and softly blending to create the smoothness of the skin. Next I create the teeth, lightly indicating the separations with incomplete lines. Then I switch to a 3B pencil to lay in more dark streaks of hair.

Step Four To render the smooth, shiny hair, I use a 4B to lay in darker values. I vary the length of the strokes, pulling some strokes into the areas at the top of her head that have been left white for highlights to produce a gradual transition from light to dark. Then I refine the eyes and mouth by adding darker layers of shading.

LIFE DRAWING (PORTRAIT)

Having models pose for you as you draw—or life drawing—is an excellent way to practice rendering faces. When drawing from life, you usually have control over the way your models are lit. If you're indoors, you can position the light source to your liking; if you're outdoors, you can reposition your model until you're satisfied.

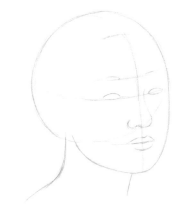

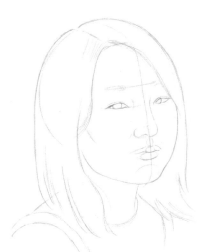

Creating a Comfortable Setup When using live models, make sure they are comfortable and in a pose they can hold for a while. Schedule short breaks every 30 minutes so that both you and your models can take a "breather."

Step One First I place the basic shape of the head with an HB pencil. My subject's head is tilted at a three-quarter angle, so I shift the vertical centerline to the right a bit. (See page 99 for specific information on placing features in a three-quarter view.) I use my guidelines to block in the eyes, nose, and mouth. Then I indicate the neck.

Step Two I use the same HB pencil to foreshorten the subject's left eye, making it a little smaller than the right eye. (See "Distorting the Features" on page 99 for more on foreshortening.) I draw only one nostril, and I make the mouth smaller on the left side. Making closer elements larger shows that the face is angled toward the viewer.

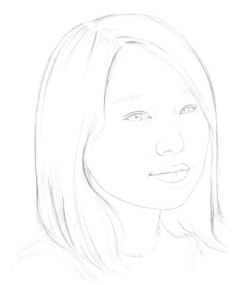

Step Three I let my model take a short break so she can relax and stretch while I check the proportions of my drawing. When I'm satisfied with the placement of the features, I begin to develop the eyes, nose, mouth, and eyebrows. I take note of what my model is wearing (her necklace and the ruffled shirt), and begin to render the details accurately.

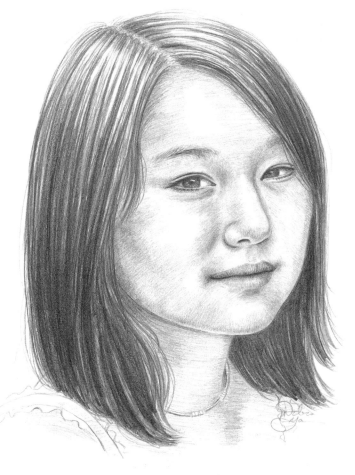

Step Four I start shading the face in the darkest areas, frequently looking up at my model to see where the shadows lie. I use a 2B pencil to develop the hair, varying the length of my strokes and leaving some areas mostly white for highlights. Then I shade the neck using light, horizontal strokes.

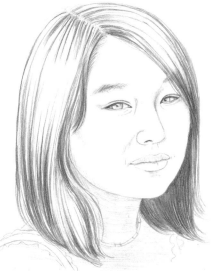

Step Five After another short break, I use a 3B pencil to add even darker values to the hair, leaving the lightest areas at the top of her head to show that the light is coming directly from above. Then, looking up at my model to locate the lightest values in her face, I use a kneaded eraser to lift out some highlights and to soften any strokes that are too dark, smoothing out the skin.

Approaching a Profile View

A profile view can be very dramatic. Seeing only one side of the face can bring out a subject's distinctive features, such as a protruding brow, an upturned nose, or a strong chin. Because parts of the face appear more prominent in profile, be careful not to allow any one feature to dominate the entire drawing. Take your time working out the proportions before drawing the complete portrait.

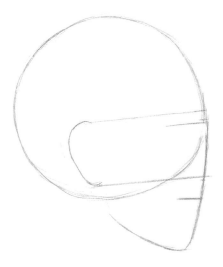

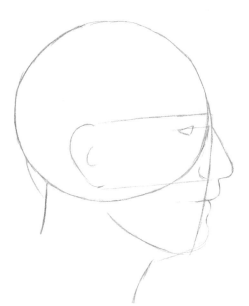

Drawing in Profile When drawing a subject in profile, be careful with proportions, as your facial guidelines will differ slightly. In a profile view, you see more of the back of the head than you do of the face, so be sure to draw the shape of the skull accordingly.

Step One After lightly drawing a circle for the cranial mass, I use an HB pencil to block in the general shapes of the face, chin, and jaw line. Then I add guidelines for the eyes, nose, mouth, and ear. (See page 99 for general rules regarding the placement of features in a profile view.) I closely observe my subject to see how the positions and angles of his features differ from the "average."

Step Two Following the guidelines, I rough in the shapes of the features, including my subject's slightly protruding upper lip. I sketch a small part of the eye, indicating how little of the iris you actually see in a profile view. (See page 100 for more information on drawing eyes in profile.)

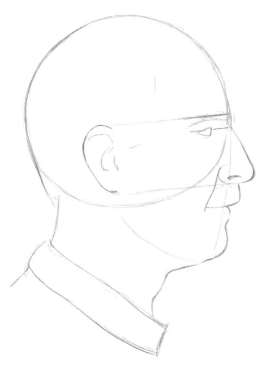

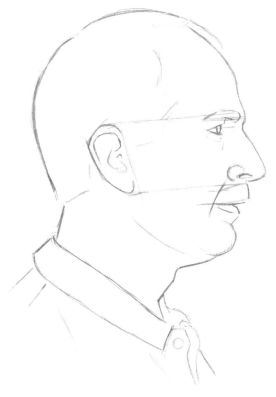

Step Three When I sketch the eyebrow, I pay particular attention to the space between the eye and the eyebrow; in this case, the subject's eyebrow is fairly close to his eye. It also grows past the inside corner of his eye, very close to his nose, and tapers toward the outside corner of the eye. Next I continue refining the profile, carefully defining the shapes of the chin and the neck (including the Adam's apple).

Step Four In a profile view, the hairline is important to achieving a likeness, as it affects the size and shape of the forehead. This subject has a very high forehead, so the hairline starts near the vertical centerline of the cranial mass. Once I'm happy with the shapes of the face and hairline, I start refining the features, giving them form.

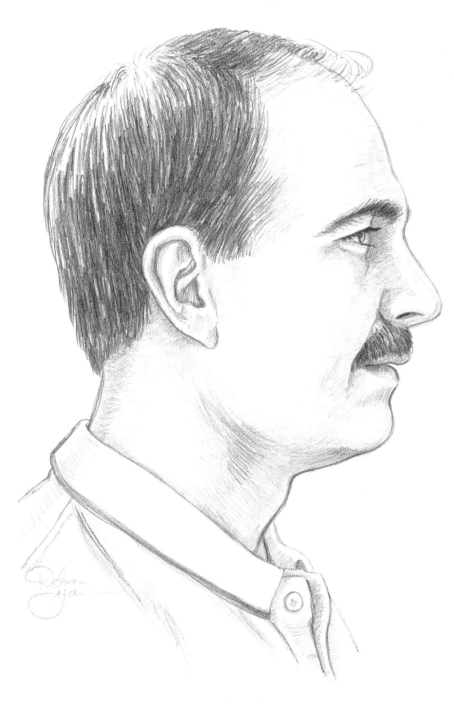

Step Five Here you can see that the drawing is really starting to resemble the subject. Next I switch to a 2B pencil and continue building up the forms: I round out the nose and chin; add light, soft strokes to the area above the lip for the mustache; and suggest the hair using short, quick strokes. Then I add more detail to the eye and develop the ear and the eyebrow.

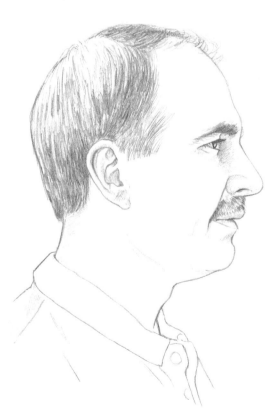

Step Six Still using the 2B, I continue to develop the hair, eyebrows, and mustache, always stroking in the direction that the hair grows. I leave plenty of white areas in the hair to create the illusion of individual strands. Next I begin to suggest the curves and shadows of the face by shading the eye, ear, and nose. (See "The Effects of Light" on page 97 for tips on shading a profile.)

Step Seven I continue shading the lips, pulling out a white highlight on the bottom lip with a kneaded eraser. Then I shade more of the ear and add even darker values to the hair, leaving highlights on the crown of the head, as it is in the direct path of the light source. I also shade the forehead, the nose, and the chin. I leave the majority of the cheek and the middle part of the forehead white. This helps indicate that the light source is coming from above, angled toward the visible side of the face.

WORKING WITH LIGHTING

Whether you're drawing from a photo or from life, lighting is extremely important to the overall feeling of your portrait. Lighting can influence the mood or atmosphere of your drawing—intense lighting creates drama, whereas soft lighting produces a more tranquil feeling. Lighting also can affect shadows, creating stronger contrasts between light and dark values. Remember that the lightest highlights will be in the direct path of your light source, and the darkest shadows will be opposite the light source.

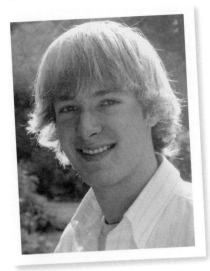

Using Backlighting Here the light source is coming from behind the subject—the face is in shadow, but the hair is highlighted. When drawing a backlit subject, try leaving some areas of paper white around the edges of the head. This keeps the hair from looking stiff and unrealistic, and it also separates the hair from the background.

Step One I sketch the basic shape of the head, neck, and hair with an HB pencil. My subject's head is turned in a three-quarter view, so I curve the guidelines around the face accordingly. (See page 99.) Then I lightly sketch the facial features, indicating the roundness of the nose and the chin.

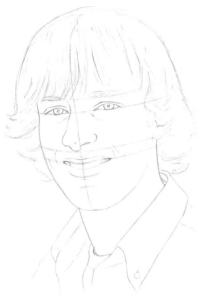

Step Two Switching to a 2B pencil, I define the features and fill in the eyebrows. I also sketch a few creases near the mouth and around the eyes. Then I add the collar, button, and neckband to his shirt.

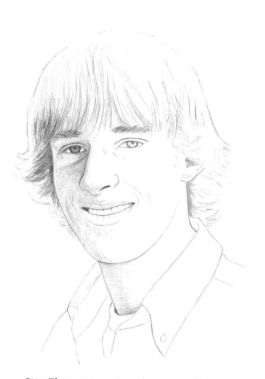

Step Three Using a 2B and frequently referring to my photograph, I shade the right side of the face: First I apply a layer of light, short strokes; then I go back and apply a layer of longer strokes, still maintaining a light touch. To shade the hair, I leave several white areas to indicate that the light is shining through it. I apply long strokes, staggering them at the top of the head to produce an uneven, more realistic shape.

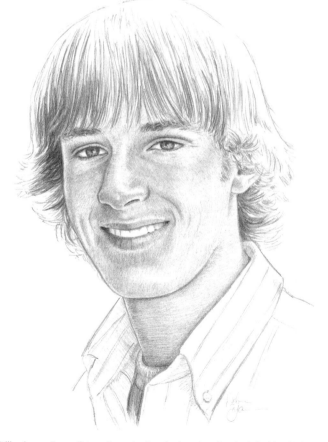

Step Four Still using a 2B pencil, I continue shading the face, keeping the left side a bit lighter in value to show that the light source is coming from the subject's left. I also refine the left eye, leaving the right eye more in shadow. I shade the neck, again making his right side a bit darker. Then I add more definition to the hair, leaving some white space around the edges to suggest the light shining through the hair.

INCLUDING A BACKGROUND

An effective background will draw the viewer's eye to your subject and play a role in setting a mood. A background always should complement a drawing; it should never overwhelm the subject. Generally a light, neutral setting will enhance a subject with dark hair or skin, and a dark background will set off a subject with light hair or skin.

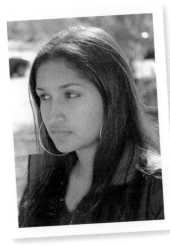

Simplifying a Background When working from a photo reference that features an unflattering background, you easily can change it. Simplify a background by removing any extraneous elements or altering the overall values.

Step One With an HB pencil, I sketch in the basic head shape and the guidelines. Then I block in the position of the eyes, brows, nose, and mouth. (Notice that the center guideline is to the far left of the face because of the way the head is turned.) Next I indicate the neck and the hair.

Step Two Switching to a 2B pencil, I begin refining the shape of the eyes, brows, nose, and mouth. I block in the hair with long, sweeping strokes, curving around the face and drawing in the direction the hair grows. Then I add a neckline to her shirt.

Step Three First I shade the irises with a 2B pencil. Then I begin shading the background using diagonal hatching strokes. Once the background is laid in, I use a 3B to build up the dark values of the hair. (I create the background before developing the hair so my hand doesn't smear the delicate strands of hair.)

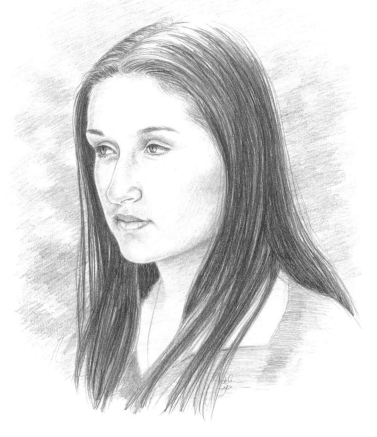

Step Four I finish shading the face, neck, and shirt with a 2B; then I switch to a 3B to add more dark streaks to the hair. I apply another layer of strokes to the background, carefully working around the hair and leaving a few gaps between the strokes to create texture and interest. Next I use a kneaded eraser to smooth out the transitions.

CREATING DRAMA

A darker background can add intensity or drama to your portrait. Here the subject is in profile, so the lightest values of her face stand out against the dark values of the background. To ensure that her dark hair does not become "lost," I create a gradation from dark to light, leaving the lightest areas of the background at the top and along the edge of the hair for separation.

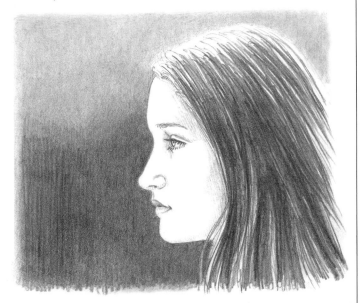

DEVELOPING HAIR

There are many different types and styles of hair—thick and thin; long and short; curly, straight, and wavy; and even braided! And because hair is often one of an individual's most distinguishing features, knowing how to render different types and textures is essential. When drawing hair, don't try to draw every strand; just create the overall impression and allow the viewer's eye and imagination to fill in the rest.

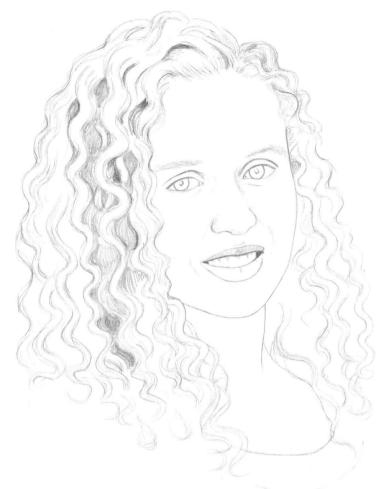

Step One I use an HB pencil to sketch the shape of the head and place the features. Then I use loose strokes to block in the general outline of the hair. Starting at the part on the left side of the head, I lightly draw the hair in the direction of growth on either side of the part. At this stage, I merely indicate the shape of the hair; I don't worry about the individual ringlets yet.

Step Two Switching to a 2B pencil, I start refining the eyes, eyebrows, nose, and mouth. Then I define the neckline of her shirt with curved lines that follow the shape of her body. Returning to the hair, I lightly sketch in sections of ringlets, working from top to bottom. I start adding dark values underneath and behind certain sections of hair, creating contrast and depth. (See "Creating Ringlets" below.)

CREATING RINGLETS

Step One First I sketch the shapes of the ringlets using curved, S-shaped lines. I make sure that the ringlets are not too similar in shape; some are thick and some are thin.

Step Two To give the ringlets form, I squint my eyes to find the dark and light values. I leave the top of the ringlets (the hair closest to the head) lighter and add a bit more shading as I move down the strands, indicating that the light is coming from above.

Step Three To create the darkest values underneath the hair, I place the strokes closer together.

Step Four I add even darker values, making sure that my transitions in value are smooth and that there are no abrupt changes in direction.

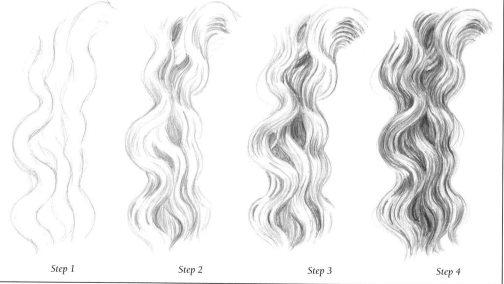

Step 1 *Step 2* *Step 3* *Step 4*

Step Three I shade the face, neck, and chest using linear strokes that reach across the width of the body. Then I define the eyes, lips, and teeth, and I add her shoulder and the sleeve of her shirt. Next I continue working in darker values within the ringlets, leaving some areas of hair white to suggest blond highlights. Although the hair is much more detailed at this final stage, I am still simply indicating the general mass, allowing the viewer's eye to complete the scene. Finally I draw some loose strands along the edges of the hair, leaving the lightest values at the top of the subject's head.

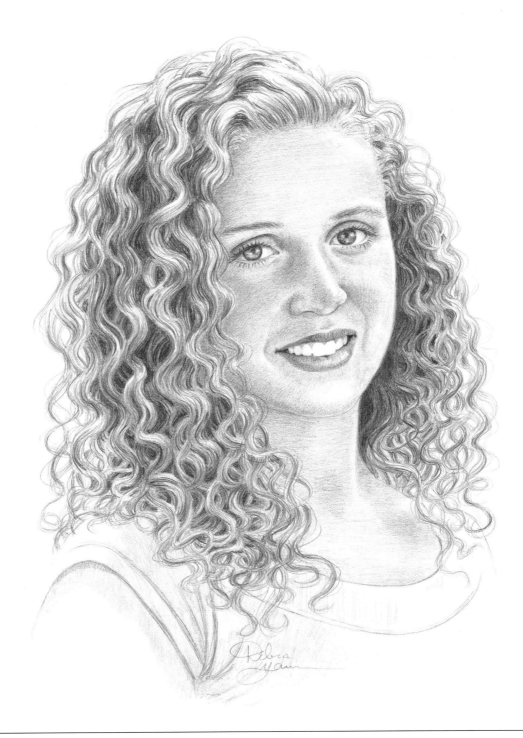

RENDERING BRAIDS

Step One First I sketch the outline of each braid. I taper the ends a bit, adding a line across the bottom of each to indicate the ties that hold the braids together.

Step Two Now I start shading each section, indicating the overlapping hair in each braid. I add some wispy hair "escaping" from the braids to add realism.

Step Three I continue shading the braids using heavier strokes. I add even more "escaped" strands of hair. Then I use a kneaded eraser to pull out highlights at the bottom of each braid, emphasizing the ties. I also pull out some highlights in the braids themselves.

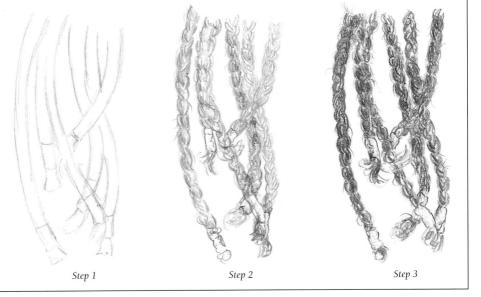

Step 1 *Step 2* *Step 3*

DEPICTING AGE

As people age, their skin loses elasticity, causing loose, wrinkled skin; drooping noses; and sagging ears. In addition, lips often become thinner, hair turns gray, and eyesight becomes poor (which is why many elderly subjects wear glasses). Accurately rendering these characteristics is essential to creating successful portraits of mature subjects.

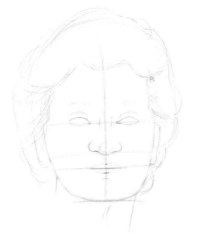

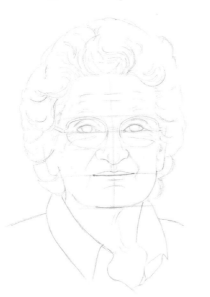

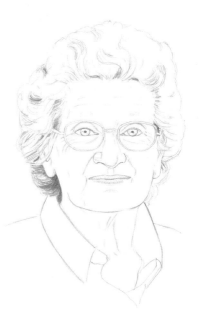

Step One I block in the face with an HB pencil. Then I add guidelines, which I use to place the eyes, nose, ears, eyebrows, and mouth. The lips thin out and move inward as a person ages, so I draw them accordingly. I also sketch the wavy outline of the hair.

Step Two I draw the basic shape of the eyeglasses, then begin to suggest my subject's age by adding delicate lines around her eyes and across her forehead. I also round out the jaw and chin to show where the skin has begun to sag. I draw loose skin on the neck and deep lines on either side of the nose.

Step Three Switching to a 2B pencil, I begin shading the hair and developing the eyes, adding light, curved lines around and under the eyes to create "bags." I magnify the wrinkles slightly where they can be seen through the glasses. (See "Rendering Wrinkles" below.)

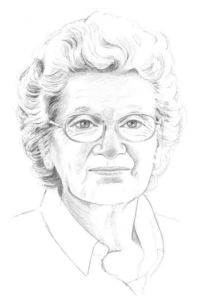

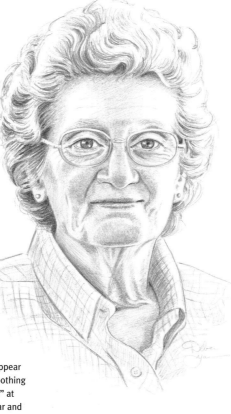

Step Four Still using a 2B, I shade the face and neck, adding strokes to the side of the neck for wrinkles. I finish shading the irises and the eyelids. I shade the area between the right side of the cheek and the jawbone to show the prominent cheekbone, and I add shading around the nose and mouth to make the skin appear puffy. Then I add darker values to the hair and earrings.

Step Five As I continue shading the face, I add more definition to the wrinkles around the eyes so they don't disappear into the shaded areas. I am careful to keep them subtle, smoothing out the transitions with a tortillon. (See "Rendering Wrinkles" at right for more on blending.) Finally I add a button to her collar and create the plaid pattern of her shirt. I stand back from the drawing, making sure that I'm pleased with the effect the angular bones, loose skin, and wrinkles have on the subject's face and that they suggest her age.

RENDERING WRINKLES

The key to drawing realistic-looking wrinkles is to keep them subtle. Indicate wrinkles with soft shading, not with hard or angular lines. You can best achieve this effect by using a dull pencil point. You also can use a cloth or a tortillon to softly blend the transitions between the light and dark values in the wrinkles. Or use a kneaded eraser to soften wrinkles that appear too deep.

When drawing a subject with glasses, as in the example below, try to magnify the wrinkle lines that are seen through the lenses. You can do this by drawing the lines of shading a little larger and spacing them farther from one another.

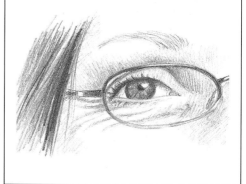

CREATING FACIAL HAIR

Facial hair is another characteristic that distinguishes one individual from the next. Short, dark strokes are perfect for rendering a thick, coarse beard; whereas light, sweeping strokes are ideal for depicting a wispy mustache. Experiment with variations of light and dark lines when drawing a "salt-and-pepper" beard, and use a series of quick, short lines when indicating stubble.

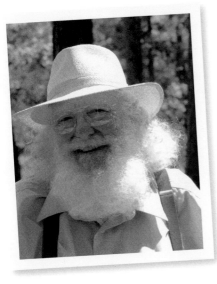

Drawing Through When drawing a face that is partly hidden by facial hair, it is important to draw the entire head first (i.e., "draw through") and then add the hair, beard, and accessories (such as the hat). Although the entire head isn't visible, it still needs to be drawn accurately so the hat sits properly.

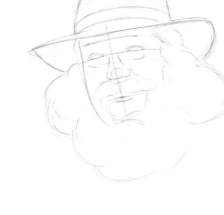

Step One First I sketch the shape of the face with an HB pencil. Then I place the guidelines and the features. Next I draw the hat, including the band. I block in the masses of the hair, mustache, and beard with loose, curved lines. Just as when drawing any other type of hair, I simply indicate the general shapes at this stage.

Step Two Switching to a 2B pencil, I refine the eyes, eyebrows, and teeth. I add wrinkles around the eyes and on the forehead; then I build up the hat, sketch the shirt collar, and draw the suspenders. Now I return to the hair, indicating the curls with circular strokes. Working from top to bottom, I fill out the top of the hair, and then I develop the mustache, which partially covers the mouth.

Step Three After erasing my guidelines, adding the glasses, and defining the eyes, I shade the hat, crosshatching to create a pattern on the band. I begin rendering the short, tight curls of the beard and the mustache. Then I add darker values to the curls on the left side of the face to separate them and to show the cast shadow of the hat.

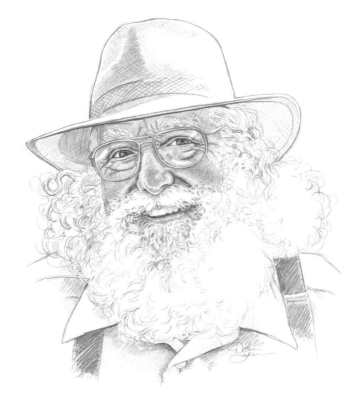

Step Four I add a layer of shading to the irises, leaving white highlights in each eye. Using the edge of a kneaded eraser, I pull out a highlight on each lens of the glasses to show the reflected light. I apply more shading to the hat to give it more of a three-dimensional look; then I shade the suspenders and the shirt. Finally I finish the curls in the hair and beard, varying my strokes between tight, curved lines and quick, straight lines. I create the shortest, most defined lines in the mustache and around the mouth, leaving most of the beard to the viewer's imagination.

FOCUSING ON BEARDS

When drawing a white beard, such as this one, group several lines together to create form, but leave some areas white. Also try drawing the strokes in varying directions—this adds interest and movement. It's also a good idea to overlap your shading a bit where the skin meets the hair, indicating that the skin is showing through the beard.

CHILDREN'S FACIAL PROPORTIONS

Children's proportions are different than those of adults: Young children have rounder faces with larger eyes that are spaced farther apart. Their features also are positioned a little lower on the face; for example, the eyebrows begin on the centerline, where the eyes would be on a teenager or an adult. As a child ages, the shape of the face elongates, altering the proportions.

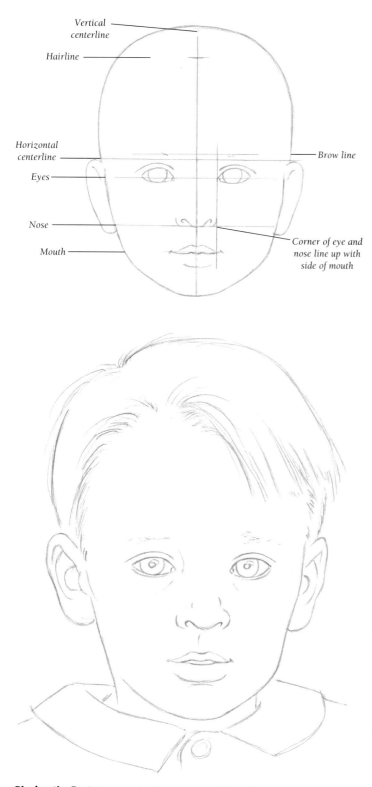

Vertical centerline
Hairline
Horizontal centerline
Eyes
Nose
Mouth
Brow line
Corner of eye and nose line up with side of mouth

Placing the Features Based on the placement of this subject's features, you can estimate that he is around five or six years old. The face has elongated enough to shift the brow line so that it lines up with the tops of the ears, showing that the child is no longer a baby. But the eyes are spaced farther apart, indicating youth. The mouth is still relatively close to the chin, which also emphasizes his young age. (See the diagrams at right for more on the shifting of the features with age.)

CHANGING OVER TIME

The placement of the features changes as the face becomes longer and thinner with age. Use horizontal guidelines to divide the area from the horizontal centerline to the chin into equal sections; these lines can then be used to determine where to the place the facial features.

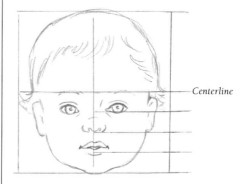

Centerline

Drawing an Infant
A baby's head fits into a square shape, as shown here. Babies have larger foreheads than adults do, so their eyebrows (not their eyes) fall on the horizontal centerline. Their eyes are large in relation to the rest of their features because the eyes are already fully developed at birth.

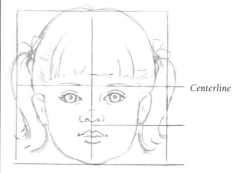

Centerline

Drawing a Toddler
As a child grows, the forehead shortens a bit and the chin elongates, so the bottoms of the eyebrows now meet the horizontal centerline. The eyes are still more than one eye-width apart, but they are bit closer together than an infant's eyes are.

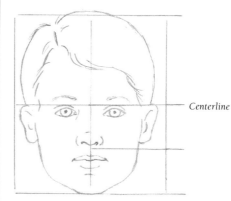

Centerline

Drawing a Child
As a child nears seven or eight years of age, the face has lengthened and fits into more of a rectangular shape. The eyebrows are now well above the horizontal centerline and the eyes are a little closer to the centerline. The ears line up with the bottom of the nose.

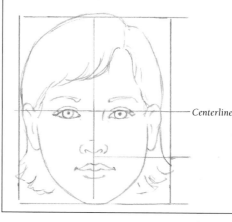

Centerline

Drawing a Teenager
By age 13, the face is even longer and has lost most of its round shape; now it's more oval. The eyes are nearly at the centerline, as on an adult's face, but a teen's face and eyes are still slightly more rounded and full. The tops of the ears are about even with the eyebrows.

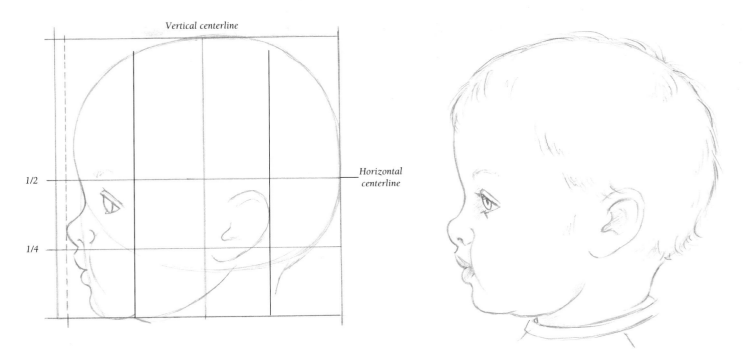

Vertical centerline

1/2

1/4

Horizontal centerline

Drawing a Baby in Profile The profile of a child usually is very rounded. Youngsters generally have bigger, more protruding foreheads than adults do. And children's noses tend to be smaller and more rounded, as well. The shape of a baby's head in profile also fits into a square. Block in the large cranial mass with a circle; then sketch the features. The brow line is at the horizontal centerline, whereas the nose is about one-fourth of the way up the face. Study where each feature falls in relation to the dividing lines. In addition, light eyebrows and wispy hair help indicate a baby's age; as children get older, their hair grows in thicker.

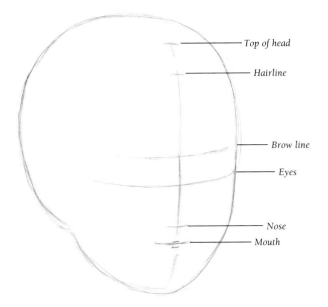

— Top of head

— Hairline

— Brow line

— Eyes

— Nose

— Mouth

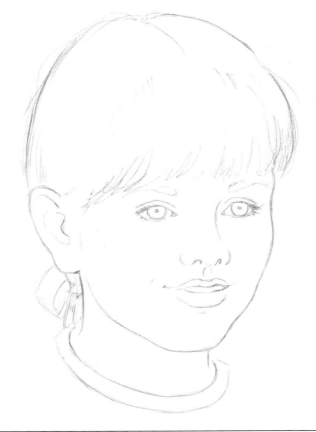

Adding Children's Details The features shift slightly in a three-quarter view, as shown here. Although a baby's features are placed differently on the head than an older child's are, their facial guidelines shift similarly, following the direction in which the head turns. Place the features according to the guidelines. Hair style and clothing—including accessories—also can influence the perceived age of your subject!

MODIFYING THE PROFILE

As children age, their profiles change quite a bit. The head elongates at each stage: The top of the baby's eyebrow lines up with the bottom of the toddler's eyebrow, the midway-point between the young boy's eyebrow and eyelid, and the top of the teenage girl's eyelid.

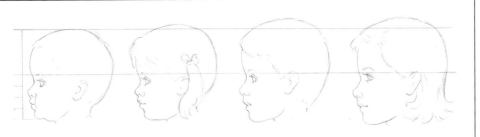

Portraying Children's Features

Children are fascinating drawing subjects, but they can be a challenge to draw accurately. It's important to get the right proportions for the particular age (see pages 112–113 for more on children's proportions) and to correctly render their features: Their eyes tend to be bigger and more rounded than those of adults, their nostrils are barely visible, and their hair is usually fine and wispy.

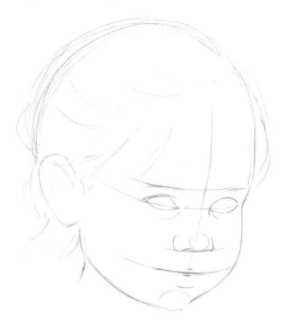

Step One With a sharpened 2B pencil, I sketch the basic shape of the face. Using my knowledge of children's proportions as a guide, I lightly draw the guidelines, which curve slightly because of the viewpoint. I place the features below the horizontal center-line, where the eyebrows begin. I block in the round eyes, placing them a little more than one eye-width apart. Then I sketch the round nose and small mouth and add some wispy hair to frame the face.

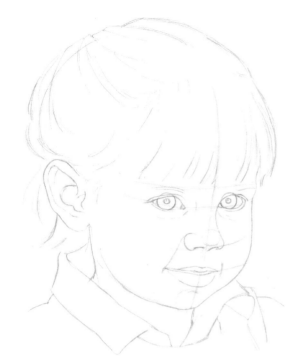

Step Two I add details to the eyes and indicate highlights. (Prominent highlights give children's eyes that curious, youthful spark.) Then I develop the ear and fill out the lips. I draw a curved line from the tip of the girl's left nostril up to her left eye to build up the nose and draw another line connecting the nose to the mouth, giving her right cheek form. I sketch a few quick lines to indicate the slightly chubby area underneath her eyes, extending the cheek a bit to round it out. I add the bangs with light, soft strokes.

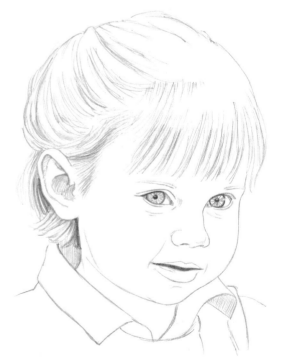

Step Three With a 3B pencil, I fill in the area between the lips, then shade the pupil and outline the iris. I add a few thin lines for hair between the scalp and the ear, darkening the hair where it is in shadow behind the ear. I keep the hair soft by sketching with light, short lines—this keeps my subject looking youthful. Switching back to the 2B pencil, I shade the inside of the ear and the underside of the shirt collar, helping to show the direction of the light source. Then I define the lines around the eyes and the mouth.

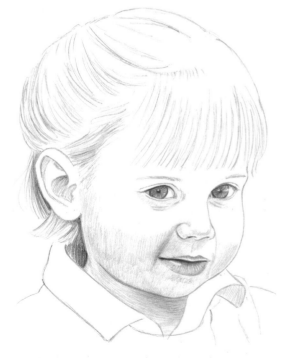

Step Four I shade the lips with a 2B pencil, leaving a light area on the bottom lip to give it shine. Then I shade the neck using light strokes that follow the shape of the neck. With a few short lines, I draw the eyebrows; I also add light shading to the lower half of the face, filling out the cheeks and making them look rosy.

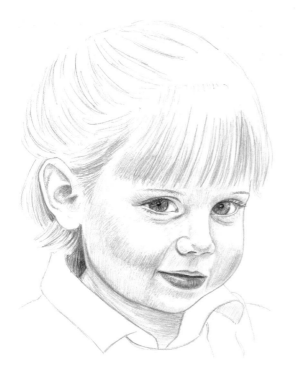

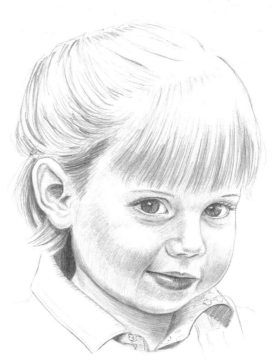

Step Five Over each eyelid, I sketch a series of small lines curving up to the eyebrows to show the youthful chubbiness. Then I add eyelashes using curved pencil strokes. To keep the subject looking young, I draw very light, almost nonexistent eyebrows. I shade the forehead in an up-and-down motion, and then I give her right cheek more form by darkening the areas around it. I use sweeping strokes to build up the bangs, leaving the paper white in areas for a shiny look.

Step Six Still using the 2B pencil, I further build up the ear. I shade a small area between the bottom of the nose and the top of the lips to suggest the indentation, and I add shading to the creases around the mouth. I create more dark strokes in the back of the hair to show where the hair is layered. Then I draw a flower pattern on the shirt collar. Adding youthful patterns to your subject's clothing helps define their age; overalls, jumpers, ribbons, baseball caps, and bows also can imply youth.

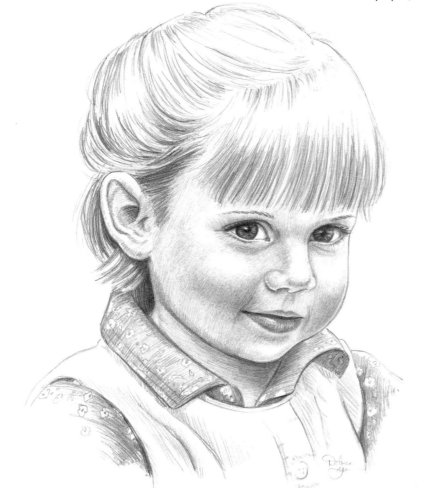

DRAWING FROM A DIFFERENT ANGLE

Because of the way this young girl's head is tilted back, you see more of her chin and neck than you do the top of her head. The ears appear a bit lower on the head, and you see more of the bottom parts of her eyes. You can even see the underside of the upper eyelid beneath the eyelashes. Even when drawing children from a different angle, the features remain rounded and childlike; for example, you can still get a sense of this girl's wide-eyed, curious expression, although you see less of the eyes than you would in a forward-facing view. And although the nostrils are a little more prominent in this view, they still retain their soft, smooth shape.

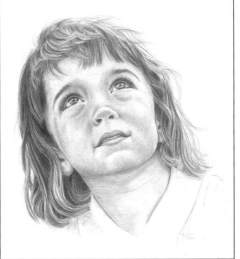

Step Seven Putting my pencil aside for a moment, I carefully drag the edge of a kneaded eraser across the top of the bangs to create the appearance of blond hair. Using the 3B pencil, I create texture on the jumper and shirt by spacing the lines of the corduroy slightly apart from one another. Then I develop the floral pattern on the sleeves of her shirt. Finally I draw a small button, then stand back from my portrait and make sure the transitions from light to dark values are smooth and that there are no harsh or angular lines that might make the subject appear older than she is.

DRAWING A BABY

Drawing babies can be tricky because it's easy to unintentionally make them look older than they are. The face gets longer in proportion to the cranium with age, so the younger the child, the lower the eyes are on the face (and thus, the larger the forehead). In addition, babies' eyes are disproportionately large in comparison to the rest of their bodies—so draw them this way!

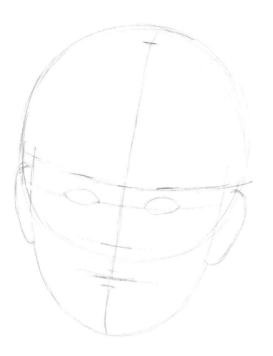

Step One Using an HB pencil, I block in the cranial mass and the facial guidelines. (See page 112 for more information on placing a baby's features.) The head is tilted downward and turned slightly to its left, so I adjust the guidelines accordingly. I place the eyebrows at the horizontal centerline and the eyes in the lower half of the face.

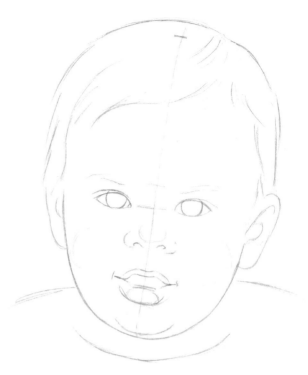

Step Two Now I create the fine hair using soft, short strokes and a B pencil. I draw the open mouth with the bottom lip resting against the chin. Then I add large irises that take up most of the eyes and suggest the small nose. I draw a curved line under the chin to suggest chubbiness; then I indicate the shoulders, omitting the neck.

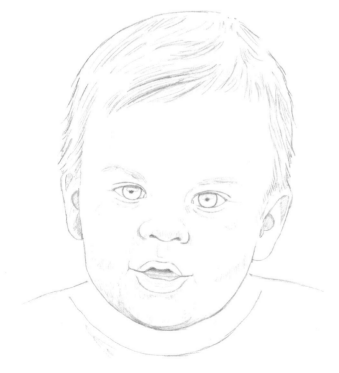

Step Three Erasing guidelines as I draw, I add pupils and highlights to the eyes with a B pencil. I lightly sketch more of the hair and eyebrows, then shade under the chin to give it form. I also shade inside the ears. Then I connect and refine the lips, shading the upturned corners to suggest the pudgy mouth. I shade the inside of the mouth, showing that there aren't any teeth; then I further define the neckline of the shirt.

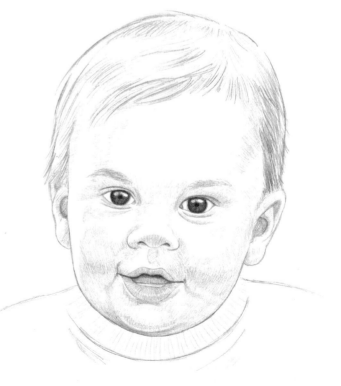

Step Four With a 2B pencil, I shade the irises, and then go back in and lighten the highlights with a kneaded eraser. I draw more soft strokes in the hair and eyebrows and shade the lips and face. I emphasize the pudgy mouth by softly shading the smile lines, then finally add curving lines to the neckline of the shirt.

Step Five I continue shading the face, then add another light layer of shading to the lips. I use the end of a kneaded eraser to pull out a highlight on the bottom lip. Then I draw some very light eyelashes. I create darker values in the hair and eyebrows and round out the outline of the face. I also lightly shade the shirt. Then I take a step back from the portrait to assess whether I've properly built up the roundness in the cheeks, chin, eyes, nose, and mouth. I use a tortillon to softly blend transitions in my shading to make the complexion baby smooth.

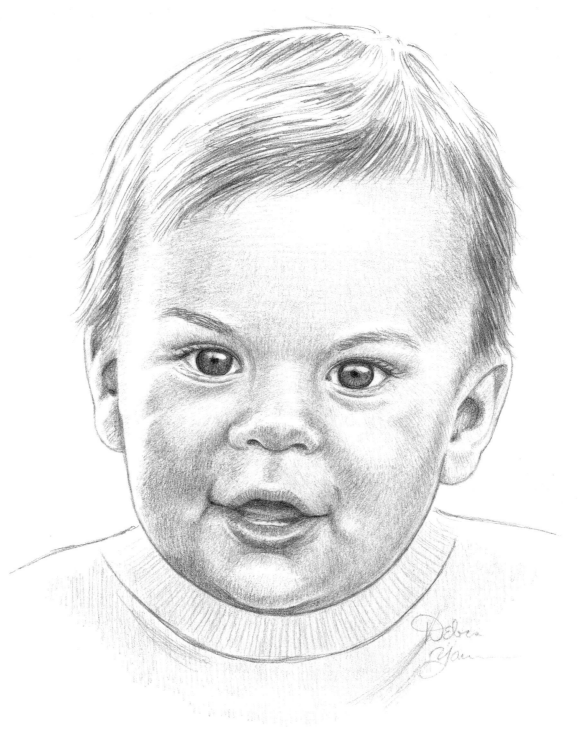

DRAWING A BABY'S FEATURES

Babies often have wide-eyed, curious expressions. Try curving the eyebrows upward to create the appearance of childlike curiosity; pull out highlights in each eye to add life and interest to your drawing. A baby's lips have a soft, pudgy appearance, and the mouth usually is not as wide as an adult's is. Adding highlights is important to convey a smooth texture, and creating creases at the corners of the mouth will help indicate youthful chubbiness.

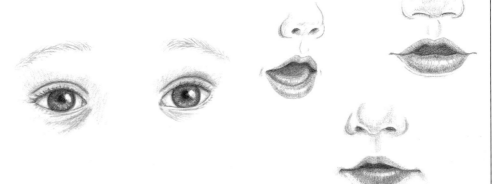

CHOOSING A PHOTO REFERENCE

If you're using a photograph as a reference while you draw, it's usually best to have several different photographs from varying angles and with different light sources to choose from. Not only does this give you a wider selection of poses and lighting options, it also allows you to combine different elements from each photograph. For example, if you are satisfied with the lighting in one photograph but you're drawn to the facial expression in another, you can combine the best parts from each for your portrait.

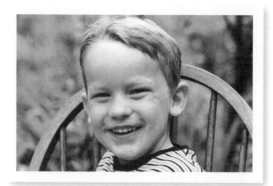

A

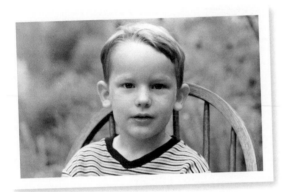

B

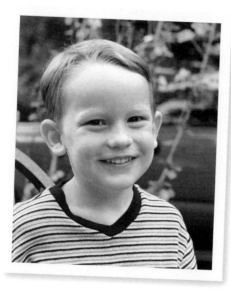

C

Finding the Best Pose In photo A, the subject's eyes are squinting just a tad too much. In photo B, the subject's pose seems stiff and stilted. But in photo C, his pose and expression are just right!

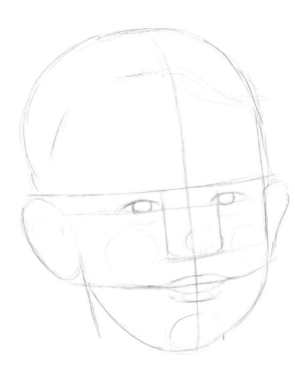

Step One After studying my selection of photographs, I choose the best one and use it as a reference to block in the outline of the face, the guidelines, and the features.

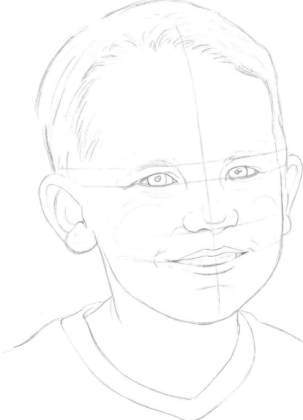

Step Two I compare my initial sketch with the photograph and make necessary adjustments, indicating the roundness of the bottoms of the earlobes with light circles. Next I draw the slightly protruding teeth.

Step Three After erasing my guidelines, I use a 2B pencil to add details to the eyes and eyebrows, and I also shade the lips and cheeks. My photograph shows that the light source is coming from above, so I leave the lightest areas at the top of the head and create the darkest values on the bottom half of the face and neck.

Step Four I darken the hair by firmly shading with a 2B. I continue evenly shading the face and the neck, then add a few light freckles with the tip of my pencil. I darken the inside of the mouth to give the teeth form and add detail to the shirt by stroking on horizontal stripes and shading the neckband. Finally I compare my photograph with my drawing, making sure I've captured the likeness.

INDICATING FAIR FEATURES

When drawing a subject with fair skin and hair, keep your shading to a minimum; apply just enough medium and dark values to create the illusion of form without creating the appearance of color. Draw blond hair by outlining the general shape, then adding a few carefully placed strokes to suggest the hair style and create some dimension. Keep in mind that light, wispy eyebrows and freckles often accompany fair skin and hair.

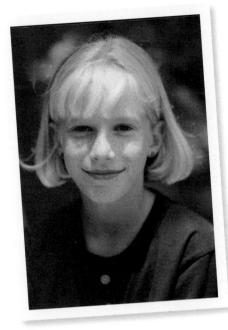

Shading Fair Skin and Hair In this photo, the overhead light makes the bangs, nose, and cheeks look nearly pure white, so I avoid these areas when shading my drawing, leaving much of the paper white.

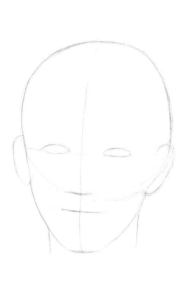

Step One First I lay out the face with an HB pencil. The face is slightly tilted to the subject's left, so I shift the vertical centerline to the left a bit as well. I lightly place the eyes, nose, mouth, and ears, then block in her long, slender neck.

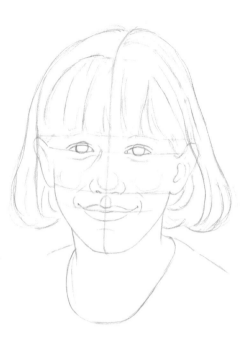

Step Two Switching to a 2B pencil, I develop the features. Although I use the photo for a reference, I use artistic license to adjust my rendering as I see fit. For example, I sketch the bangs so they fall straight onto her forehead, rather than being swept to the side as they are in the photo. I also omit the strand of hair that is blowing in the wind.

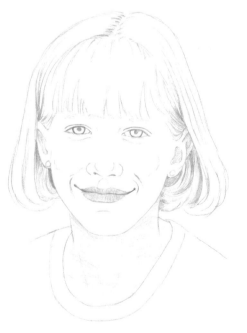

Step Three Now I refine the features, erasing my guidelines as I draw. I continue building up the hair, leaving the top and sides mostly white, adding only a few dark strands here and there. The darkest values are around the ears where the hair is in shadow. Next I add small circles for the earrings and shade the insides of the ears. I develop the lips, then use horizontal strokes to shade the neck.

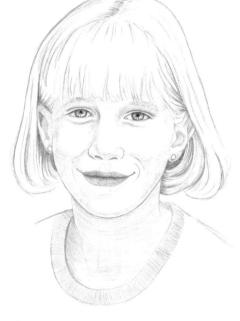

Step Four I shade the face with light, soft strokes to depict the subject's fair skin. Then I make short, quick strokes for the eyebrows, keeping them light and soft to indicate blond hair. Next I shade the irises using strokes that radiate out from the pupil. I also add some hatching strokes to the neckband of the shirt.

DEPICTING FINE HAIR

Blond hair is often finer than darker hair, especially in children. Draw fine hair in narrow sections, leaving plenty of white areas showing through the dark values. Add some short, wispy strands of hair at the forehead to frame the face.

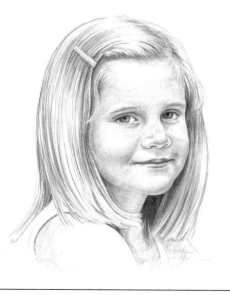

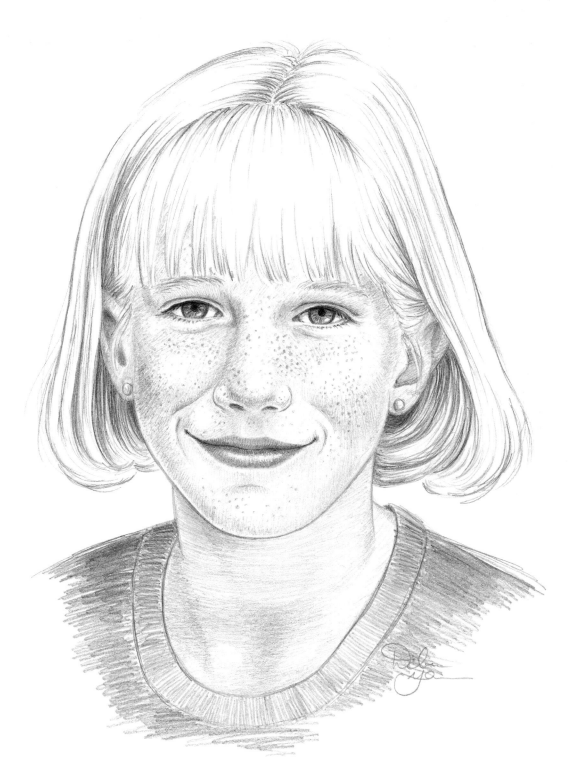

Step Five Using a kneaded eraser, I pull out a highlight on the bottom lip. Then I create more dark strands of hair and further develop the eyes and eyebrows. I begin adding freckles, making sure that they vary in size and shape. (See "Creating Realistic Freckles" below.) Finally I shade the shirt, using relatively dark strokes. It's easy for a blond subject to look washed out on white paper, so the dark values in the shirt help frame the subject and make her face stand out.

CREATING REALISTIC FRECKLES

To draw freckles, space them sporadically, in varying sizes and distances from one other. You don't have to replicate every freckle on your subject's face—just draw the general shapes and let the viewer's eye fill in the rest.

▶ **What to Do** Make sure some of the freckles overlap, and make some light and some dark by varying the pressure you place on the pencil.

▶ **What Not to Do**
When drawing freckles, do not space them too evenly or make them equal in size, as shown here. These freckles look more like polka dots!

Replicating Dark Skin Tones

When depicting dark skin tones, pay attention to the value of the skin tone and how it compares with the values of the features; for example, when the skin is dark, the lips need to be shaded even more heavily. In addition, look for differences in features that indicate ethnicity or race, such as the nose, lips, or eye shapes and the hair color or texture.

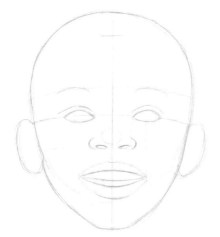

Step One With a 2B pencil, I block in the basic head shape and place the features, following the guidelines. I draw the almond-shaped eyes, wide nose, and full lips, accurately depicting the features as I see them. Then I block in the teeth and indicate the hairline, eyebrows, and ears.

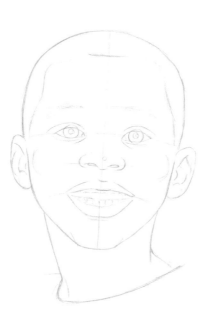

Step Two Still using the 2B pencil, I sketch in the curved neck and define the chin. Then I develop the eyes and use short, quick lines to draw the eyebrows. Next I start defining the ears and teeth. Then I block in the hairline and the neckline of the shirt.

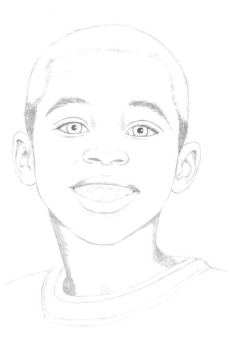

Step Three Next I shade the nose, neck, and top lip, trying to make the lip appear full. I shade the nostrils relatively darkly so they will stand out against the dark skin. Using quick, circular strokes, I start to render the short, curly hair. Then I detail the eyebrows and eyes and define the neckband of the shirt.

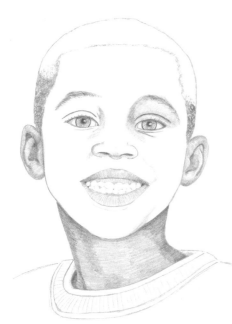

Step Four Using strokes that follow the shape of the mouth, I continue shading the lips; then I shade the gums, carefully working around the teeth. I make sure the lips and gums won't contrast too sharply with the skin, because if they're too dark they'll look unnatural. Next I build up the coarse hair with more circular strokes. Then I move to the neck, using horizontal lines that curve with the shape of the neck. Notice how these lines overlap and blend into the shading that was applied in step 3.

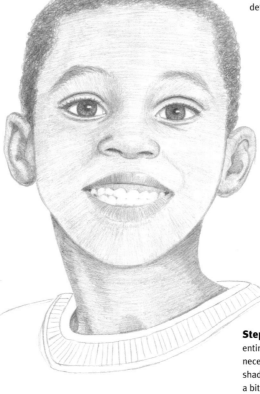

Step Five Now I apply a light layer of shading over the entire face, always varying the direction of my strokes as necessary to follow the shapes of the different planes. The shading is starting to round out the face, which has looked a bit flat up to this point. I'll add more shading later to make it appear even rounder and fuller.

Step Six I continue shading the face, making the sides of the forehead a bit darker and leaving the middle area lighter to show where the light hits. Then I darken the nose, leaving a white highlight on the tip. I also refine the shirt, curving the strokes as they go around the back of the collar. Next I further shade the lips to accentuate their fullness, then pull out a highlight on the top lip with a kneaded eraser. Finally I go back and soften the transitions between values by very lightly blending them with a kneaded eraser.

ESTABLISHING VALUES

Every skin tone is made up of a variety of values—when drawing in graphite pencil, you can accurately capture these differing tones using varying degrees of light and shadow. Before you start drawing, be sure to study your subject to establish the richest darks and brightest lights of their skin tone, whether they are fair-, medium-, or dark-skinned. In the examples at right, hair color and contrasting values work together to suggest the medium skin tone of the boy to the far left and the fair skin tone of the boy at center. The darkly shaded, fully formed cheeks of the boy to the far right give his skin a ruddy, tanned appearance.

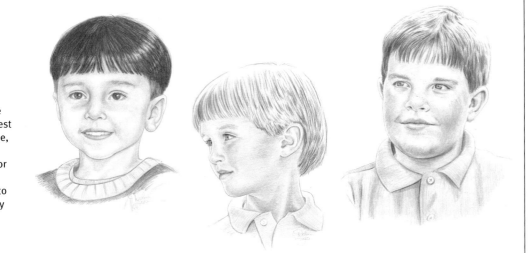

UNDERSTANDING BODY ANATOMY

Figure drawing is easier when you have an understanding of the basic structure of the body. The muscles and bones give the body three-dimensional form, with the muscles filling out the skeletal foundation. Together they give the figure correct proportion—the relationship of the individual body parts to one another and to the body as a whole. Knowing what is beneath the skin of the figure will make your drawings more realistic and true to the form of your subject.

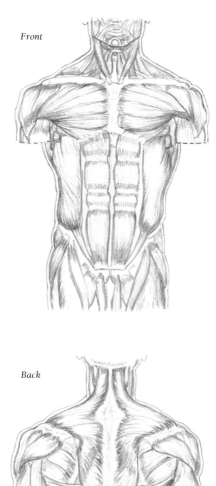

Front

Back

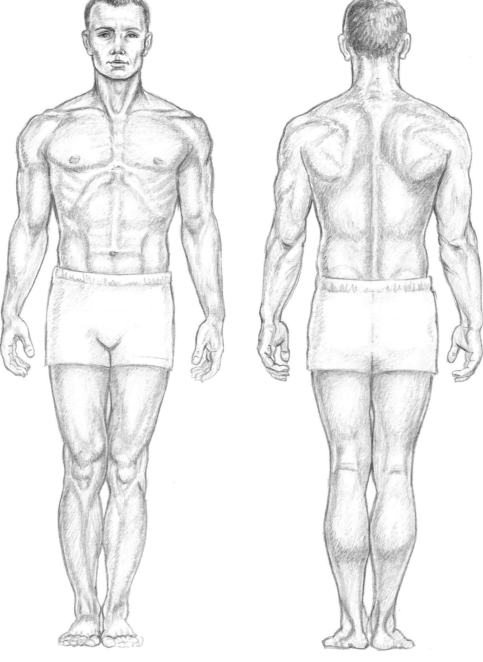

Muscles Affect Form The musculature of different individuals can vary depending on their level of physical fitness, but we all have the same muscles underneath. Therefore the general pattern of bumps and curves that make up the shape and form of a figure are very similar from person to person. It's a good idea to become familiar with the placement of the structures shown in the front view (above) and back view (below) so you can better envision the way the skin lays over the muscles to create the human form.

Torso Musculature (Front) The torso muscles—from the neck to the shoulders, across the chest, down and around the rib cage, and then from the hips to the legs—control the movement of the body and give form to the skeleton. Compare this with the drawing at top left.

Torso Musculature (Back) The muscles in the back of the torso generally extend across the body, rather than up and down as in the front. They hold the body erect, stretching tightly across the back when the limbs move forward. Compare this with the drawing at far left.

ADULT BODY PROPORTIONS

The proportional measurements of the parts of the human body vary slightly for every person, making them unique; paying attention to these variations will help you render accurate likenesses. But first it's important to understand how we're all the same by studying the average proportions of the human body, which are more apparent when we look at the skeletal and muscular views of the body. When drawing a figure, we measure in "heads," the vertical distance from the top of the head to the chin. Use rough measurements to help place the parts of your figure. If a head or other body part appears too large or too small, you can check the body's proportions to correct the problem.

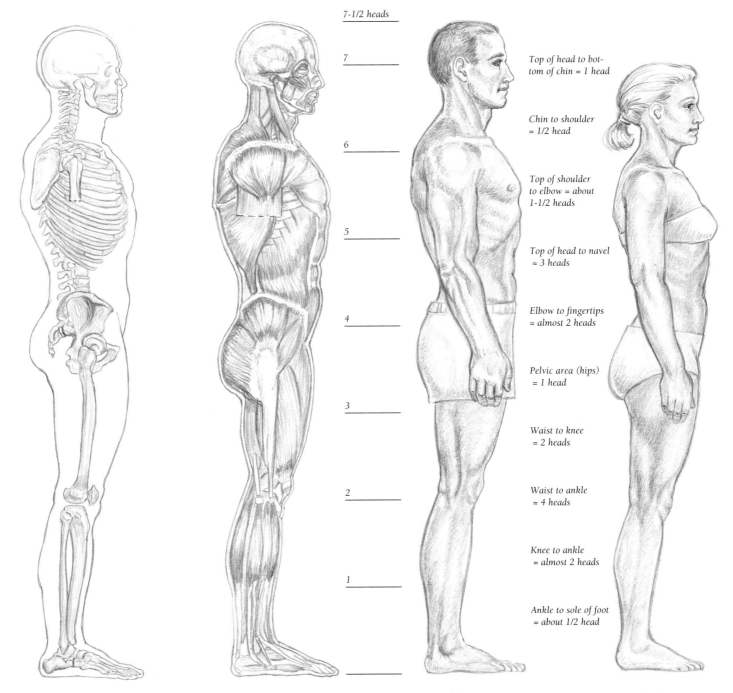

7-1/2 heads

7

6

5

4

3

2

1

Top of head to bottom of chin = 1 head

Chin to shoulder = 1/2 head

Top of shoulder to elbow = about 1-1/2 heads

Top of head to navel = 3 heads

Elbow to fingertips = almost 2 heads

Pelvic area (hips) = 1 head

Waist to knee = 2 heads

Waist to ankle = 4 heads

Knee to ankle = almost 2 heads

Ankle to sole of foot = about 1/2 head

Skeletal Structure By studying bone structure, we can clearly see the relationship of the length of each part of the body to the whole.

Body Musculature Proportion doesn't apply to length alone—the thickness of the body also must be proportionate. This aspect of proportion varies depending on the fitness of the individual, but the drawing above will help you assess these proportions based on an ideal human musculature.

Male Proportions The average male is approximately 7-1/2 heads high; of course, these proportions vary with different body types. Often artists use an 8-head-high figure for the male as an ideal proportion.

Female Proportions The average female is about half a head shorter than the male, or 7 heads high. Artists often elongate the female figure, especially in fashion drawings. Generally the female has narrower shoulders and a smaller waist than a male, but proportionally wider hips.

HANDS

Hands are very complex and involve many moveable elements, which can be a challenge to draw. Some positions of the hand are more difficult to draw than others. You may want to try posing a hand—yours or a model's—in many different positions and drawing them for practice. In general, draw men's hands more angularly, with a heavier line quality; draw women's hands lightly with smooth, graceful lines. When sizing a hand to a figure, remember that a hand is about the same length as the face, from chin to hairline. If a hand is posed in a way that does not allow you to see all the fingers, don't be tempted to draw what you can't see or it will look unnatural. Try not to be discouraged if your first few drawings aren't lifelike; hands definitely take a lot of practice!

HAND ANATOMY

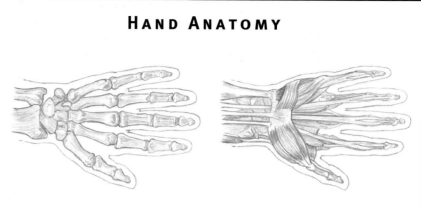

Bones and Muscles Studying the bones and muscles of the hand can help you understand the form and movement of the hand. That, in turn, can help you render more successful drawings. Notice the joints of the fingers, their relationship to the other fingers, and how the bones and muscles extend from the base of the hand.

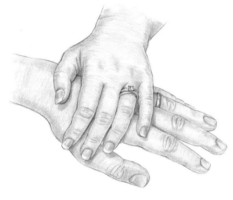

Differences in Male and Female Hands Here the hands of a young married couple clearly show how male and female hands are drawn differently. The strong lighting is from above, creating bright highlights on the back of the woman's hand.

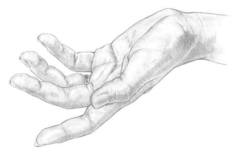

Showing an Open Palm An open-palm rendering of an adult female's hand could be at rest, showing us something in her hand, or reaching for something. With lighting from above, the highlights are on the tops of the fingers and palm, with the back of the hand in shadow.

Extended Versus Folded Fingers The skin at the base of the thumb shows more modeling or folds than the other fingers. This view is lit from above, so the highlights are on the tops of the fingers, and the shadows are beneath.

Holding a Pen or Brush This adult male hand holds a paintbrush, but the same pose could hold a pen or pencil. The strong light source from the right highlights the fingers and leaves the back of the hand and wrist shadowed.

Making a Fist The middle-aged male fist here could be holding something tightly or using a tool. The lighting is soft and evenly distributed from a source that is to the viewer's left.

Playing an Instrument In this view of a young male's hands on a keyboard, several of the fingers are not visible. These hands also could depict reaching for something. The light here is from above, highlighting the backs of the hands.

Feet

Toes are less flexible than fingers, so feet are not as complicated to draw as hands. Because feet have a unique structure, however, it is still helpful to study the bones, muscles, and tendons to assist you in rendering accurate drawings. Practice drawing feet in various views, as shown here, to build your skills.

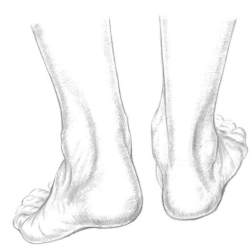

◄ Back View of Feet When viewed from behind, the heel and leg bone catch the light and become one large area. Very little of the front of the feet are visible from this angle.

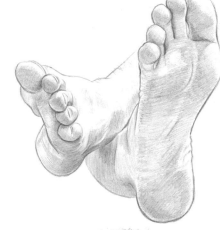

◄ Crossed Feet From our viewpoint in front of this man's crossed feet, we see the entire bottom of his right foot. The left leg is crossed over the right and the foot is pointed at us, so there is severe foreshortening (see page 129); the toes are just ovals when they are seen straight on like this.

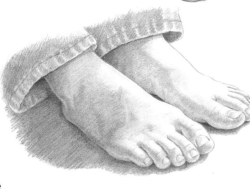

◄ Young Female Feet The feet of this young girl are smooth on top because she is sitting with her feet extended in front of her. The strong lighting from above gives the tops of the feet bright highlights and casts dark shadows.

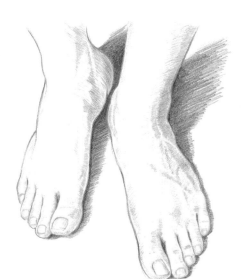

◄ Adult Male Feet This man is lifting his right foot at an angle to take a step; it looks smaller than the other foot because it is farther away from the viewer. Notice how the raised foot catches the light, but the foot on the floor shows more intricate shading of light and dark areas.

◄ Feet in Profile In this view of a woman walking, her right foot is a complete side view with only the big toe showing. Her left foot is bending at the toes and pointed slightly toward us, so we can see all the toes on that foot. Notice the difference between the shape of the foot when flat as opposed to when it is bent.

FOOT ANATOMY

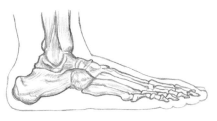

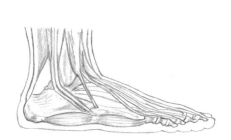

Skeletal Structure In this frontal view, we see that the main bones of the feet are heavier than those of the hands. The toe joints are close together, as compared with the widely separated finger joints.

Heel and Arch Formation Both the attachment of the leg bones at the ankle and the heavy bone that forms the heel and arch are visible in this side view of the skeletal structure of the foot.

Muscles The relationship between the foot and leg are easy to see in this side view of the musculature of the foot. You can follow most of the foot muscles up the leg, from which most foot movement comes.

SHOWING MOVEMENT

All the parts of the body combine to show movement of the figure. Our jointed skeleton and muscles allow us to bend and stretch into many different positions. To create drawings with realistic poses, it helps to study how a body looks and changes when stretched or flexed, as well as when sitting or standing. Begin by drawing the *line of action* (a line to indicate the curve and movement of the body) or "gesture" first; then build the forms of the figure around it.

Extending and Contracting The spine is flexible and allows us to bend many ways while stretching and contracting our limbs. These three poses show how the shape of the body can change drastically while the proportions stay the same.

Stretching and Bending You almost can feel the muscles stretching on this cheerleader's body as she pulls up her right leg behind her head. Notice how the bending figure creates wrinkles and tightly stretched areas in the clothing. Be sure to draw these creases and smooth areas to make your drawing believable.

Everyday Action This woman kneeling in her garden is bending into an S shape. All wrinkles or folds in the fabric are on the inward side of the body's bend; the back side is fairly smooth. The curve of her turned head has only a slight influence on the line of action.

FORESHORTENING

To achieve realistic depth in your drawings, it's important to understand foreshortening. *Foreshortening* refers to the visual effect (or optical illusion) that an object is shorter than it actually is because it is angled toward the viewer—and that objects closer to the viewer appear proportionately larger than objects farther away. For example, an arm held out toward the viewer will look shorter (and the hand will look larger) than an arm held straight down by the subject's side. When foreshortening something in a drawing, be sure to draw the object the way you really see it—not the way you think it should look. Foreshortening helps create a three-dimensional effect and often provides dramatic emphasis. Study the examples here to see how foreshortening influences their sense of depth.

Straight-On View Now the legs are extended directly toward the viewer—so the legs are foreshortened, making them appear much shorter than they really are. This distortion creates the illusion that the feet are much closer to the viewer than the rest of the body. The torso, head, and arms are all on the same plane, so they are in proper proportion to one another. Notice here that the stretched-out legs appear to be only about 2 heads long.

Angled View In this view, the head is closer to the viewer than the feet. The thighs seem to disappear behind the hips. Only part of one foot is visible, and it is relatively small due to foreshortening. The right arm supporting the head is not distorted by perspective because the full length is parallel with the side of the picture plane (i.e., not angled toward or away from the viewer). The torso is slightly distorted by foreshortening; the shoulders are closer to us and appear a little larger in comparison with the hips.

Side View In this view, the young woman's limbs are not distorted because the view is directly from the side, not at an angle. Her torso, head, and legs are all at roughly the same distance from the viewer. The fingers of her left hand are somewhat foreshortened because they are turned toward the viewer.

Foot to Head View Here the feet are closest to the viewer, and the head is farthest away, so the feet appear relatively larger than they would normally. The lower legs are foreshortened because they are angled directly toward the viewer. Most of the torso and the arms are hidden behind the legs—remember that you shouldn't draw what you can't see!

Back View with Angled Head and Arm In this view, most of the body is on the same plane (and parallel to the picture plane), but the head and arms are angled slightly away from the viewer, so they appear relatively small when compared with the rest of the body.

FOCUS ON FINGERS

When foreshortening occurs, you must forget everything you know about proportion and draw what you see instead of what you expect to see. Even something as simple as a fingertip can take on a drastically different appearance.

Fingers When viewing a finger from the side (A), the tip of the finger is much smaller than the knuckle. When viewed straight on (B), the tip and the knuckle appear equal in size. When the lines of the rounded fingertip and nail are shortened, both appear quite square (C). Foreshortening from this angle causes the length of the fingernail to appear quite short as well.

UNDERSTANDING LIGHTING

An important aspect of drawing—especially when draw-ing people—is lighting the subject. Lighting can have a dramatic effect on the figure's appearance, eliciting an emo-tional response from the viewer and setting the mood of the drawing. Subtle lighting often is associated with tranquility and can make a subject appear soft and smooth. This type of lighting tends to lighten the mood, generally lending a more cheerful feel to the composition. On the other hand, strong lighting makes it easier to see the contrasts between light and dark, which can add drama and make the subject appear more precisely formed. Longer shadows can mute the mood of a por-trait, producing an air of pensiveness. Here strong shadows on the subject's face make her subtle smile seem reflective rather than content.

Step One First sketch the outlines of the figure on white drawing paper, using an HB pencil. Start with the torso, and then add the shape of the head. This is a three-quarter view of the body, but the face is in complete profile as the subject looks out the window. Block in the lines of the shoulders and chest; then add the window frame and sketch both arms. Draw the seat of the chair, and indicate the chair legs. Then add the subject's legs, with the sub-ject's right leg stretched out in front of her and the left leg pulled back toward the chair. Lightly sketch the entire back leg, "drawing through" the front leg to help position the leg correctly, and then erase any unnecessary lines.

Step Two Switching to a B pencil, begin refining the head by adding the features and the hair, erasing unneeded lines as the drawing progresses. Refine the shirt and jeans, adding details like the seam along the leg. Add the back of the chair, and refine the shape of the rest of the chair. Draw the lower window frame, and refine her fingers and the shapes of the shoes. The main concern at this stage is establishing the overall shape of the figure—shading to indicate lighting and mood will come next.

Step Three Using a very light touch, draw the edges of the shadows along the face, neck, arms, hands, and ankles. These lines will serve as a guide for adding the shading later. Also add this shading line to the shirt and pants, following your reference photo to outline areas where the lightest highlights will be, as this part of the paper will remain white. Begin to shade the hair, curving the strokes to follow its shape. Then shade the front of the chair.

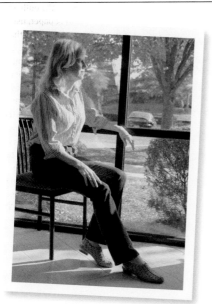

Using Strong Natural Light The model for this drawing is sitting beside a floor-to-ceiling window. The sun is streaming through the glass from above and in front of her. The strong light creates visual interest by casting deep shadows and creating bright highlights.

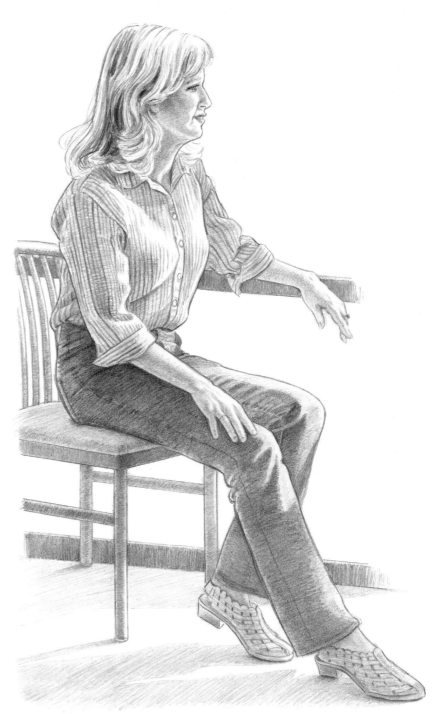

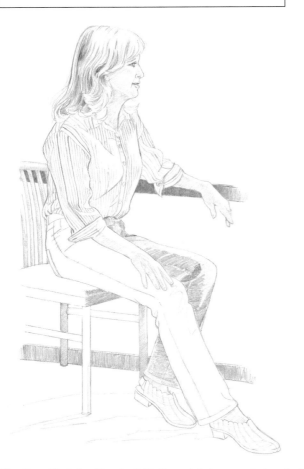

Step Five Switch back to a very sharp B pencil to add some details to the face. Using a 2B pencil, create more dark values in the hair and shade the stripes on the shirt. Darken the rest of the jeans using strokes that follow the form of her legs. With a sharp pencil point, carefully add a layer of shading to the darker areas of the skin. Reflected light from the shirt lightens her jaw line. Reflected light also appears on her arms and fingers; stroke across the arms to give them form. Shade the rest of the chair, leaving white on the chair legs where the light hits them. Because this portrait utilizes strong contrasts in light, larger portions of the drawing will remain nearly white—including the highlights on her legs, her throat, and her chest. A portrait that comprises varying degrees of shadows without these large areas of highlight would lose drama and intensity. Next shade the shoes, making them darker where the woven pattern is more detailed. On the floor, use diagonal hatching strokes, angling away from the light to create the shadows cast by the legs of both the subject and the chair.

Step Four Shade the skin using light, diagonal strokes, except where the highlight is strongest. Erase any remaining shading guidelines. Then draw the stripes of the subject's shirt, following the folds and curves of the fabric over her form and leaving the lightest areas white. After adding details to the shoes, use a 2B pencil to create dramatic contrasts in value—shading the inside of the left leg, adding a few more dark values to the hair, and drawing the outlines of the shadows on the floor. Look at your reference photo frequently to check the placement and strength of your highlights and dark values. Then apply additional shading to the back and legs of the chair, and shade the window frame.

LIFE DRAWING (FULL BODY)

Drawing from a live model (also called "drawing from life" or "life drawing") is a wonderful exercise in drawing the human body in its various shapes and positions. Drawing from life helps you avoid overworking your drawing because you're instead focused on quickly recording the gesture and specific details of your model before he or she moves, resulting in a spontaneous, uncomplicated finished drawing. Take advantage of available models—your children, other family members, or friends—whenever possible. When drawing from life, be sure the pose is comfortable for the model. Allow short breaks for your models (also providing you time to rest), and don't require them to smile, as this can tire out their facial muscles. Because you're working at a faster pace, drawing from life will help you learn freedom and flexibility—both of which will benefit your drawings regardless of the type of reference. It also will help you appreciate the subtleties the eye perceives that the camera can't—such as the twinkle in this man's eye!

Step One Using an HB pencil, lightly block in the basic shapes of the figure and the rocking chair, paying particular attention to the vertical lines and balance to make sure the figure doesn't look as if he's going to tip over in the chair. Notice that the model's back curves forward while the back of the chair angles backward, and his head aligns vertically with the back of the chair leg. Foreshorten the right leg and make the right foot larger than the left because the right leg is angled toward the viewer.

Step Two Begin to refine the shapes, indicating the clothing and shoes. Then block in the mustache and beard, and place guidelines for the facial features. Study the model's face to see how the proportions and placement of the features differ from the "average" proportions.

Step Three With a B pencil, draw in the facial features and refine the shapes of the head, including the ear, hair, and hat. Then hone the rest of the body, drawing the folds and details of the fabric and adding the fingers on the left hand. Next further develop the chair, using a ruler to create straight lines. Continue by shading the hat, the sock, the far rocker, and the model's back.

Step Four Using a 2B pencil, begin shading the hat, leaving the top edge and a line on the brim white. Add some detailing to the hair and beard with short strokes, following the direction of growth. Shade the clothing, leaving the areas white along the side where the light hits. Watch the shapes of the wrinkles and how they affect the lights and shadows. Also shade some of the rocker, and lightly sketch in the shapes of the cast shadows.

FACE DETAIL

To create the beard, apply very dark tone to areas of the beard, showing the gaps between groups of hair. Also leave some areas of the paper completely white to reflect the areas of the beard that are in the direct path of sunlight. When detailing the face, shade very lightly to indicate wrinkles and creases. The wrinkles should appear soft, so avoid using hard lines. To create the twinkle in the eyes, pull out a highlight in each pupil with a kneaded eraser.

Step Five Lightly shade the face, varying your strokes to follow the different planes. Add further details and shading to the eyes, nose, mouth, ear, hair, and facial hair. Study your model to see what details will help create a likeness. Then shade the clothing and chair, always keeping in mind where the light is coming from and adjusting the lights and shadows as needed to enhance the illusion of depth. Use a 4B pencil for the darkest areas and leave the lightest areas pure white. Soften any hard edges with an eraser, a tortillon, or a tissue. Finally, step back from your drawing, squint your eyes, and see if there are any areas that need to be corrected. If any areas are too light or too dark, adjust them as necessary.

BRIDAL PORTRAIT

Special occasion photos, such as a bridal portrait, provide great references for drawing people. When drawing a bride, focus on capturing the key elements that symbolize the event, such as the veil, bouquet, and gown. The details of these objects are always unique to the particular subject, making it easy to achieve a likeness. Pay special attention to the way the gown and veil drape, the small details on the gown, the way the veil fits on the bride's head, and how her hair is styled. Finally, be sure to capture the glowing expression on her face!

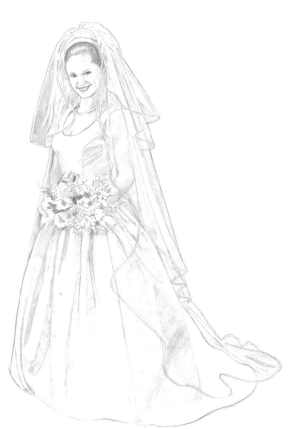

Step One With an HB pencil, sketch in the shape of the figure. (Notice that this particular subject is only 6-1/2 heads tall.) Start with an oval for the head, and then block in the basic shapes of the veil, dress, and bouquet. Check the proportions before continuing. Make sure that the skirt of the gown is long enough in relation to the bodice and that you haven't made the head too small or too big in relation to the body. (You may find it easier to get the proportions right if you block in the subject's entire body first, then draw the clothing over it.) Once you're happy with the basic outlines, add guidelines for the facial features, curving them as necessary for the three-quarter view.

Step Three Switch to a B pencil. Then shade the pulled-back hair, working from the hairline toward the crown and curving the strokes around the head. Be sure to leave the white highlight near the front of the head, as shown. Next lightly shade the dress and the veil to indicate the folds, always thinking about where the light is coming from. Be sure to leave strong highlights along the ridges of the veil to suggest the translucency of the filmy, white fabric. Shade the flowers in the bouquet, suggesting the shapes of the different types of flowers. Now refine the facial features, darkening the eyes and lips and creating the shape of the nose. Then begin to lightly shade the skin of the face, chest, and arm. It's important not to make the skin too dark; use a kneaded eraser to pull out some of the tone or create highlights as needed.

Step Two Using the facial guidelines, place the eyes, eyebrows, nose, mouth, and ear. The ear sits high on the head because the face is tilted down. Begin finding the location of the folds in the dress and veil, and sketch in placement lines. Remember that the way a fabric drapes depends on the thickness of the fabric as well as the form underneath it. Then block in the flower shapes inside the oval bouquet shape, and indicate the necklace with one line where it lays on her neck.

Step Four Finally, refine the shading by adding more layers of strokes where darker values are needed. Keep the shading smooth, applying the strokes very lightly and close together. Use a kneaded eraser to create some white edges on the veil. To soften the shading and give the material a more realistic appearance, lightly use a tortillon on a few areas of the veil and dress. Add more shading to the flowers, using a 2B pencil in the darkest areas. Use the same pencil to further shade the hair, still leaving some white along the front for shine. Finish by using diagonal strokes with a 3B pencil to shade the background, which helps the white veil and dress stand out from the white paper.

CHILDREN'S BODY PROPORTIONS

Drawing children can be challenging because you have to get their proportions just right or your drawings will look odd. Children's proportions are much different than adults', and children's proportions change as they age. For example, a baby's head is extremely large in proportion to its body—but as the child grows up, the head becomes smaller in proportion to the body. Additionally, a child's head is wider than it is long, so it's rounder than that of an adult. If your drawings of children look too old, make sure you're not using adult proportions!

Proportion Scale for Growth Years Infants' bodies are short, making their torsos and limbs appear proportionately thicker. As infants grow into toddlers, their faces and bodies begin to elongate. By age five, children are about half as tall as they will be as adults; and by age eight, growth spurts will add another 1 to 2 heads in height, further elongating the body. By the early teens, the face has elongated to such a degree that the eyes are almost at the centerline of the face (where they are located on adults' faces); the change in proportion results in a less chubby look, thus we say bodies lose their "baby fat." People reach their full adult height between the ages of 18 and 20; musculature is still developing, but adult proportions have been achieved. Note: These proportions and observations are based on averages; carefully study your subjects to determine their individual proportions.

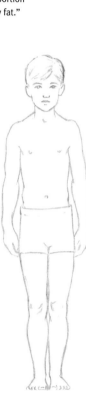
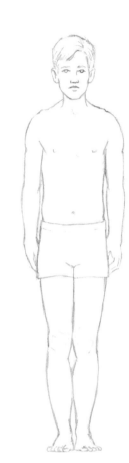
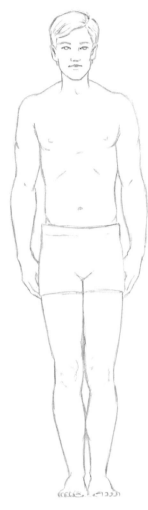

Toddler *(3-3/4 heads tall)*	*Age five* *(4-1/2 heads tall)*	*Age eight* *(6 heads tall)*	*Young teen* *(6-1/2 heads tall)*	*Older teen* *(7 heads tall)*

TODDLERS' LIMBS

Arm and Hand The arm of a two-year-old usually is a bit pudgy and has wrinkles at the joints. Deep folds of skin at the inner elbow and wrist are fairly common, as are dimples on the elbow and knuckles.

Hand and Fingers The back of a toddler's hand is chubby and rounded. The fingers are plump and fleshy, even at the tips.

Legs and Feet The legs are short, which makes them look fairly thick. Plump, two-year-old toes are short, round, and nearly shapeless. The foot is just starting to form an arch at this stage.

CHILDREN IN ACTION

To capture children's actions, train your eye to assess the essential elements of the movement, and then quickly draw what you see. One way to rapidly record details is through a gesture drawing, a quick sketch establishing a figure's pose. First determine the main thrust of the movement—or the line of action—from the head, down the spine, and through the legs. Then sketch general shapes around this line. As you can see here, a quick sketch is all you need to capture the main gesture—and you always can add details later.

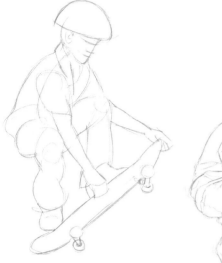

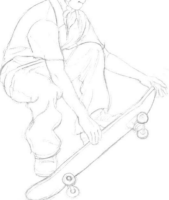

Step One A pose of this nature can be challenging because skateboarders often appear to defy gravity! But just record this action the same as you would any other: Draw the line of action down the spine, sharply curving through the left thigh. Then add the arms and the right leg for balance. Keep the head in line with the spine.

Step Two Here again, minimal shading and detail are the best ways to keep the movement from looking stiff. Loose speed lines around the boy's helmet, hand, and skateboard also indicate motion.

Step One This ballet pose has two lines of action: The main line curves with the torso and runs down the left leg; the secondary line starts at the left hand and flows across the chest, down the right arm, and through the right hand. Most of the weight is on the left leg; the right leg is extended for balance. If the basic gesture isn't correct, the figure will look like she's falling over.

Step Two When blocking in and refining the shapes of a complicated pose such as this one, it's important to keep in mind many of the concepts you've learned in this book, including the head and body proportions and how foreshortening affects them.

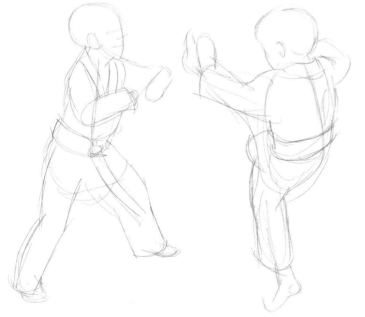

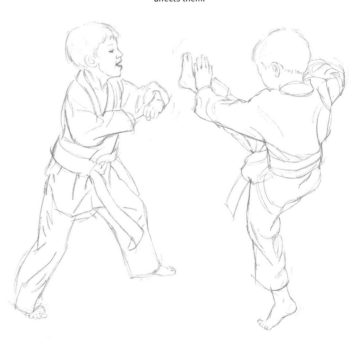

Step One To capture the gesture of these boys, first establish the lines of action; then block in the general shapes surrounding them. For the boy on the left, the line of action moves down his spine and through his left leg, where his weight is balanced. The boy on the right is kicking with his right leg—note the way the kick causes his body to bend forward in order to balance, curving the line of action at the base of his spine.

Step Two After placing the lines of action correctly and blocking in the basic shapes, add a few details on their heads, hands, feet, and clothing, keeping the lines loose. Karate uniforms are loose fitting, but you can see how the boys' movements have pulled the fabric taut in some places.

CHOOSING A POSE

Not every photo you take is going to be good, and not every pose your model strikes is going to be perfect. Look for poses that are natural and balanced, not stiff or boring. Some movement or tension can make the pose more interesting, but your subject should look stable and comfortable in the position. Unless in motion, the model should not have his or her arms and legs stretched out in all directions; instead, he or she should be more compact and relaxed. The pose should reflect the personality or interests of the subject. Take many photos to use as references, and evaluate them for suitability.

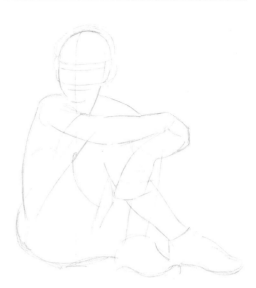

EVALUATING PHOTOS

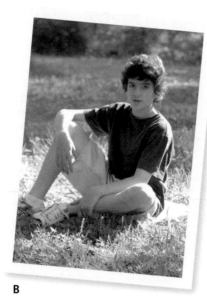

A

B

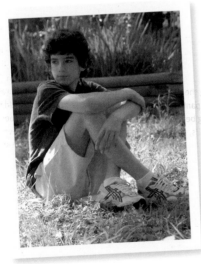

C

Step One Using an HB pencil, block in the figure. Place the head above the center of the main body mass, as indicated by the vertical line. Sketch the shapes of the arms and legs, drawing through the overlapping body parts for correct placement. The vertical centerline on the head shows the three-quarter view. Add the horizontal guidelines for the facial features. Sketch the general shapes of the shoes and the lines for the ends of the shorts and the shirt sleeve. Be sure the pose and proportions are accurate before adding any details.

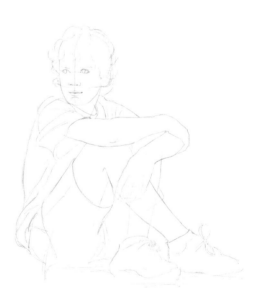

Selecting a Photo Reference In photo A, the subject has a stable, compact pose, but he looks a bit stiff and bored; his personality doesn't show through. The pose in photo B is more relaxed, but the boy looks a little out of balance, and his arms and legs are in awkward positions; in addition, the light behind him is a bit harsh. Photo C is a great pose to represent this young man. He looks quite comfortable, and his hands and feet are in good, natural positions; his head is turned at a 90° angle to his body, which helps give some movement and interest to the pose. The lighting is more even as well. This is the best pose to use for a drawing.

Step Two Now it's time for some definition. Place the facial features on the guidelines. Remember: The guides you learned about earlier are based on averages; to achieve a good likeness, be sure to follow your photo reference and adjust accordingly—for example, accounting for this boy's high forehead and wide-set eyes. Indicate the hair, and sketch in the clothing, showing some of the folds and wrinkles. Sketch in the shapes of the fingers of his left hand and the elbow of his right arm. Refine the shapes of the shoes, and indicate laces.

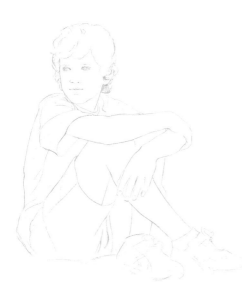

Step Three Erase the guidelines. Then use a B pencil to refine the facial features and the hair. Give the fingers a more precise shape, and add the fingernails. Refine the shapes of the arms, legs, and clothing, removing unneeded lines with a kneaded eraser. Using "artistic license" (the artist's prerogative to ignore what actually exists, and to make changes, deletions, or additions), the author decides to change the shoelace so it is not awkwardly sticking up at an odd angle.

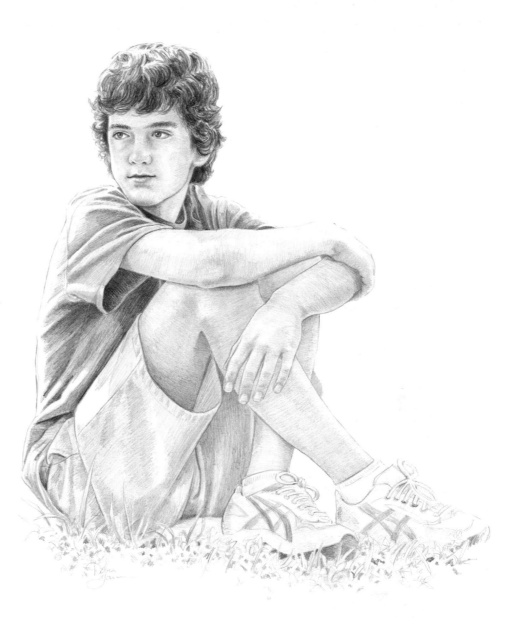

Step Four Using a 2B pencil, begin shading the hair with strokes that follow the direction of growth. Leave areas of white paper where the light hits the hair. Shade some darker areas around the eyes, cheekbones, and under the lips, as well as on the neck. Use a very sharp pencil and small strokes for the eyebrows and lashes. Darken the legs where they are in shadow; these strokes follow the curve of the leg and help show its form. (See "Shading the Forms" at right.) Begin to shade the arms and other areas in shadow, such as the ends of the fingers. Add more shading to the clothing and shoes, rendering additional details as you go.

Step Five Using a very sharp 2B pencil with light pressure, shade the face, leaving a white highlight on the nose and chin and on the side of the right cheek that is in more direct sunlight. To show the delicate form of the face, place your shading strokes very close together and follow the contours of the face, often changing direction. Shade the arms and legs using a little pressure for the lighter areas; press harder for darker areas. Leave a white highlight on the top of the right arm to show where the sunlight is reflected. Along the back, leave a vertical area of white paper to represent the bright sunlight on the shirt; other folds of the shirt and pants also have highlights. Use a 3B pencil to add some dark areas in the hair and in the darkest areas of the clothing before switching back to the 2B pencil. The shoes receive a little more refining and shading; don't draw all the details, as they are not needed. Add some grass, leaves, and a little shading to show that the boy is sitting outside. Leave a lot of white paper around him, providing very little detail to the grassy area to keep the focus on the boy.

SHADING THE FORMS

Shading with varying values—from black through all shades of gray to white—enhances the illusion of depth in a drawing. Effective shading also adds life and realism to a drawing. When shading cylindrical elements, such as the arms and legs, make sure your pencil strokes follow the curved forms, as shown in the diagram at right. This illustration has been exaggerated to demonstrate the different directions the shading lines should follow; your strokes, of course, will be smoother with subtle gradations and highlighting.

INDEX